Penguin Classics of World Art

The Complete Paintings of the Van Eycks

Except for a few ambiguous documents, there exists almost no trace of Hubert van Eyck, the elder of the two brothers, although much is known about the life of Jan, the younger, and more than eighteen works attributed to him survive.

Both artists seem to have contributed to the formulation of the Eyckian technique, a technique which was then developed by Jan. From an inscription on the Ghent altarpiece, the most magnificent of their works, Hubert's participation in it seems certain: 'The painter Hubert van Eyck, than whom no greater has been found . . . and Jan, his brother, second in art . . .' Doubt has been shed on the factual accuracy of this statement, however, as the inscription itself is a sixteenth-century transcription and there is no mention of Hubert's contribution to the Ghent altarpiece in earlier references.

Jan's life is well documented. He was born around 1390 in the village of Maaseyck near Maastricht. From 1422 to 1424 he worked as a painter for John of Bavaria, Count of Holland, and in 1425 he was summoned to Lille as court artist and equerry to serve Philip the Good, Duke of Burgundy, a powerful ruler and patron of the arts in Flanders. Philip grew to admire Jan greatly and the trust he placed in him was evident in the number of diplomatic missions that Jan carried out on his behalf, two of which were concerned with marriage negotiations, one to Spain in 1427 and the other to Portugal in 1428. Jan also worked for wealthy Italians in the Netherlands, such as Giovanni Arnolfini, and his fame spread to Italy very quickly: Vasari wrongly credited him with the invention of oil paint, although Jan probably did perfect an oil medium and varnish which enabled his brilliant colour to survive almost unchanged. In 1431 he moved to Bruges and about the same time married a woman named Margaret, with whom he had at least two children. He continued to paint until his death in 1441; some of his best-known individual works are *The Arnolfini Wedding* (1434) and *The Madonna with Chancellor Rodin* (c. 1436).

Jan van Eyck's ability and inventiveness make him the major artist of the Early Netherlandish School. Admired both then and now for the naturalistic detail in his paintings, his aim was not merely to reproduce, but to reconstruct nature. Because he believed that the natural world embodied God and that all creation was a symbol of the workings of his mind, Jan carried out an unprecedented analysis of form, colour and light, and their relationships with each other, capturing their underlying unity and harmony. In the words of M. Dvořák: 'This is the new "discipline of Flanders", which was often admired and imitated by the Italians and which made it possible for the Netherlanders, in the age of great discoveries, to make one of the greatest, and that is to discover again the whole universe . . .'

The Complete Paintings of

The Van Eycks

Introduction by **Robert Hughes**

Notes and catalogue by **Giorgio T. Faggin**

Penguin Books

Penguin Books Ltd, Harmondsworth, Middlesex, England
Viking Penguin Inc., 40 West 23rd Street, New York, New York 10010, U.S.A.
Penguin Books Australia Ltd, Ringwood, Victoria, Australia
Penguin Books Canada Limited, 2801 John Street, Markham, Ontario, Canada L3R 1B4
Penguin Books (N.Z.) Ltd, 182–190 Wairau Road, Auckland 10, New Zealand

First published by Rizzoli Editore 1968
This translation first published in Great Britain by Weidenfeld & Nicolson, 1970
Published in Penguin Books 1986
Text adapted and updated by Sebastian Wormell

Copyright © Rizzoli Editore, 1968
Introduction and translation © copyright by George Weidenfeld & Nicolson Ltd, 1970
All rights reserved

Printed in Italy

Photographic Sources

Color plates: Blauel, Munich; Breyne, Bruges; Brunel,
Lugano; Flammarion, Paris; Musée Royal des Beaux-Arts,
Antwerp; Metropolitan Museum of Art, New York; Meyer,
Vienna; Museum Boymans-van Beuningen, Rotterdam;
National Gallery of Victoria, Melbourne; National Gallery
of Art, Washington; Philadelphia Museum of Art,
Philadelphia; Scala, Florence; Staatliche Museen,
Gemäldegalerie-Dahlem, Berlin; Witty, Sunbury-on-
Thames.
Black and white illustrations: Rizzoli Archives, Milan.

Introduction

Few people have been so eclipsed by their younger brother as Hubert was by Jan van Eyck. Today, Hubert is the merest phantom; he is that part of the Ghent altarpiece of *The Adoration of the Lamb* which is not by Jan – the curl of paper left by art historians when they have finished cutting out Jan van Eyck's silhouette. His name, spelt variously as Ubert, Lubert and Hubert, appears briefly four times in the city archives on the Ghent altarpiece: "The painter Hubert van Eyck, than whom no greater has been found ... and Jan, his brother, second in art ..." Posterity has reversed even this judgment, and apart from the five documents, the stylistic evidence of the altarpiece, and the probability that *The Three Marys at the Sepulcher* in the Van Beuningen Collection may, on the grounds of what Panofsky called its "archaically overemphatic" linear perspective, be attributed to him, we know next to nothing of Hubert van Eyck, his life, his tastes, his peregrinations and jobs.

Jan, of course, is a different matter. He was born somewhere around 1390 in the village of Maaseyck near Maastricht. Between 1422 and 1424, he was employed as a painter by John of Bavaria, Bishop of Liège; the next year, 1425, his famous relationship with Philip the Good, Duke of Burgundy, began. As court artist and equerry, he moved to Philip's court at Lille. Few such cases of mutual serendipity adorn the history of Renaissance patronage: instead of treating his artist as something between a *jongleur* and an artisan, as the Medici in their off moments were apt to do, Philip was moved to declare that he "would never find a man so much to his taste, or such a paragon of science and art." For eleven years, Jan van Eyck worked in an atmosphere of gracefully reciprocated admiration. He worked, not only for Philip, but for wealthy Italians resident in the Netherlands, such as Giovanni Arnolfini; his fame spread rapidly to Italy, whose humanists called him the "*onore della pittura*" and "*il più grande pittore del nostro tempo*"; Vasari wrongly credited him with the invention of oil painting. His intimacy with Philip the Good is strikingly indicated by the diplomatic missions (whose object, insofar as it can be discovered, was to negotiate marriages for the Duke) that Jan van Eyck undertook on his behalf: to Spain in 1427, to Portugal and England in 1428, and another, perhaps to Prague, in 1436. There was one thing, apart from Jan's social position and professional contacts, which this extensive travel must have benefited: his prodigious visual memory. Jan van Eyck was almost unique among northern – or, for that matter, Italian – artists of the early *quattrocento* for his virtuosity as a recorder of historical style. When he paints a Romanesque capital (as in *The Madonna of Chancellor Rolin*) he gets it right: it is not a Gothicization of Romanesque. The stained glass window and *niello* pavement inlays in the Washington *Annunciation* exactly preserve what must have struck him as their primitive crudeness. It is typical of Van Eyck that this should have been so. No painter has ever been more preoccupied with artifacts – with the exact way a square-cut ruby is set in its flange to the rim of a crown or pearls are sewn to the hem of a robe, with the joints in an arch, the dull sheen of pewter or the luster of polished silver, the pin in an iron door-hinge, the binding of a missal or the angular wooden soles of a pair of discarded chopines. In a lesser artist, this preoccupation might become fetishistic. In Jan van Eyck, it does not. Each of the refined and sumptuous objects with which his world was populated is both concrete *and* self-transcending; or so we instinctively feel. Why?

We may look for the answer in the hypothesis that Jan van Eyck pushed the problem of representation in art further than any artist had done before, or has since. Put baldly, this problem is: how much *exact* information can I load into a painting before suggestion takes over from fact? Total reality is unpaintable, because it is infinite. One can make approximations

in paint which produce this or that illusion, but below a certain scale the approximations turn into shorthand – microscopic reality cannot be rendered with a pasty, sloppy, granular substance like powdered minerals mixed in oil. William Blake's "eternity in a grain of sand" was no visionary fancy, but a sober fact about matter.

I have before me a peach on a plate. For a Cézanne, a Bonnard or a Velasquez, the reality of this peach is its volume, and in a generalized way, its bloom and color: a yellow globular object flushed with crimson patches, matt in surface, not shiny like an apple, its apparent texture (guessed from memories of other peaches) firm but tending to pulpiness. The illusions and sensations produced by a blob and half-a-dozen licks of paint, from the hand of such masters, will suffice to give so much information to the man who looks at that still-life. But the peach is not exhausted, as an object of scrutiny, by these properties. For instance, its "bloom" is caused by a dense coating of short, fine hairs of vegetable fiber, growing from the pigmented skin, which diffuse reflected light. Seen under a glass, each of these fibers becomes a detailed form; under the microscope it may disclose unimaginable complexities of structure. And so one could go on. There is no limit to the describable properties of that fruit, or anything else. But where? At what point does he choose to nip this stupendous ramification of objecthood?

We can see only a limited amount with the naked eye. Worse, we are apt to scan inattentively. Most representational painters, in trying to engage the attention, force one to complete the reading of clues which they leave unfinished: they halt their process of literal description somewhere short of the limit of information which an object normally renders up.

Two feet from the canvas, the glint on Rembrandt's potato nose becomes a blob of white paint and the puckers in Titian's sleeve turn into flat slaps of umber on a blue ground. We turn these marks back into velvet and sweaty skin by making the right guesses. The painters force us to.

Jan van Eyck's extraordinary achievement rests on the fact that he did the opposite. In his paintings, he extended detailed information about things far past the ordinary limits of scrutiny; his eye acted "both as a telescope and as a microscope", and it left us with too much, not the suggestive too little of other realist art. Who, allowed to look into the room where Arnolfini and his bride hold hands in their private sacrament, would even notice what Van Eyck saw, or bring to it the obsessed and simultaneous focus he imposed on every object, large or tiny, far or near – the grain in those fractionally uneven floorboards, the differences of texture and springiness between the lapdog's hairs and the fur of Arnolfini's robe, the limp silk tassels of the beads hanging on the wall and the stiff bristles of the twig broom – which repeats their shape on the other side of the mirror? Only with great difficulty – one might almost say, only by a strenuous act of the *imagination* – can you make the green and gold brocade behind the Ince Hall *Madonna* become paint at all. A fifteenth-century writer praised Van Eyck for his landscapes, which seem to stretch "for fifty miles." The point is that such a way of presenting the world as a visual whole has no more to do with the way we *see* it than, say, Leonardo's quick-frozen notations of eddies in a mill-race. Distance blues out the colors of objects, alters their tones and fuzzes their contours. We do not perceive everything within a given field with equal and perfect clarity; we scan and select. Jan van Eyck's realism is not a metaphor of natural, or human vision. He painted the world as if everything in it were both knowable and perfectly known; his aim (to paraphrase Panofsky again) was not representation, but reconstruction. His art is a harmony parallel to nature: "Myself will I remake" – and the world, too. Thus, Van Eyck's realism was creative in an almost hubristic way, for its object was to suggest God's perceptions in creating the universe: to see things from the standpoint of absolute knowledge which is uniquely God's possession.

Thus each object, each face and body in Jan van Eyck's work is spiritualized by its almost total detail: his scrutiny goes beyond the concrete and waits for our symbolic imagination to catch up with it. The objects themselves are charged with symbolism; Jan van Eyck's attitude to nature was medieval in that he seems to have regarded each created thing as a symbol of the workings of God's mind, and the universe as an immense structure of metaphors. The casual eye is apt to read the Arnolfini betrothal portrait as a piece of genre, which looks forward to Vermeer and the Dutch intimists. But the probability is that Van Eyck designed it as a web of disguised symbols, intending to make a familiar comparison between the sacrament of marriage and the ideal relationship of the Virgin Mary as bride of God. The mirror on the wall, which is explicitly turned into a religious object by the ten scenes of Christ's passion set in its frame, is a symbol

of candor and purity; the little dog, an image of marital faithfulness – and so on. Spiritual states are externalized in objects. Even the fantastic splendors of marble, gold, glass and brocade in *The Madonna of Chancellor Rolin* are allegorized. The picture is one of the most aggresively confident celebrations of the belief that riches are a proof of virtue that has ever been painted; Chancellor Rolin has the wealth and contacts to arrange a private audience with God and His mother, and the angel holds the crown over Mary's head with the faint, obsequious smile of a salesman at Cartier's. Yet this image is, quite obvi-ously, a variation on a more ancient one, that of the Virgin in her *hortus conclusus,* surrounded by attributes of purity and grace (the lily, the aromatic shrubs, the peacocks), remote from the mundane life of the city below the loggia.

By such means of vision and symbolism, Jan van Eyck temporarily did away with the division between secular and religious works of art. All nature is sacramentalized by the sheer intensity of his gaze. To the realist's modest claim that "This is the way it was," Jan van Eyck adds "is now, and ever shall be, world without end; Amen." ROBERT HUGHES

An outline of the artist's critical history

Hubert and Jan van Eyck were each famous in their lifetimes and after their deaths. Hubert was called "second to none" in the most important record we have of him, the inscription on the frame of the Ghent altarpiece (p. 90). But his reputation became eclipsed by his brother's, and an idea of his work has had to be reconstructed by modern art historians. The celebrated Jan was at once given homage by Netherlanders and Italians alike. Bartolomeo Facio, Dürer, Vasari are among the better-known writers who expressed their admiration for the art of Jan (for further examples, see pp. 9–12). To give just one well-known example of the great influence of Jan on other painters, Antonello da Messina's work can be understood properly only if Jan's art is also borne in mind.

Jan's work continued to be prized during the two centuries after his death – Rubens, a most discriminating collector, owned more than one of his works. A certain incomprehension, and often plain ignorance of "Gothic" art succeeded in the eighteenth century: the German traveller Forster (quoted on p. 10) could only see "mistakes" in the Ghent altarpiece. Eighteenth-century taste was so out of sympathy with fifteenth, that in 1781 the Ghent altarpiece was nearly demolished. However, the attitude changed: the great Germans of the Romantic Movement were enchanted by Eyckian art. Schlegel, Goethe and Schopenhauer all recorded their admiration. Nineteenth-century scholarship now began to treat the art of the Van Eycks seriously with Waagen and Burckhardt (*Opere d'arte nelle città belghe*, 1842) in the middle of the century. The monumental study of Weale appeared in 1908, incorporating fundamental research which is still of great value. At about the same time, Dvořák was inquiring into the Hubert-or-Jan riddle in relation to the Ghent altarpiece, and Hulin de Loo, following the lead of Durrieu, was pursuing the same question in relation to the exciting and newly discovered miniatures of the *Très Belles Heures de Notre Dame*, then divided between Turin and Milan. Hulin opened up a question which still remains to be settled (as with many other Eyckian problems), especially as some of the miniatures were destroyed only two years after their discovery in 1904. The next generation of scholars, Friedländer, Tolnay, Baldass, Panofsky, still holds the field in the main: their assessment of individual works as well as of the broader field of the development spent in the Low Countries in the periods preceding and succeeding the Van Eycks has enormously contributed to our understanding of Eyckian art.

The famous John of Bruges, honor of painting. ... Cyriacus of Ancona (1391–1457) in Colucci, *Antichità Picene* XV, 143, c. 1450

Jan van Eyck is considered the greatest painter of our times, cultivated as well in letters but chiefly in geometry and the disciplines that have to do with painting. ...
B. FACIO, *Liber de viris illustribus*, 1454–5

> In Bruges, the most praised of all
> Was the great Ioannes (van Eyck), his disciple
> Ruggero (van der Weyden),
> And many others endowed with high merit,
> In which art and in the high mastery
> Of coloring they so excelled
> That they often surpassed reality ...

G. SANTI *Cronaca rimata*, after 1482

The king of painters, whose perfect and minute works will never fall into vain oblivion. ...

J. LEMAIRE, *Couronne margaritique*, 1510

... To the right ... is a chapel (in Ghent Cathedral) where there is a panel at whose two ends are two figures, on the right is Adam and on the left is Eve, almost life-size and naked, worked in oil with such perfection and naturalness in the proportion of the limbs and coloring and shading, that without doubt one can say of this picture that it is the most beautiful work of Christians; and according to what the canons said, it was made by a master from Magna Alta named Robertus one hundred years ago, and yet (the figures) seem as if they had just been made by that master's hand. And the subject of that painting is the Ascension of the Madonna, which since that Master could not finish it, because he died, it was completed by his brother who was also a great painter. ...
A. DE BEATIS, *Relazione del viaggio del cardinale Luigi d'Aragona ...*, 1517

... I saw the St John (Ghent Cathedral) panel, a stupendous painting full of intelligence ...
A. DÜRER, *Tagebuch der niederländischen Reise*, 1521

It was a very beautiful invention and a great convenience to the art of painting, the discovery of oil coloring; the first inventor was Giovanni de Bruggia (Jan of Bruges) in Flanders, who sent a panel to King Alfonso in Naples; and to the Duke of Urbino, Federigo II (*Woman Bathing*, 58); and he did a St Jerome, which Lorenzo de' Medici had, and many other praiseworthy works …
G. VASARI, *Le vite*, 1550

… it seems to me that the works of the masters from the time of Giotto until Donatello are clumsy, and thus it is in our lands and throughout Germany from that time until Master Rogiero (van der Weyden) and John of Bruges, who opened the eyes of colorists, who imitating his manner and thinking of nothing else, have left our churches full of things that resemble nothing good or beautiful, but are only furnished with beautiful colors …
L. LOMBARD, Letter to Giorgio Vasari, 1565

… Jan van Eyck, the prince of all painters …
M. VAN VAERNEWYCK, *Spieghel der Nederlandsche Audtheydt*, 1568

This consummate painter was a very careful observer and seems to have wanted with his polyptych (of Ghent) to give the lie to the famous writer Pliny, where Pliny writes that artists, when they have to paint a hundred faces always make some of them similar and thus cannot match nature, which, instead, does not make two faces in a thousand similar; but in this painting there are three hundred and thirty complete heads, and no two are alike. High fervor, affection, devotion, and other sentiments can be read in these faces; in Mary's the lips seem to utter the words that she is reading in a book; in the landscape one can see many exotic plants and just as much for the plants as for the trees, one can give a real name to each of them. They are painted in excellent and exquisite fashion. The hats and the horses' tails and manes seem so subtle and natural that artists are dumbfounded when they contemplate this work. And many illustrious princes, kings and emperors have admired the work with great satisfaction, King Philip II, the thirty-sixth Count of Flanders, would have liked to own such a jewel, but not wishing to deprive the city of Ghent of the work, he had it copied by Michiel Coxcie …
K. VAN MANDER, *Het Schilderboeck*, 1604

… *The Adoration of the Lamb* … contains a great number of figures in a hard manner, but there is great character of truth and nature in the heads; and the landscape is well-colored. (Of *The Madonna with Canon van der Paele*) the art is here in its infancy; but still having the appearance of a faithful representation of individual nature, it does not fail to please …
SIR JOSHUA REYNOLDS, *A Journey to Flanders and Holland* (made in 1781-2), in *Works*, ed. Malone, London, 1809, Vol. II

… (In *The Adoration of the Lamb*) the composition is deficient, as one might expect in those times, in order and clarity as well as in efficiency and grandeur; the drawing, notwithstanding the great diligence, is rigid and incorrect; perspective and bearing are altogether missing; the colors are strident and vivid without shading. This, however, is the way people painted even in Italy at the time of Perugino …
J. A. G. FORSTER, *Ansichten vom Niederrhein, von Brabant, Flandern, Holland, England und Frankreich*, 1790

The three heads of God the Father, the Virgin, and St John the Baptist (in the Ghent Polyptych) are not inferior in roundness, force or sweetness to the heads of Leonardo da Vinci, and possess a more positive principle of color …
H. FUSELI, *Writings on Art*, 1802

The rigidity, the Egyptian grandeur of these holy figures (God the Father, the Virgin, and John the Baptist in the Ghent Polyptych), straight and severe, that seem to appear out of far distant times, call forth an intimate reverence and draw us strongly towards them like incomprehensible monuments of a distant past, larger and sterner …
F. W. SCHLEGEL, *Gemäldebeschreibungen aus Paris und den Niederlanden*, 1805

Nature has given him as a Netherlander a sensibility chiefly oriented towards color: like his contemporaries, he knew its worth and thus it was possible for him – staying within the sphere of fabrics and carpets – to raise the splendor of the painting beyond all reality. To achieve this result one undoubtedly needs real art, for in reality sight is conditioned by a host of fortuitous circumstances, concerning both the eye and objects seen, while on the contrary, the painter works according to precise laws … Van Eyck was also a master of perspective and the variety of landscape and, especially, of an infinite number of architectural "motifs", which, in his work first appear instead of that miserable background of gold or carpets.
 At this point it may seem strange if I say that when he rejected the material and technical imperfection of art as it had been until then, he also relinquished a technical perfection hitherto guarded in secret, i.e., the concept of symmetrical composition … On the other hand, since without symmetry any object loses its force of attraction, he, man of taste and sensitivity that he was, recreated the macrocosm in his own way. The result is something that produces a more harmonious and, at the same time, a deeper effect than that which can be achieved by following the canonical laws of art …
W. GOETHE, *Kunst und Alterthum am Rhein und Mayn*, 1816

Few artists have managed to relinquish their own subjectivity to such a degree, to be so exclusively objective, as Jan van Eyck. He presents the most varied characters in the most diverse circumstances and states of mind, in such a lively and coherent fashion, and his figures are so much a part of the events depicted – even though they are altogether natural and even though they have no awareness of being observed and being grouped in that way in order to depict a certain action – that it almost seems as if the curtain has been raised on a different world just as the depicted action is under way, and we look at it and its actors cannot even vaguely suspect our presence. The artist, i.e., the instrument by means of which nature has created these figures, so retreats into the background at this point that the figures seem to burst forth from the hand of nature itself …
C. G. WAAGEN, *Über Hubert und Johann van Eyck*, 1822

(*The Madonna with Canon van der Paele*) In its composition, style, and nature of its form, color and workmanship, it brings to mind the Louvre *Madonna (with Chancellor Rolin)*. It is no more precious in its finish nor more sharply observed in its detail. The ingenuous

chiaroscuro that bathes the small painting in the Louvre, that perfect truth and that idealization of every object achieved by his brush, the beauty of the workmanship, the inimitable translucence of the material; this mixture of meticulous observation and of dreams achieved by means of half tones – these are the superior qualities that the Bruges panel achieves and does not surpass. But in the Bruges painting everything is larger, riper, more amply conceived, built, and painted. And the work is more masterful because of this, in that it fully enters into the aims of modern art ... The tonality of the painting is solemn, mute and rich, extraordinarily harmonious and strong. The color flows in full stream. It is full but very knowingly composed and still more knowingly held together by subtle color values. In truth, when one gives this picture one's full attention, it is a work that makes one forget everything else and makes one think that art has said its final word, and that at its very first moment ...
E. FROMENTIN, *Les Maîtres d'autrefois: Belgique*, 1876

If we compare a fourteenth-century painting or an Italian painting of the fifteenth century executed in the traditional technique with a work by Jan van Eyck or his followers, we become aware of a two-fold difference. First, the colors are different. One realizes that at once when, for example, one is in a gallery and passes from a room of early Italians into one of early Netherlanders. It is as if our eyes turned from statues painted in vibrant red, blue or green to a field in flower. Like the figures and forms, so too the colors in late-medieval painting are conventional and only rarely based on direct observation ... But none of this is applicable when one gets to the works of Jan. True, his color seems as little naturalistic as that of the early masters, for he does not portray colors as they are presented by some part of nature without making a choice, but rather he composes, as he does scenes, the harmonies of colors, to make them as rich and splendid as possible. But if one compares the new chromatic harmonies with those of the past, one has the impression that now, all of a sudden, the painter's eyes have been opened to the whole magnificence of the colors of the world: so infinitely rich in tones is the palette of the new style compared with the old formulas.

Nevertheless, incomparably more important and of greater meaning for the history of painting was another innovation in the rendering of color ... For the first time after an interval of almost a thousand years, in fact, the painters of the new Netherlandish school realized that a particular local color does not always have to be identical to nature, being subject, instead, to light, the adjacent colors, and its position in space with respect to the observer.

The great and revolutionary importance of these observations consists in the fact that, in place of conventional modeling, modeling abstracted from the temporary circumstances of light and color, a new sense of modeling was introduced into painting, one founded on the relationship between colors, lighting, and the spatial location of the objects depicted. In Jan's pictures, color is no longer an accident that one could relinquish without essentially modifying the formal content of the representation. At first sight, this novelty appears in the fact that the smooth, monochromatic and almost sanded protrusions and depressions of modeling disappear and are replaced by diversely lighted surfaces, by contrasts of light and dark, by sharp lights and by an infinity of modifications of color in relation to space and light.

This is the new "discipline of Flanders," which was often admired and imitated by the Italians and which made it possible for the Netherlanders, in the age of great discoveries, to make one of the greatest, and that is to discover again the whole universe ...
M. DVOŘÁK, *Das Rätsel der Kunst der Brüder van Eyck*, 1904

We always find irreconcilable conflicts in history. It is true that in the fifteenth century there were two rigidly separated kinds of life: on the one hand, the culture of men at court, pompous, ambitious, avaricious, different, ardently passionate; on the other hand, the silent, subdued, and grey climate of the *devotio moderna*, of serious men and submissive women of the people, who sought refuge in the confraternities and in the convent of Windesheim ... In my opinion, the art of the Van Eycks, with its controlled and devout mysticism, is linked to the latter milieu. And yet its place is in that other world. The attitude of the adepts of the *devotio moderna* to the great art that was then emerging was negative. They rejected the polyphonic music of Dufay and his colleagues, and Geert Groote wrote a treatise against superfluous splendor in the churches (*Centra turrim Trajectensem*). *The Adoration of the Lamb* would have seemed a vain work of pride to them ...
J. HUIZINGA, "De kunst der van Eyck's in het leven van hun tijd", in *De Gids*, 1916

... (In *The Madonna with Chancellor Rolin*) the meticulous precision with which the fabrics of clothing, the marble slabs and columns, the glitter of the windows and the Chancellor's missal are treated, would have been pedantry in any other painter .. And here comes the miracle: in all of this ... unity and harmony are not lost ...
J. HUIZINGA, *Herfsttij der Middeleeuwen*, 1919

The fascination which (The Ghent Altarpiece) has exercized is, in one way, the result of the splendors of its achievement. For it is a major monument not only of Flemish but of European art. It makes a great cleavage with the art of the Middle Ages, for it treats a religious subject with a new reality which embraces landscape and figures alike. ... Above all (Jan) had perceived that it is the fall of light which gives to each object its own reality. His unmatched technical accomplishment was so great that he could convey the multiplicity of tiny things which he clearly loved, and which were part of the rich civilization in which he lived. But the Ghent altarpiece is more than a collection of intricate details. It is a great religious painting, a serene tribute to what both painter and patron recognized as the glory of God and His creation.
MARGARET WHINNEY, *Early Flemish Painting*, London, 1968.

His insight was so penetrating that the very structure of the human body was discernible beneath the clothing. This was a matter with which the painters of miniatures had never concerned themselves. With the same determination he mastered every aspect of reality, landscapes, the effects of light, the relationships between objects, green fields and rocks, fabrics and metals equally with the individuality of man and the consistency of his make up. His understanding of fabrics rivaled that of a weaver, of architecture that of a master mason, of the earth that *11*

of a geographer and of plants that of a botanist. With the passing of the years, van Eyck's art developed in the direction of even greater restraint and clarity. His compositions became increasingly simple and calm, and more fluid, and at the same time achieved a greater economy of means and an increasing stature. Jan van Eyck was a loyal son of the Church and his equable temperament was not ruffled by the discrepancy between the pleasures of the sensual world and his own function of interpreting that world to the faithful.

N. J. FRIEDLAENDER, *Die altniederländische Malerei*, 1924–37

As far as the delineation of the figure is concerned, van Eyck is clearly still closely linked to the Middle Ages and his own century, but he is outstanding in poetic vision and perhaps too in a certain philosophic view of the microcosm. Little by little as the principles of monumental art were becoming eroded and painting was taking the place of sculpture as a means of interpreting the universe, the taste for the infinitely small continued to grow. But can such enthusiasm for detail minutely executed ever be confused with that attitude of supine inactivity which we generally term as realism? If in fact we were to see reality with our own eyes we would be overcome with dizziness. When we look at those vast canvases of views of the city with their minuscule detail, where people who are scarcely discernible and yet are fashioned to perform all those necessities that life requires, come and go in the public squares, we must ask ourselves whether the ideas of the artist are not linked to those of the astrologers and the mystics, and whether he has not seen fit to introduce into the world of the deity a world of paint which represents its limits in miniature, just as the human figure placed in the center of the circle of the zodiac represents the microcosm of the universe. I myself find evidence of this in the circular concave mirror hanging on the wall of the bridal chamber where the Arnolfini are pledging their faithfulness to each other. In a certain sense every aspect of reality has a mystic quality for van Eyck; he finds himself face to face with an object as if he were discovering it for the first time: he studies it with visionary patience as if he wished to extract from it the solution to an enigma, to "put a spell" upon it and to instill into his imagery a new and silent life for it. Everything for him is unique and, in the true sense of the word, individual. In such a conception of the universe, where nothing is interchangeable, the incidental and the inanimate assume the same physical value as a human face.

H. FOCILLON, *Art d'Occident*, 1938

If one contemplates the *Madonna of Chancellor Rolin* for any length of time, one becomes lost in wonder at the sight of the outstanding living element with which the artist imbued it – the light, which silently permeates the spaces of the picture, touching now one object and now another, and could well be that "divine light" of which the mystics speak. Could there be a more perfect way of expressing the presence of God throughout creation, than by this transfiguration of transient people and things into imperishable jewels?

An analysis of the content of the picture enables us to define the style of Jan van Eyck's creation. The painting is conceived as a collection of precious objects, and of characters whose attitudes display a calculated austerity previously unknown in art; they are beyond human emotions and appear to take no

account of the world outside them. They too have become transmuted into immutable precious objects.

The "prospect" of the picture as conceived by Jan van Eyck makes its own contribution too to the geometrical spatial arrangement. It is not strictly accurate from a geometrical point of view, since the verticals meet in a number of various principal places, which is evidence that it was the result of entirely empirical research and observation and not based on the mathematical principles that the Italian painters of the age were using. Nevertheless, the illusion is perfect and fulfills the artist's intentions of conveying the effect of cubic volume.

If one agrees with Hegel that the essential basis of "classicism" is the reconciliation of conception and reality, then Jan van Eyck's style can be considered the earliest classical style in Northern Europe. Before him, in fact, the concept had always taken precedence over reality in Northern art. Van Eyck succeeded in achieving a naturalness which although in no way false is permeated by a higher concept of reality, pure and absolute.

CH. DE TOLNAY, *Le Maître de Flémalle et les frères van Eyck*, 1939

In the case of those artists who gave form to the reality in which they lived, it is meaningless to speak of realism or idealism. Van Eyck and his successors were neither realists or idealists; they were objectivists in the fullest sense of the word: they transferred to canvas with a craftsman's ability of which they were justly proud everything that they saw exactly as they saw it, with an apparent objectivity which we do not find elsewhere in so comprehensive a form either before or after them, and yet everything that they saw was infused with metaphysical overtones. It is this factor which marks the difference, too often overlooked, between the sort of reality which the Flemish primitive painters represented and the more strictly bourgeois reality which inspired the Dutch masters of the seventeenth century. Likewise, it marks the complete contradiction between the so-called realism of a van Eyck, a van der Weyden and a van der Goes on the one hand, and on the other that physical reality divorced from any spiritual content which the naturalist painters of the nineteenth century were aiming to achieve to the accompaniment of noisy expositions of philosophical theories.

A. STUBBE, *Van Eyck en de gothiek*, 1947

The art of Jan van Eyck marks the highest point of achievement of the early painters of the Low Countries. The individuality of artistic talent displayed by a painter who brought such perfection to studio painting, and the expressive power of his canvases are sufficient witness to this. No painter has ever to the same degree achieved such intensity and harmony of colors in all their brilliance and depth. The central painting of the *Ghent Polyptych* demonstrates most clearly the skill of his hand. However, the significance of Jan van Eyck's art can accurately be judged simply by recording that the techniques which he established were adopted by the French and German painters of the second half of the fifteenth century. A great many of the individualities of style to be found in the works of Jan van Eyck defy all comparison, for they were for the first time and exclusively typical of Flemish art and later, in the fifteenth century, typical of European art north of the Alps. One of these characteristics of his style which constitutes an extremely important factor in the development of the new technique of painting in oils is the

endeavor of the artist to involve himself wholeheartedly in the execution of every detail so as to depict nature as faithfully as possible, even to the detailed finish of surfaces, a thing which the Italians had never attempted. Another characteristic is the besetting urge to give individuality to the human figure. The art of Jan van Eyck as a portrait painter was at this time a unique phenomenon in Europe.

L. BALDASS, *Jan van Eyck*, 1952

Generally speaking, Jan van Eyck's portraits are descriptive rather than interpretative, but as soon as the descriptive process involves reconstruction rather than reproduction they no longer come within the limits of a particular category but form a class on their own. It is certainly difficult, if not impossible, to define his characters in psychological terms, or to imagine what their background has been or to enter into their thoughts and feelings. They also give the impression of being only potentially alive, at any rate in relation to others, but in fact, this lack or rather obscurity of definable qualities gives them a particular profundity, a profundity which we feel at the same time tempted to explore and discouraged from exploring. We find ourselves confronted with not so much the essential appearance of an individual as with the very soul and essence of his being, unique and yet divorced from time and place unaffected by any extraneous considerations whatever, and yet completely human.

E. PANOFSKY, *Early Netherlandish Painting*, 1953

Jan van Eyck was undoubtedly a painter of great merit, but nothing in his work bears the stamp of creative genius. It was Hubert who opened his eyes to the pictorial aspect of the discovery of nature and who made him realize how a painting is the pictorial projection on a two-dimensional surface of an enclosed space containing a variety of objects. Jan, even more than Hubert, was a shrewd observer not of what happened to himself but of what his eyes saw. He was, besides, a painstaking craftsman and a tenacious worker who brought his works to completion with an unbelievable patience. He was neither imaginative nor inventive, but his rendering of what he had observed is inexorable; he restricts the number of characters and observes them in repose and depicts them in static poses under an unchanging light. Jan van Eyck is a portrait painter who affirms, expounds and develops faithfully the individual character of each model. He penetrates the mask which hides the virtues and vices of the individual and by dint of rendering every visible detail with shrewd objectivity reveals the person's very soul.

In his work the art of portrait painting took a great leap forward.

L. VAN PUYVELDE, *La peinture flamande au siècle des van Eyck*, 1953

The van Eyck technique was bound to give a revolutionary impression simply because the pictorial style of Jan van Eyck had virtually nothing in common with his predecessors. It was only in fact in his work that there appeared the modern idea of a studio picture, that is to say an apparently three dimensional representation of the visible world, and all the consequences which stem from it.

It was a stroke of genius whose profound effects it is difficult to appreciate today. Van Eyck had the courage to reject completely not only the attractions of late Gothic linear decoration but also the flat drawing in gold which formed the background of the Franco-Flemish painters and miniaturists, and substituted for them the closer or more distant view of a landscape or interior. Apart from the Sienese of the fourteenth century, there is no doubt that Pol Hennequin and Herman de Limbourg had carried out some outstanding experiments along the same lines in their celebrated and fine miniatures of the *Très riches Heures de Jean duc de Berry* (Chantilly, 1409–16), but these in no way lessen the outstanding merit of van Eyck's masterly accomplishment in grasping and realizing on a vast scale both linear and aereal perspective, that is to say the perspective of both line and color.

One of the oustanding gifts of Jan van Eyck and one which was to be characteristic from that time on of the whole Flemish school was his incomparable feeling for the material appearance of the objects which he depicted, which reveals itself above all in the extreme punctiliousness with which even the most insignificant details are painted.

There is more even than this. The thing which confers an inestimable value upon his gifts of technique and form is the spiritual content with which he invests them. The subjects are still fundamentally religious and are treated with a religious conviction of exemplary purity, and yet it is in the exceptional and well-balanced synthesis of natural objects with mystical vision that we can with good reason recognize the fundamental secret of Jan van Eyck. In spite of the by this time earthy look of his angels and saints and the surroundings in which they are placed, the contemplation of them gives rise to a deep religious feeling conducive to prayer. In order to enable him to transmit the ancient faith in which he himself was brought up in complete sincerity and simplicity the master loves to make use of the elements which the visible world affords, and for this reason the corresponding unreality in these mystical representations at first goes unnoticed because of the normal everyday appearance of all the people and all the objects of which they are composed.

V. DENIS, *Tutta la pittura di Jan van Eyck*, 1954

This portrait (*The Arnolfini Wedding*) regarded in the light of its pictorial originality makes captive a poetic vision of the world by means of light. Nature and the social life of the north are enchanting, affirms van Eyck, the humanist and painter to the court and the wealthy bourgeoisie, and the light which suffuses every detail brings out its poetry. The transformations, certainties and subtleties which the light makes with the object has to be depicted. The open window, the convex mirror which captures in depth the whole foreground and animates the whole microcosm with new, subtle reflections, are symbolic of the achievements of the picture, more profound than those of conjugal fidelity, which are also present and were in their turn perceived and commented on with such acute sensitiveness by Panofsky.

This then is the poetry of van Eyck. He created in Flanders representational painting of landscapes, portraits, still life and even genre painting. But by contrast with the older Italian works which have recently been presented as the prototypes of these themes and which in fact have only an isolated existence, van Eyck makes of the landscape or an object or a face the elements of an organized whole. In this way the forms of things and nature create an atmosphere which embraces the spiritual.

R. GENAILLE, *La Peinture dans les anciens Pays-Bas, de van Eyck à Bruegel*, 1954

13

The urge for precision and perfection which animated van Eyck led him to divergent results: a symbolism invariably more complex in his architecture and a realism invariably more extreme in the recognition of the appearances of life. In spite of these opposing forces, the structure and the content of his pictures blend into a descriptive art in which one is tempted to regret a certain lack of mystery.

This method of approach is noticeable when Jan van Eyck, not content with including a human character in a sacred composition, extracts the principal element, which is to say the group of the Virgin and Child beneath the baldachin, in order to give it an effect of isolation like that of a portrait. In this way *The Lucca Madonna* and the *Ince Hall Madonna* are placed in surroundings where the whole solemn set up operates in a familiar bourgeois interior. We are in the presence of a relative anthropomorphism of the symbol, and yet without this the Virgin would be lacking in dignity and would be reduced to the level of the earthly figure which she appeared as in the other Flemish painters. Van Eyck's Madonnas remain remote, with a composition which approaches very closely to a geometric construction, and it is doubtless on account of this that they were never imitated or popularized while those of Rogier (van der Weyden) separated from no matter what magnificent frame were reproduced from one century to the next to adorn the privacy of holy oratories.

J. LASSAIGNE, *La peinture flamande. Le siècle de van Eyck*, 1957

The course of Jan van Eyck's art is extremely gradual and comprises within its scope only slight variations. Its point of departure was a fresh hesitant wonder at the discovery of reality, and its point of arrival was the elevation of this reality to a sphere of deep contemplation. But the connection between naturalism and the transformation of reality always remained the same and the deeper and more detailed that the investigation of the particular became the greater emphasis was given to the monumental nature of the complex imagery which resulted from this application.

R. SALVINI, *La pittura fiamminga*, 1958

Van Eyck's imagery admits of being examined and questioned, always reveals itself for what it is and allows a specific meaning to be attributed to every color, every line and every subtlety of light and shade. One must, however arbitrarily, attempt to define the quality of Jan van Eyck's poetic vision which he grasped all at once at a time when poetic terms did not exist outside poetry, which charged them with religious significance, and when similarly there were no objects or details in existence which could not be used in the composition of pictorial imagery, or which could be excluded from it by an authoritarian act, prior to the imaginative conceptions of this artist. For Jan van Eyck, nature was a storehouse more fabulous than the garden of Eden, in which to cast one's net and on which to draw wholeheartedly: it is in this guise of an exhaustible storehouse and never ending bounty that nature offers herself to the artist with a richness of themes and details which do not admit of selection but must be taken as a whole. Nothing less than the whole context of the phenomenon must appear in the imagery. There must be no diminution or calculated reduction, no symbol or abbreviation of the phenomenon, but the imagery must be virtually as open to observation, study and analysis as the phenomenon itself; and still the imagery remains, freed from the tyranny of time, and springing up in its own space . . . in its own space?

Without doubt, Jan van Eyck's pictorial imagery evinces its own spatial concept, but the most important aspect of this concept lies in not any abstract quality but its importance by the very implications inherent in the phenomenon itself.

Jan van Eyck was not only unwilling to give up any of the phenomenal attributes of an object which he elevated into an image, an inner symbol that is, but it was so repugnant to him to relate it to generalized concepts of space which diminished the present imminence of each phenomenal detail, that in his work even lines of perspective which are only hinted at converge upon the object and attach themselves to it, as attributes of the object, rather than to define the spatial relationships, as guides that is to say to the method of locating the object in space.

Van Eyck did not entirely give up expressing his imagery in terms of its own spatial concept, but this concept did not seek to express itself in arbitrary definitions of "space" but rather in the relative, incidental terms of "ambience".

C. BRANDI, *Spazio italiano, ambiente fiammingo*, 1960

It is undeniable that the works of Jan van Eyck were painted with a technique which by any count differs considerably from that which we find in the painters of the fourteenth century. His method of characterizing objects, his way of putting deep patches of color in full light, of rendering the surfaces of rocks, bright metals or oriental carpets would have been impossible with the traditional techniques of tempera. The new style brought about a new medium. It was now possible to "paint" and not simply to draw with the brush, to blend colors into one another rather than make a series of contiguous brush strokes as was necessary when working in tempera.

"The discovery of the visible world" has been claimed to be the greatest glory of the brothers van Eyck. It is impossible to deny the revolutionary nature of their art even though it owes not a little to the achievements of the immediately previous generation of painters, but the development of Flemish painting in the fifteenth and sixteenth centuries would be inconceivable without the van Eycks.

O. KURZ, *Hubert e Jan van Eyck*, in "Enciclopedia universale dell'arte", V, 1961

Jan van Eyck's ruthless physiological studies, which focused on every imperfection and peculiarity of the countenance whether in full or three-quarter face and directly resembling a clinical diagnosis of the state of his sitters correspond with a more generalized search for realism and are meticulous to an even greater degree in giving rein at times to expressionism and even an approach to late Gothic.

The portrait painting of the van Eycks exhibits a most marked distinction between the sacred and the profane, where the sacred is idealized and the profane approximates most closely to reality. This distinction exerted a major influence in artistic circles and was eventually imitated throughout Europe during the whole of the fifteenth century.

E. BATTISTI, *Ritratto (Il Quattrocento)* in "Enciclopedia universale dell'arte", XI, 1963

The paintings in color

List of plates

The Virgin in a Church [4]
Plate I
Whole

The Ghent Polyptych [9 A¹–T]
Plate II

The Erythrean Sibyl [B¹] and the
Cumaean Sibyl [C¹]
Plate III

Details of the double-lighted
window [B²] and wash basin [C²]
Plate IV

The Angel of the Annunciation
[A²]
Plate V

The Virgin of the Annunciation
[D²]
Plate VI

The Donor [E] and St John the
Baptist [F]
Plate VII

St John the Evangelist [G] and
the Donor's Wife [H]
Plate VIII

The Prophet Zechariah [A¹] and
the Prophet Micah [D¹]
Plate IX

Detail of St John the Evangelist [G]
Plate X

Detail of the Angel of the
Annunciation [A²]
Plate XI

Detail of the Virgin of the
Annunciation [D²]
Plate XII

Adam [I²] and the Angels singing
[J]
Plate XIII

Angels making Music [N] and
Eve [O²]
Plate XIV

Details of Adam [I²] and Eve [O²]
Plate XV

Detail of God [L]: the crown and
the edge of the cloak
Plate XVI–XVII

The Virgin [K], God [L] and
St John the Baptist [M]
Plate XVIII

Detail of the Virgin [K]
Plate XIX

Detail of St John the Baptist [M]
Plate XX

The Just Judges (copy) [P] and
the Warriors of Christ [Q]
Plate XXI

The Holy Hermits [S] and the
Holy Pilgrims [T]
Plate XXII

Detail of the Warriors of Christ
[Q]: figures in the foreground
Plate XXIII

Detail of the Holy Pilgrims [T]:
landscape on the right
Plates XXIV–XXV

The Adoration of the Lamb [R]
Plate XXVI

Detail of *The Adoration of the Lamb*
[R], with the bishop, saints and
confessors on the left, above
Plate XXVII

Detail of *The Adoration of the Lamb*
[R], with bishop and saints in the
right foreground
Plate XXVIII

Detail of *The Adoration of the Lamb*
[R], with architectural elements,
right, above
St Francis receiving the Stigmata [5]
(Philadelphia)
Plate XXIX
Whole

Timotheos [12]
Plate XXX
Whole

Portrait of Giovanni Arnolfini [20]
Plate XXXI
Whole

The Man with the Red Turban [13]
Plate XXXII
Whole

*Portrait of Cardinal Nicolas
Albergati* [11]
Plate XXXIII
Whole

Ince Hall Madonna [14]
Plate XXXIV
Whole

The Annunciation [18]
(Washington)
Plate XXXV
Whole

Plate XXXVI
Details: *A* The Angel of the
Annunciation – *B* The Virgin of
the Annunciation – *C* Decorated
tiles of the floor – *D* Frescoes and
stained-glass window on the rear
wall

The Arnolfini Wedding [15]
Plate XXXVII

Whole
Plate XXXVIII

Detail of Giovanni Arnolfini
Plate XXXIX

Detail of Giovanna Cenami
Plate XL

Detail with dog
Plate XLI

Detail of the back wall with
chandelier, inscription, mirror
and other objects
Plate XLII

Details: *A* The middle zone, left –
B The joined hands, center – *C*
Wooden slippers, left below – *D*
Slippers, center, towards the
bottom

The Madonna with Chancellor Rolin
[16]
Plate XLIII

Whole
Plates XLIV–XLV

Detail of middle zone
Plate XLVI

Details: *A* Figured capitals, left –
B The Madonna's cloak, fore-
ground – *C* The crown held by an
angel

The Dresden Triptych [25 A–E]
Plate XLVII
Whole of the open triptych: St
Michael and the Donor, the
Madonna and Child Enthroned
with St Catherine of Alexandria

The Madonna at the Fountain [29]
Plate XLVIII
Whole

*The Madonna with Canon van der
Paele* [21]
Plate XLIX

Whole
Plate L

Detail of St Donatian
Plate LI

Detail of Canon van der Paele and
St George
Plate LII

Detail of the Madonna and Child
Plate LIII

Details: *A*, *B*, *C* Capitals (left,
background; right of throne; and
right, background, respectively) –
D, *E*, *F* Sculptured decoration on
the Madonna's throne (Samson
slaying the Lion, right; Eve,
right; the Slaying of Abel, left) –
G The hands of the Madonna and
Child, with flowers and parrot – *H*
Edge of the Madonna's robe and
carpet, right – *I* The hands of
Canon van der Paele, with book
and glasses

The Thyssen Annunciation [24 A–B]
Plate LIV

The Angel of the Annunciation
Plate LV

The Virgin of the Annunciation

Portrait of Baudouin de Lannoy [19]
Plate LVI
Whole

Portrait of Jan de Leeuw [22]
Plate LVII
Whole

St Barbara [26]
Plate LVIII
Whole

The Madonna in an Interior [23]
Plate LIX
Whole

Margaretha van Eyck [28]

Plate LX
Whole

The Annunciation [35]
(New York)

Plate LXI
Whole

The Three Marys at the Sepulcher [1]
Plate LXII
Whole

The New York Panels [3 A–B]
Plate LXIII
The Crucifixion and the Last
Judgment

The Man with a Pink [17]
Plate LXIV
Whole

The arabic number in square
brackets after each painting refers
to the number in the Catalogue
(pp. 85–101), where the works
are described. In the plate captions
the actual width of the painting or
detail reproduced is given in
centimeters.

PLATE I

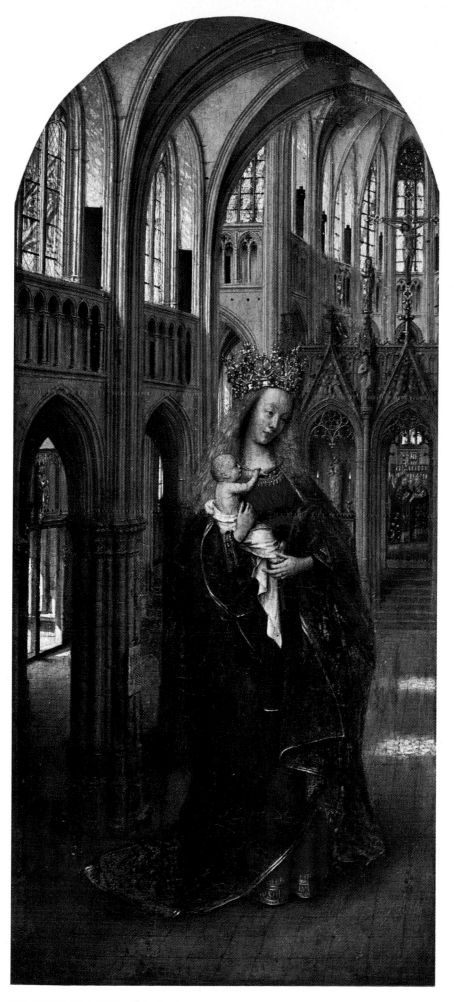

THE VIRGIN IN A CHURCH Berlin, Staatliche Museen, Gemäldegalerie-Dahlem
Whole (14 cm.)

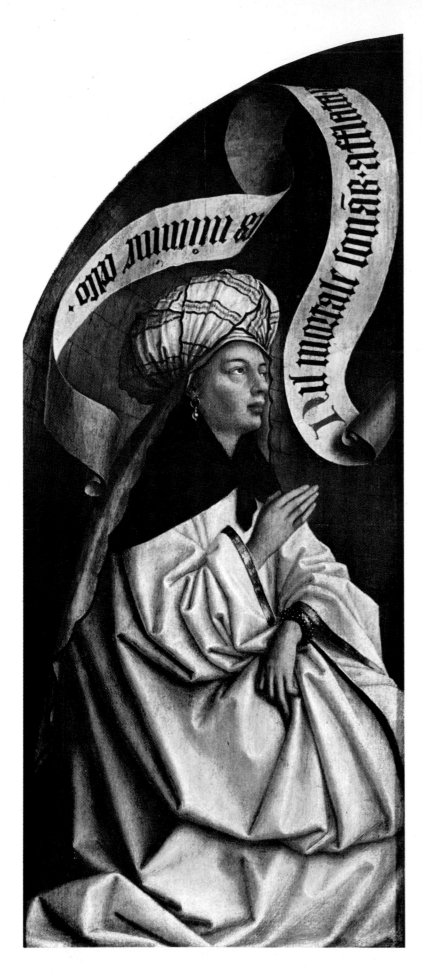
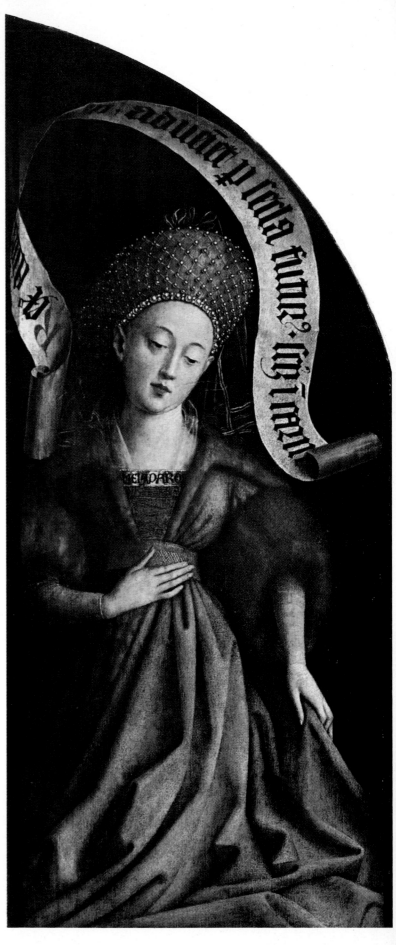

PLATE II THE GHENT POLYPTYCH Ghent, Cathedral of St Bavon
The *Erythrean Sibyl* and the *Cumaean Sibyi* (37.1 and 36.1 cm. respectively)

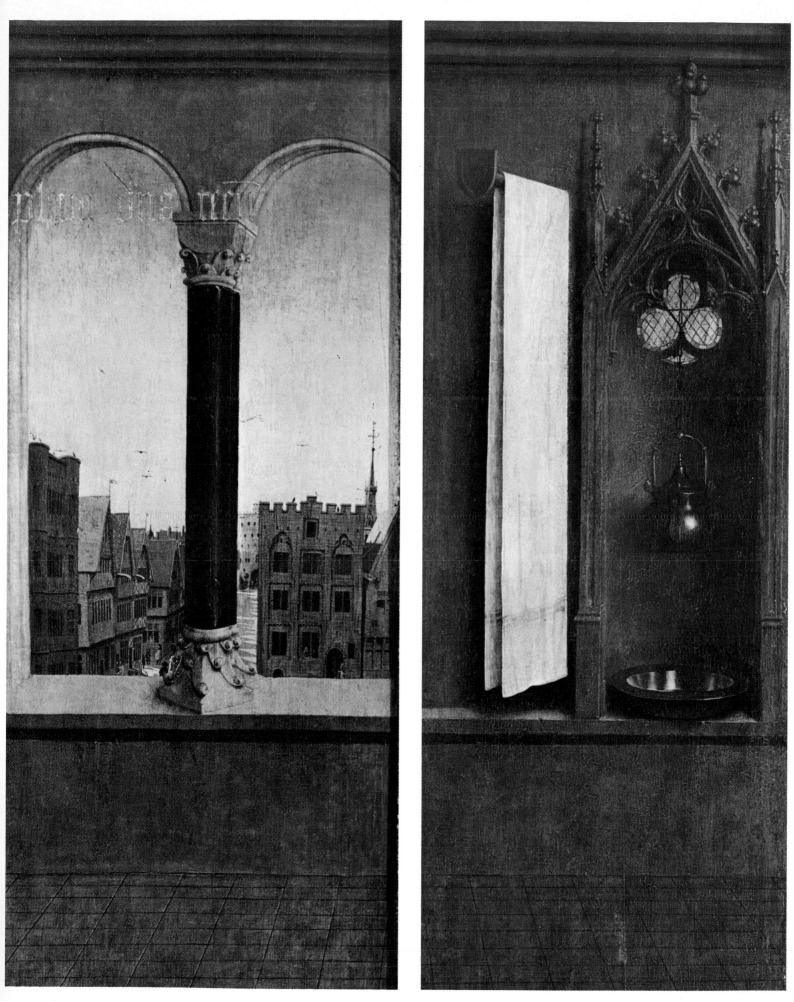

PLATE III THE GHENT POLYPTYCH Ghent, Cathedral of St Bavon
Details of the double-lighted window and the wash basin (37.1 and 36.1 cm. respectively)

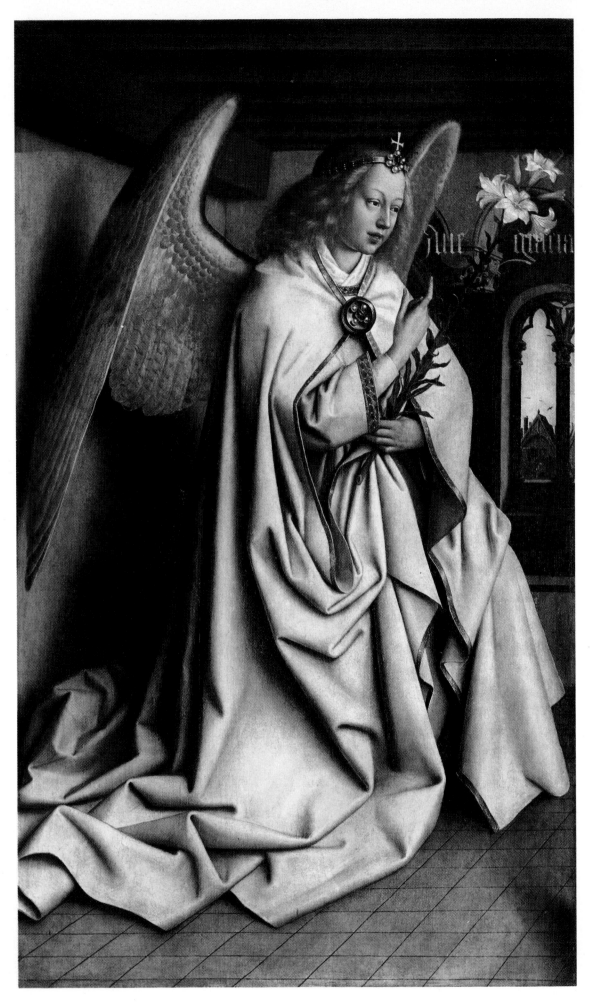

PLATE IV THE GHENT POLYPTYCH Ghent, Cathedral of St Bavon
The *Angel of the Annunciation* (71.7 cm.)

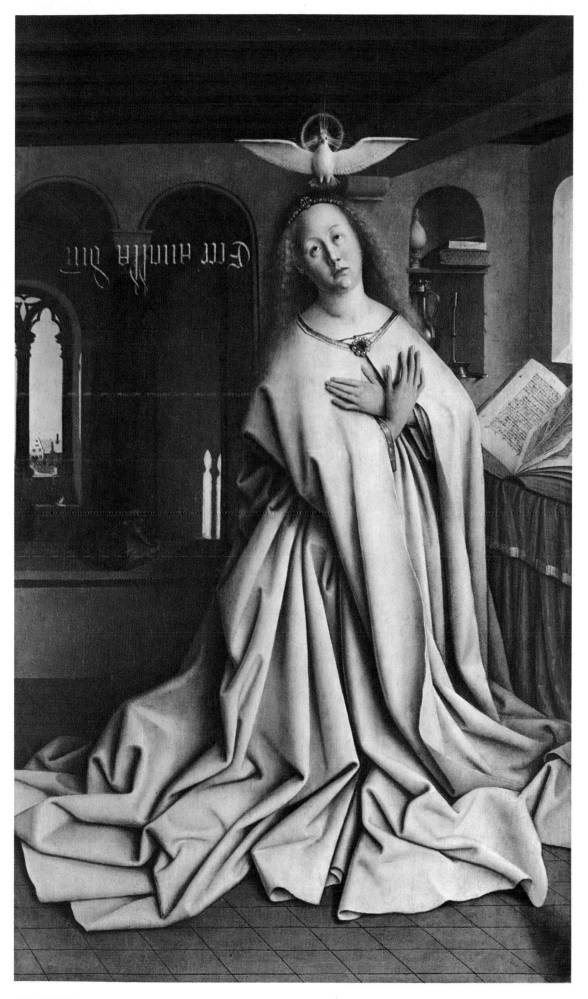

PLATE V THE GHENT POLYPTYCH Ghent, Cathedral of St Bavon
The *Virgin of the Annunciation* (73 cm.)

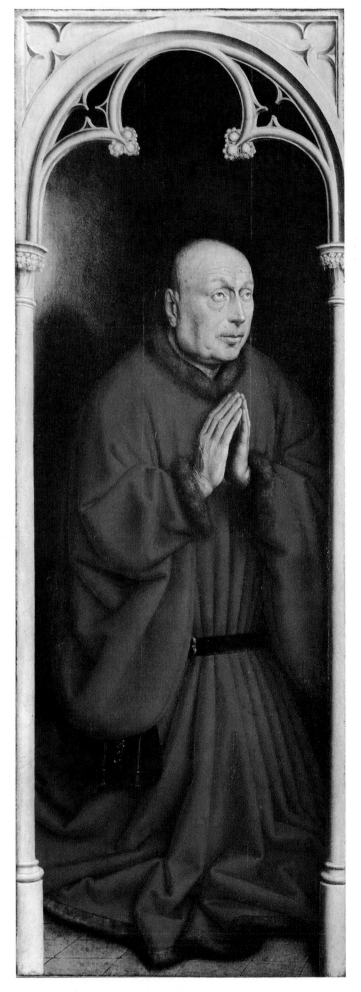

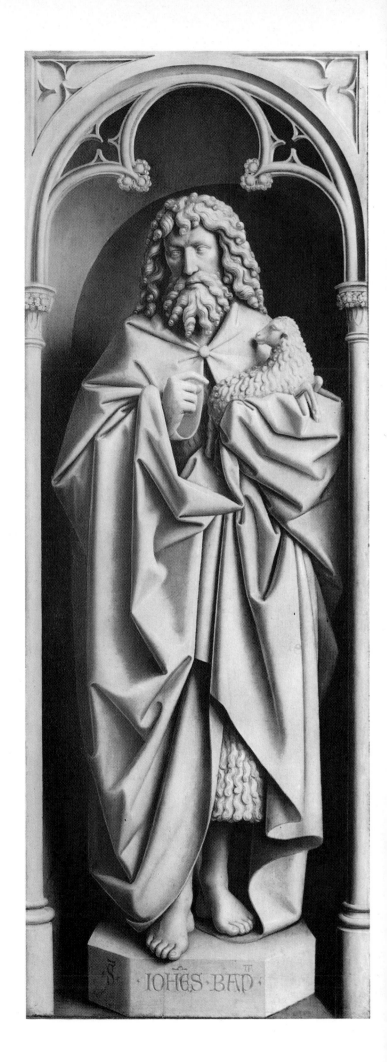

PLATE VI THE GHENT POLYPTYCH Ghent, Cathedral of St Bavon
The *Donor* and *St John the Baptist* (54.1 and 55.1 cm. respectively)

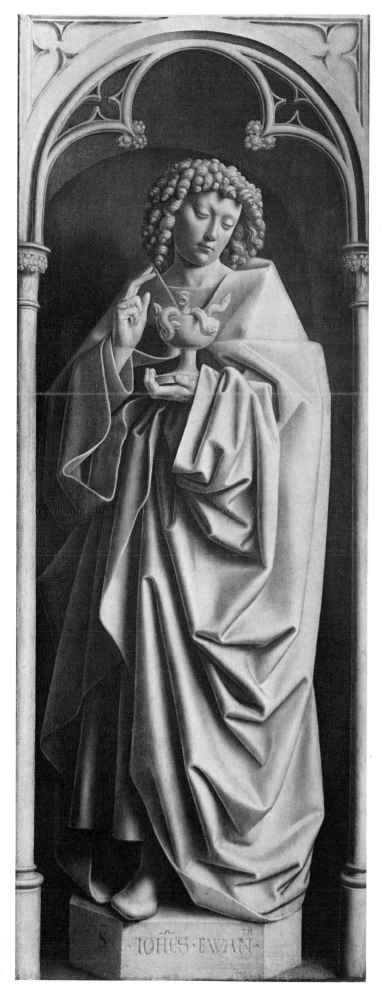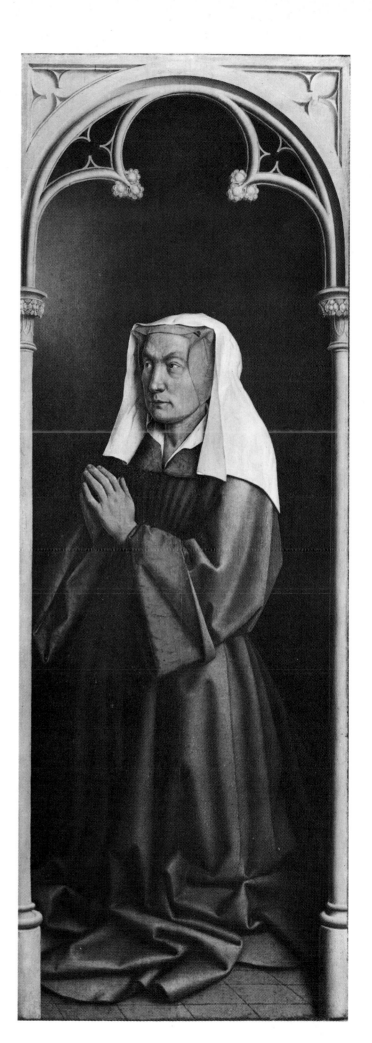

PLATE VII THE GHENT POLYPTYCH Ghent, Cathedral of St Bavon
St John the Evangelist and the *Donor's Wife* (55.3 and 54.2 cm. respectively)

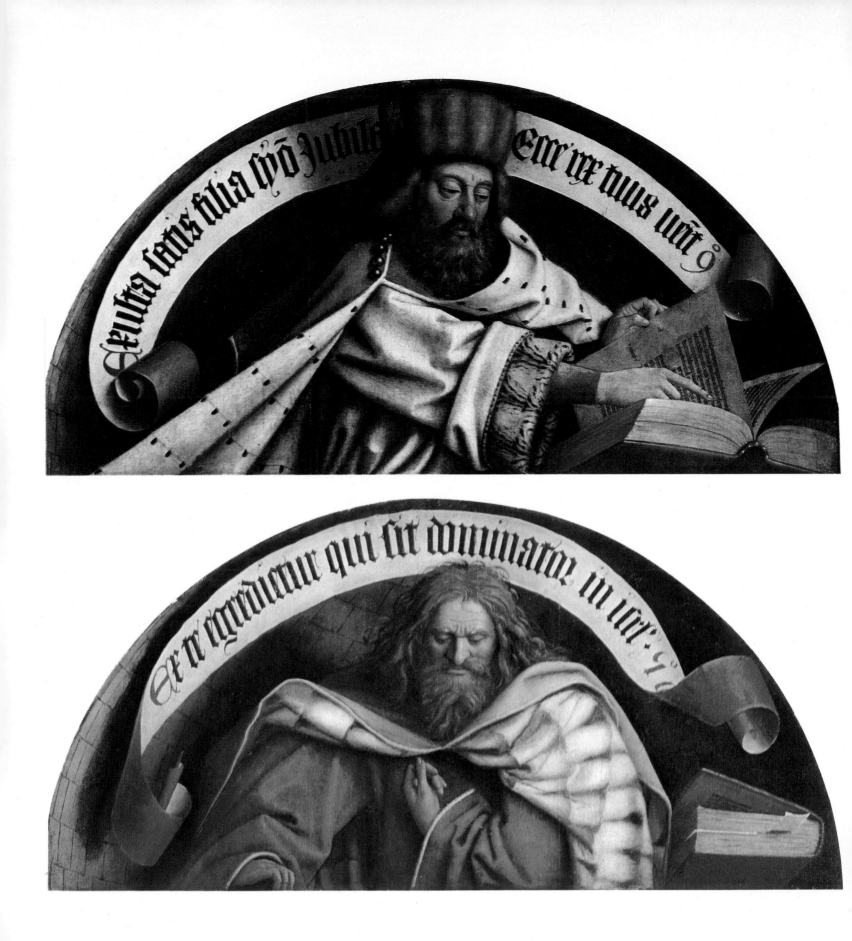

PLATE VIII THE GHENT POLYPTYCH Ghent, Cathedral of St Bavon
The *Prophet Zachariah* and the *Prophet Micah* (71.7 and 73 cm. respectively)

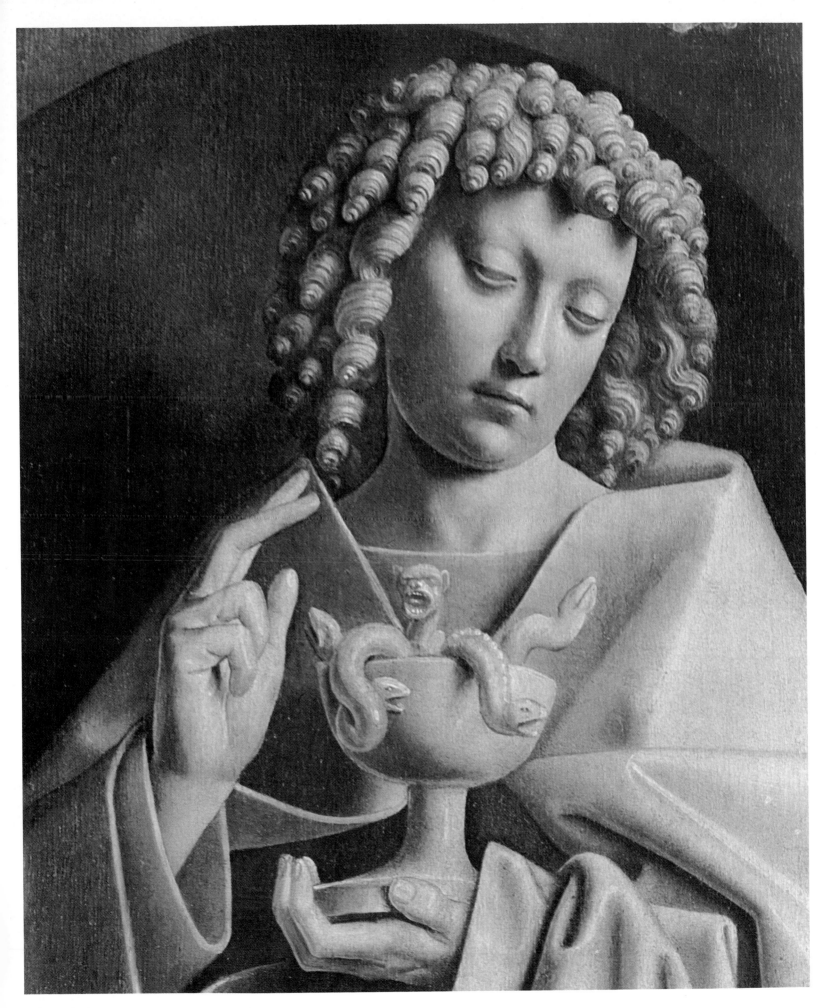

PLATE IX THE GHENT POLYPTYCH Ghent, Cathedral of St Bavon
Detail of *St John the Evangelist* (32.5 cm.)

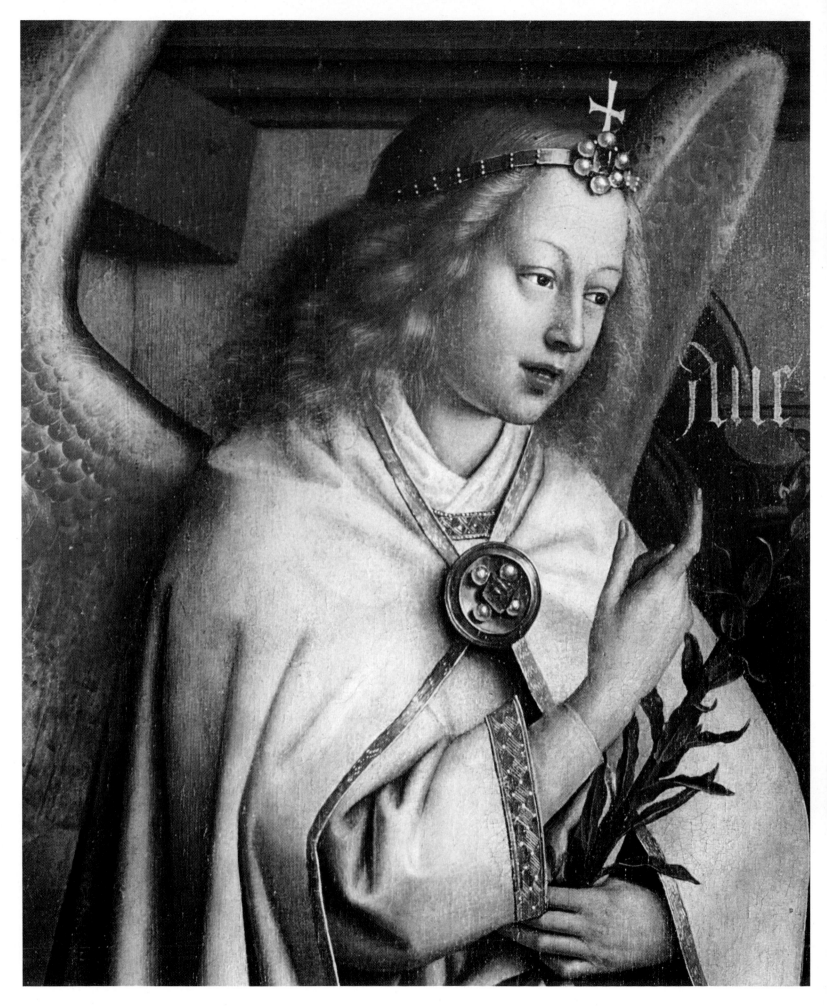

PLATE X THE GHENT POLYPTYCH Ghent, Cathedral of St Bavon
Detail of the *Angel of the Annunciation* (35.5 cm.)

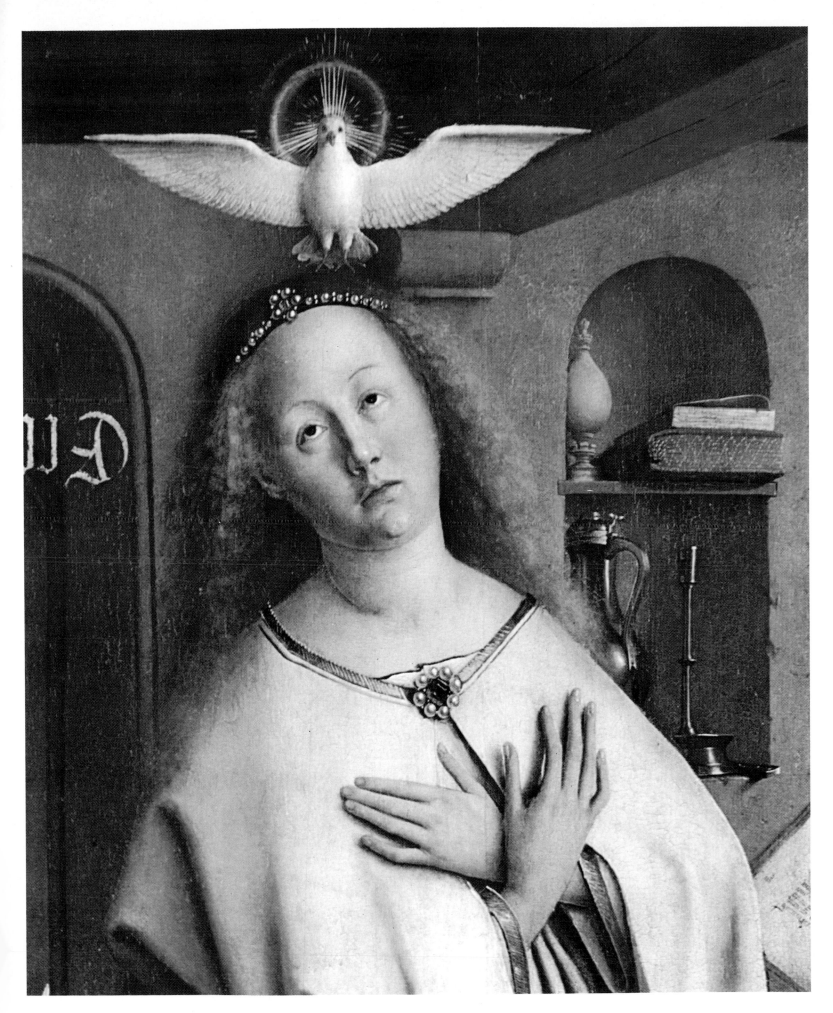

PLATE XI THE GHENT POLYPTYCH Ghent, Cathedral of St Bavon
Detail of the *Virgin of the Annunciation* (35.5 cm.)

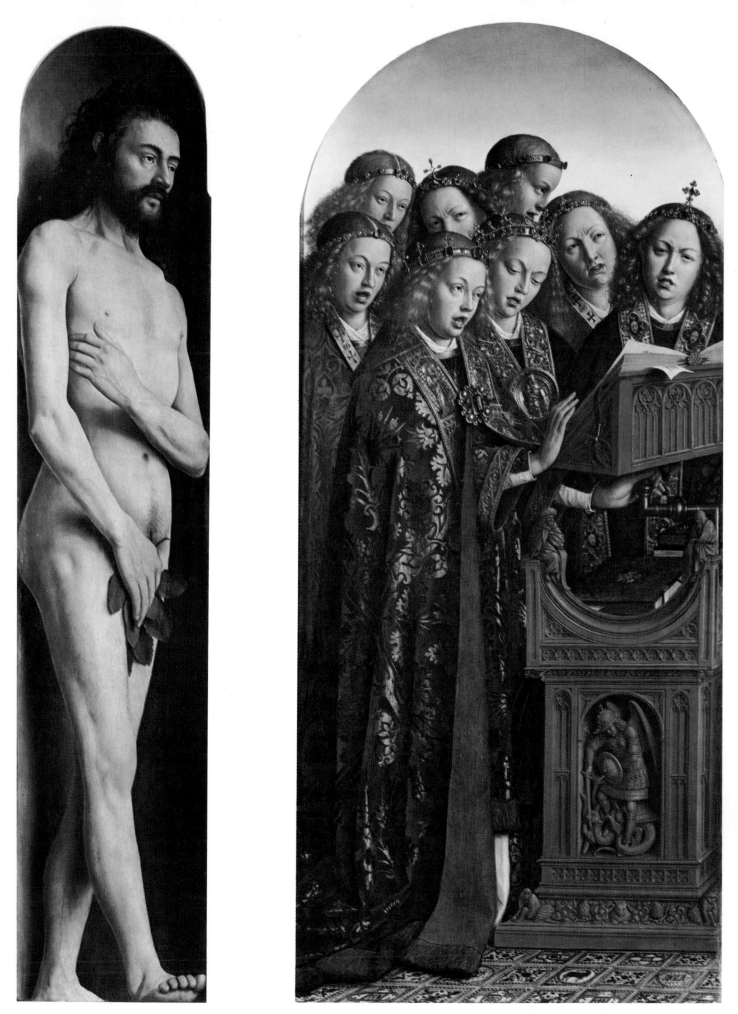

PLATE XII THE GHENT POLYPTYCH Ghent, Cathedral of St Bavon
Adam and the *Angels singing* (37.1 and 71.5 cm. respectively)

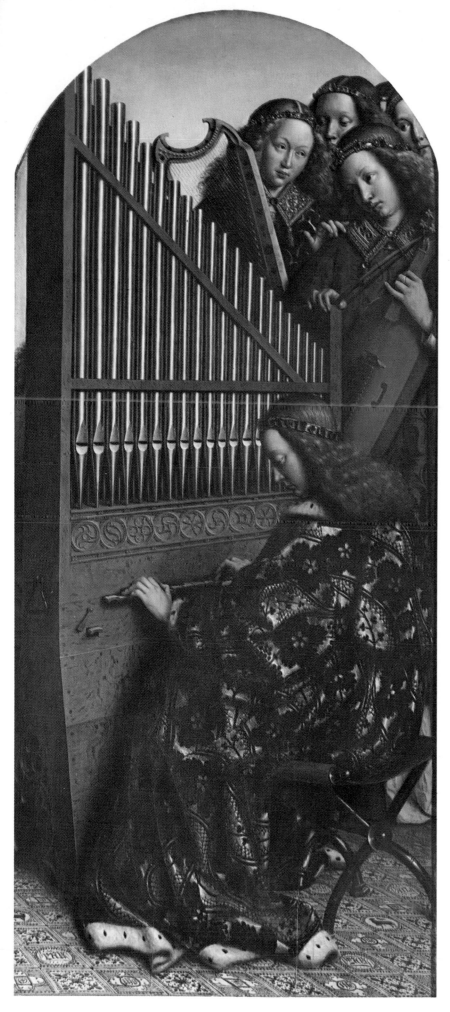 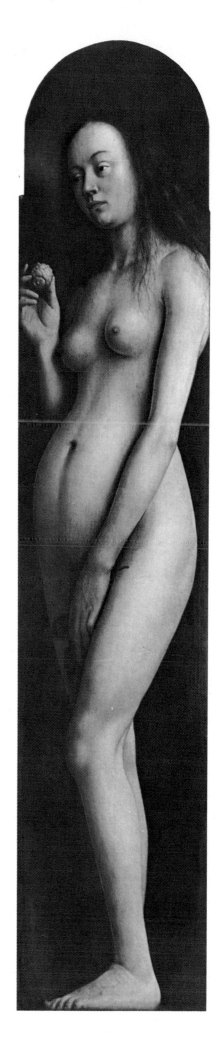

PLATE XIII THE GHENT POLYPTYCH Ghent, Cathedral of St Bavon
Angels making Music and *Eve* (72.9 and 32.3 cm. respectively)

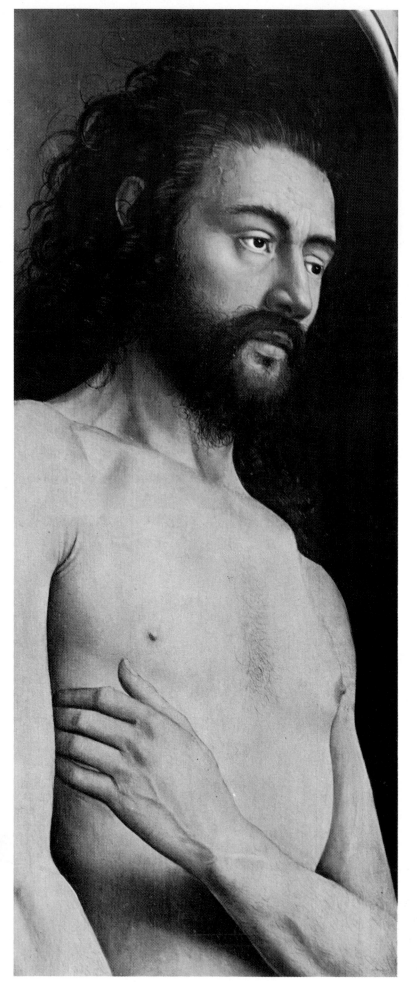
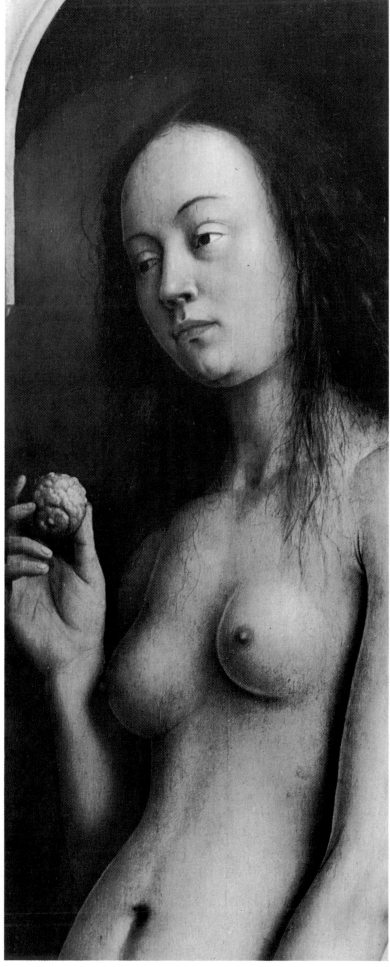

PLATE XIV THE GHENT POLYPTYCH Ghent, Cathedral of St Bavon
Details of *Adam* and *Eve* (28.5 and 26 cm. respectively)

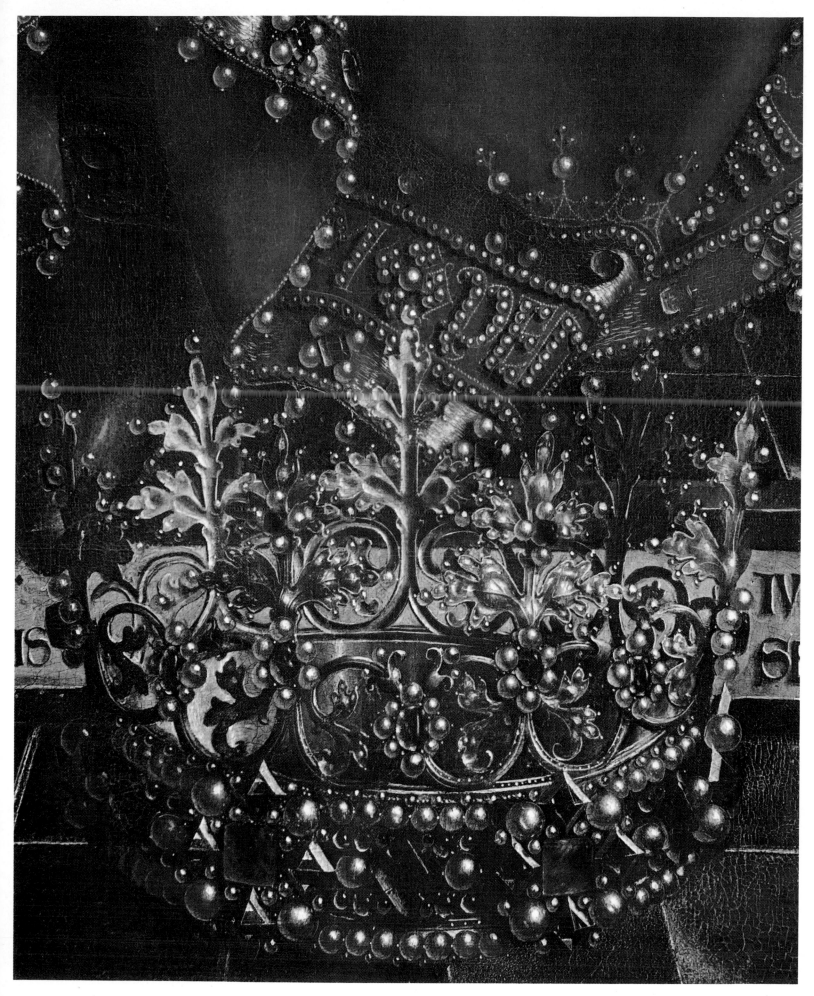

PLATE XV THE GHENT POLYPTYCH Ghent, Cathedral of St Bavon
Detail of *God* (31.5 cm.)

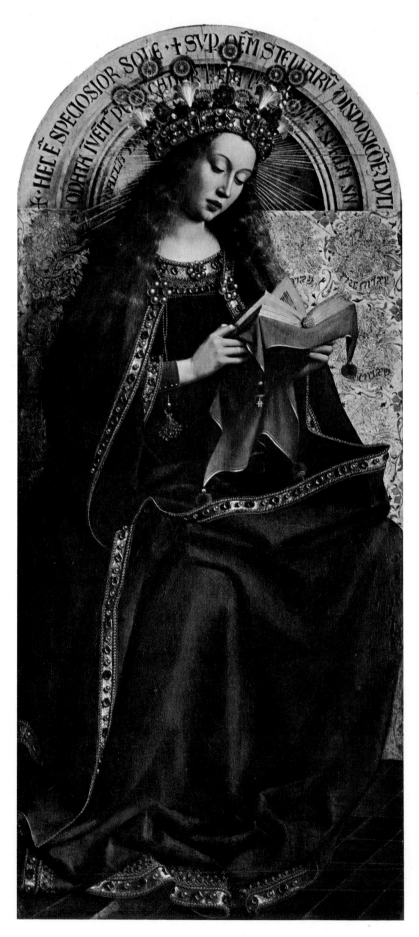

THE GHENT POLYPTYCH Ghent, Cathedral of St Bavon
The *Virgin*, *God*, and *St John the Baptist* (74.9, 83.1 and 75.1 cm. respectively)

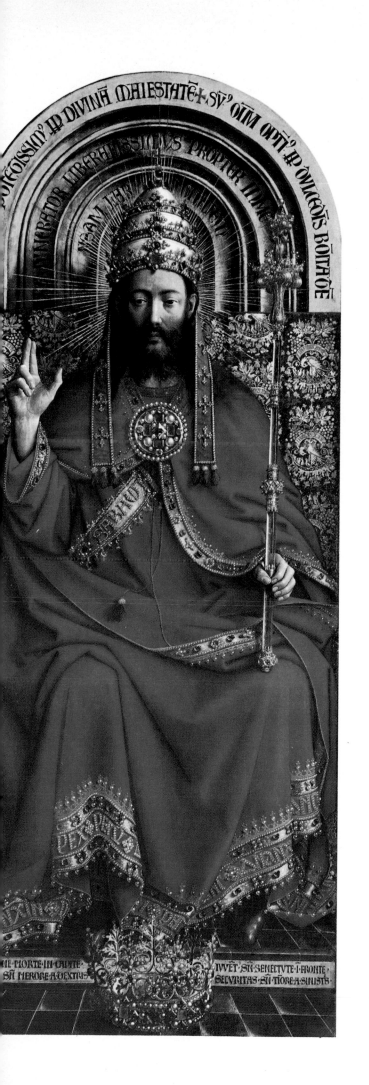

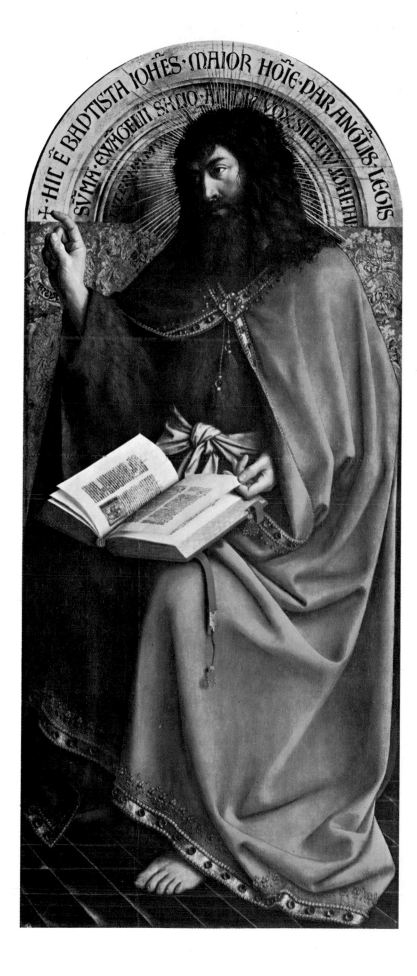

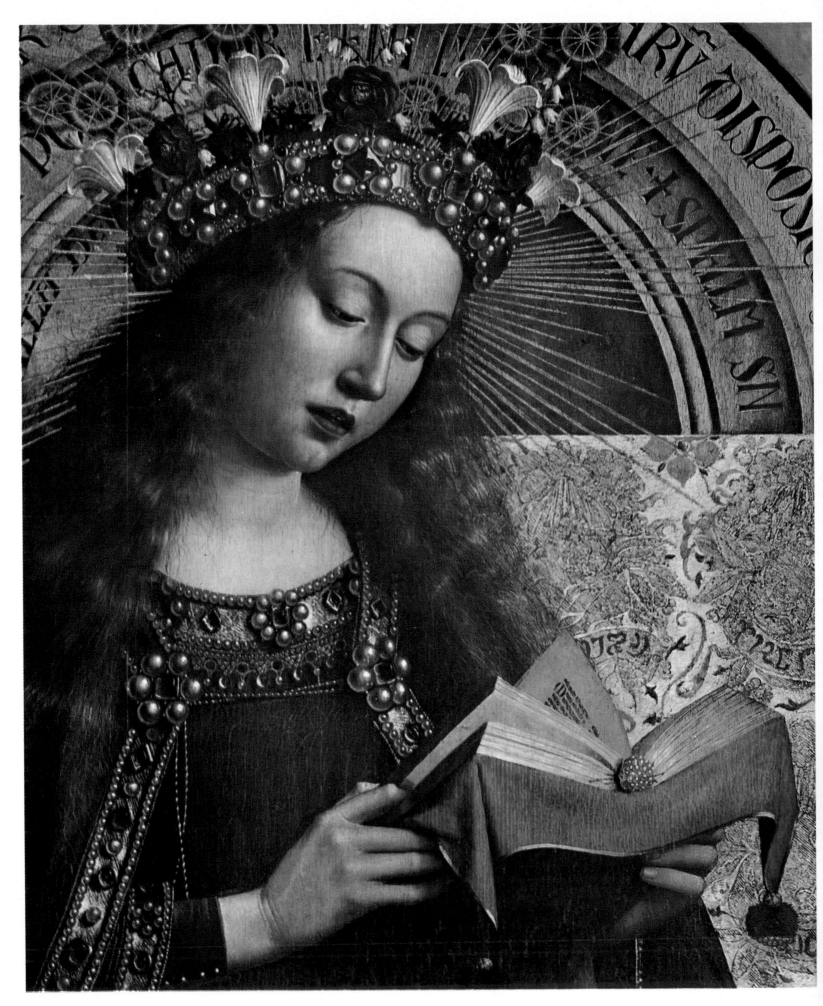

PLATE XVIII THE GHENT POLYPTYCH Ghent, Cathedral of St Bavon
Detail of the *Virgin* (49 cm.)

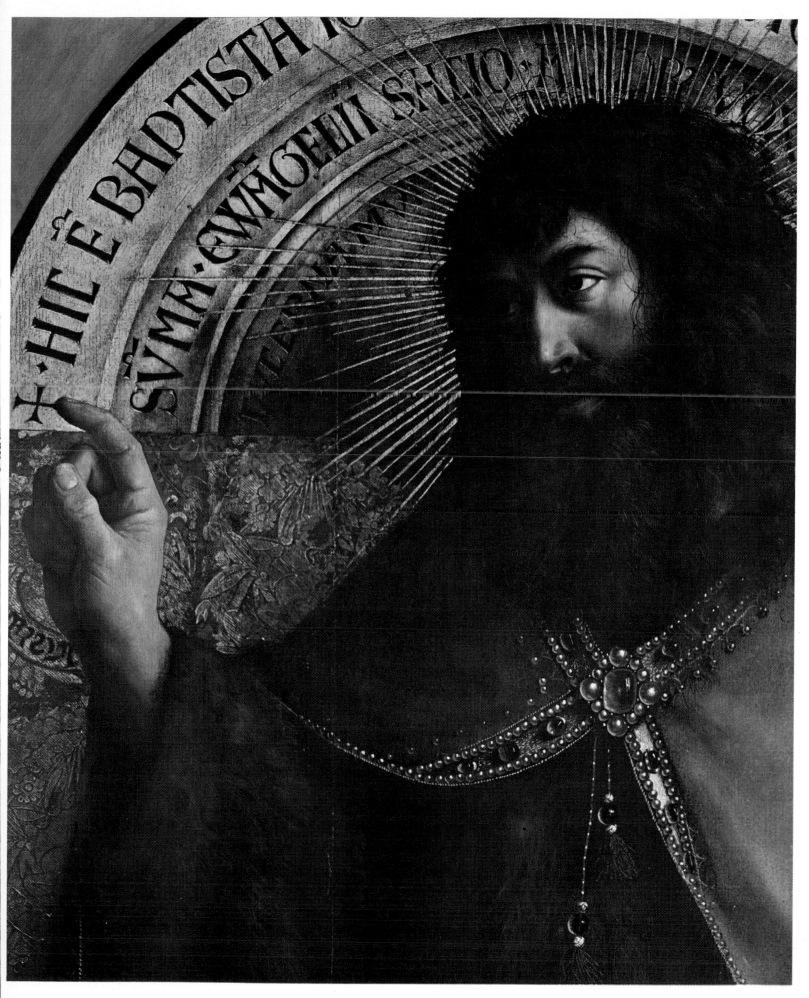

PLATE XIX THE GHENT POLYPTYCH Ghent, Cathedral of St Bavon
Detail of *St John the Baptist* (49 cm.)

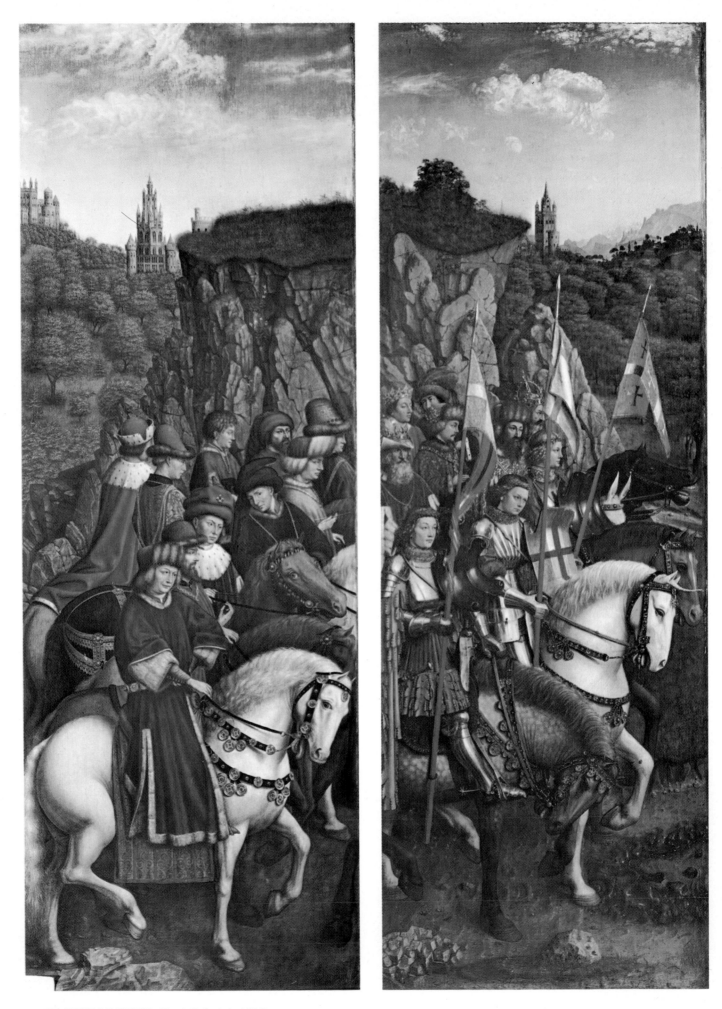

PLATE XX THE GHENT POLYPTYCH Ghent, Cathedral of St Bavon
The *Just Judges* (copy) and the *Warriors of Christ* (51 and 54 cm. respectively)

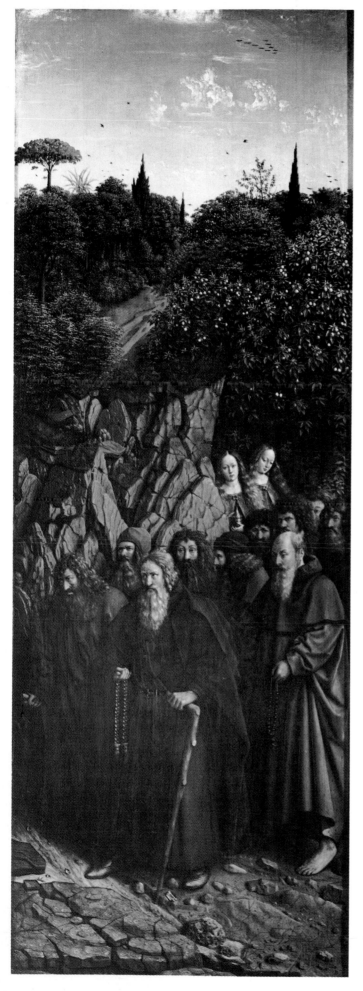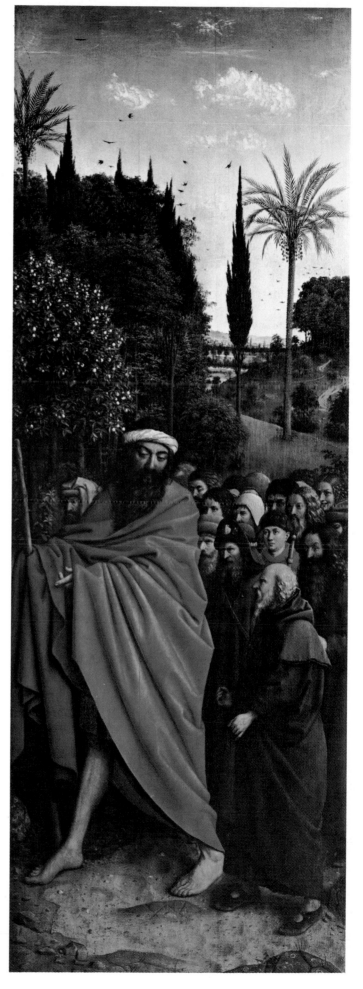

PLATE XXI THE GHENT POLYPTYCH Ghent, Cathedral of St Bavon
The *Holy Hermits* and the *Holy Pilgrims* (53.9 and 54.2 cm. respectively)

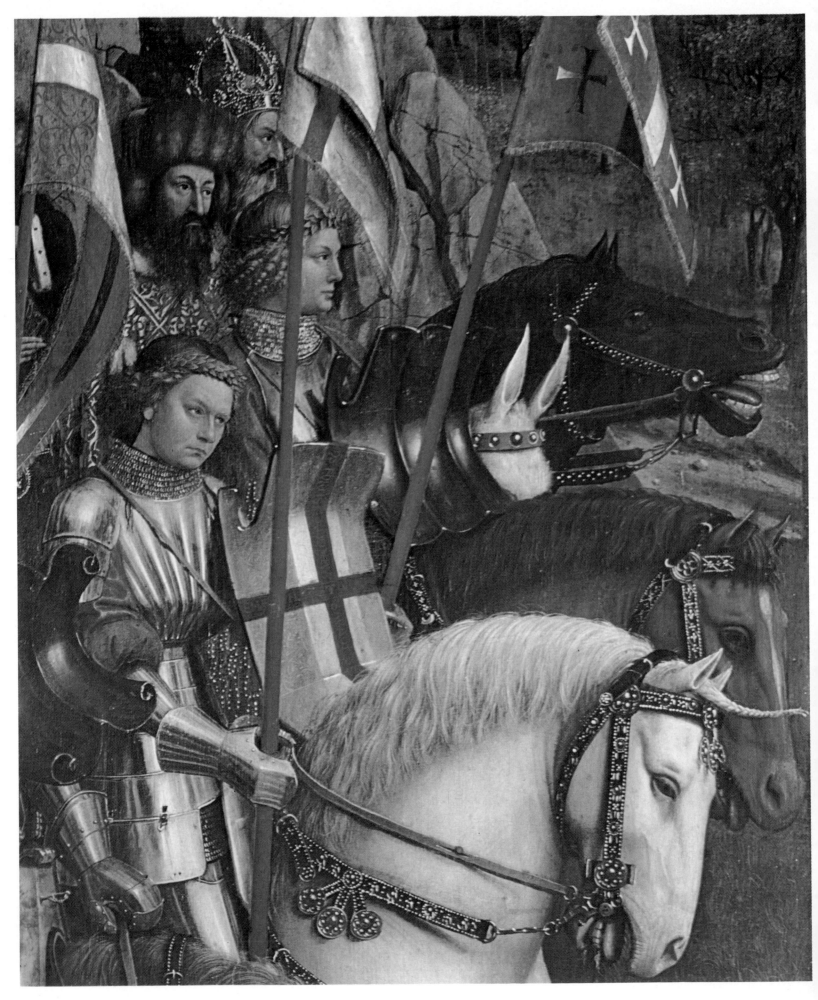

PLATE XXII THE GHENT POLYPTYCH Ghent, Cathedral of St Bavon
Detail of the *Warriors of Christ* (39.5 cm.)

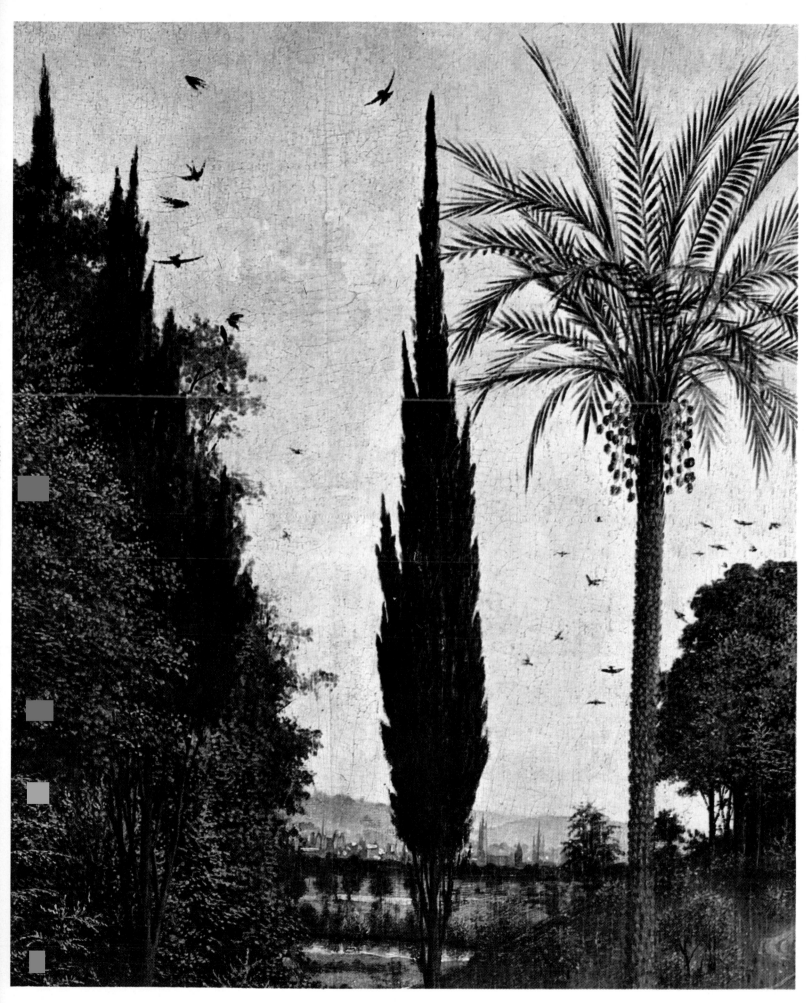

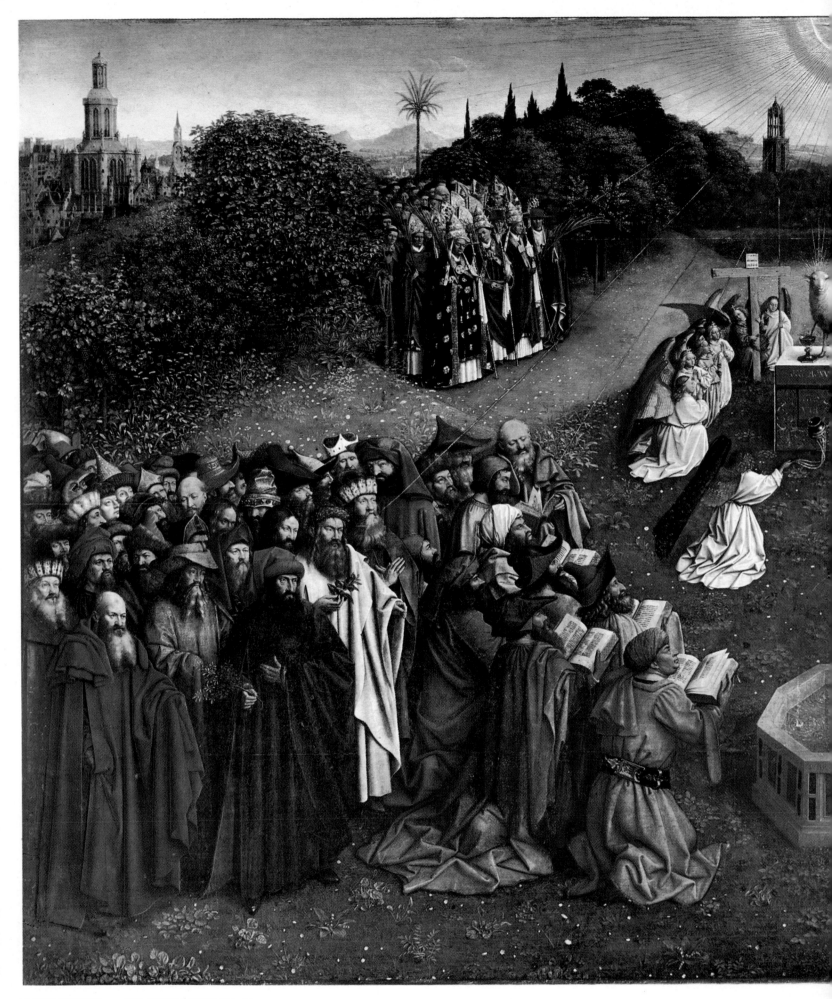

PLATES XXIV-XXV THE GHENT POLYPTYCH Ghent, Cathedral of St Bavon
The *Adoration of the Lamb* (242.3 cm.)

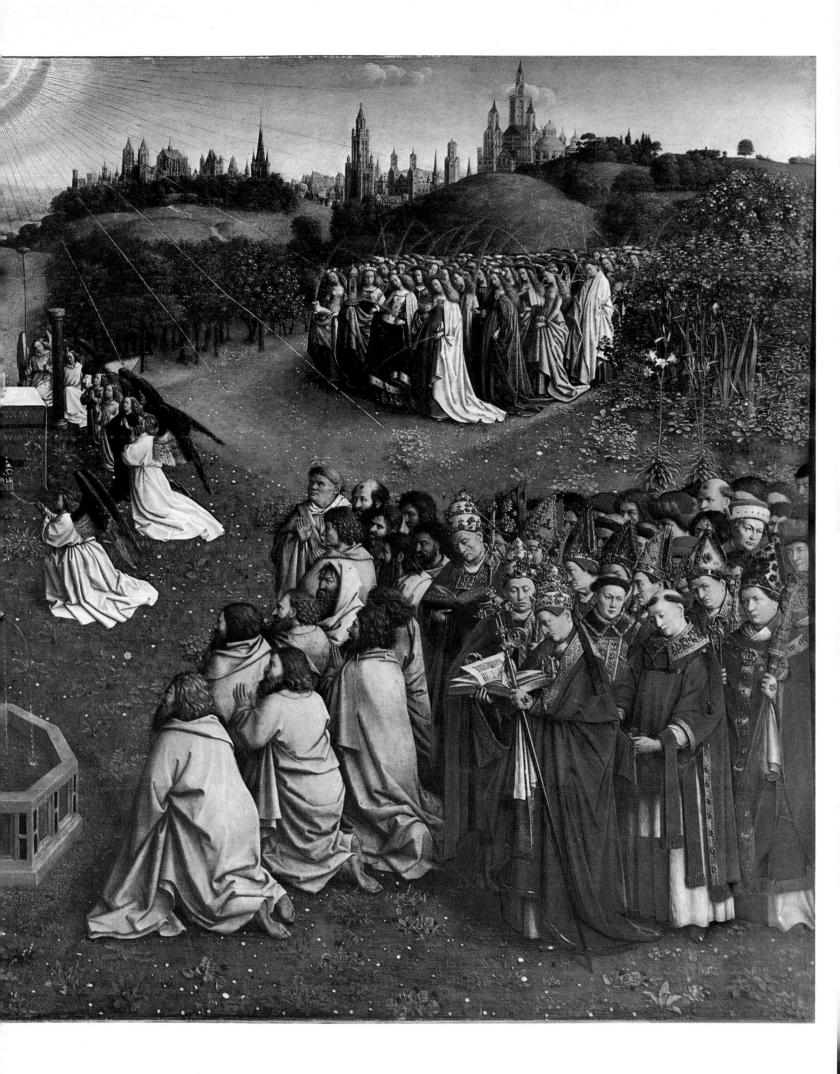

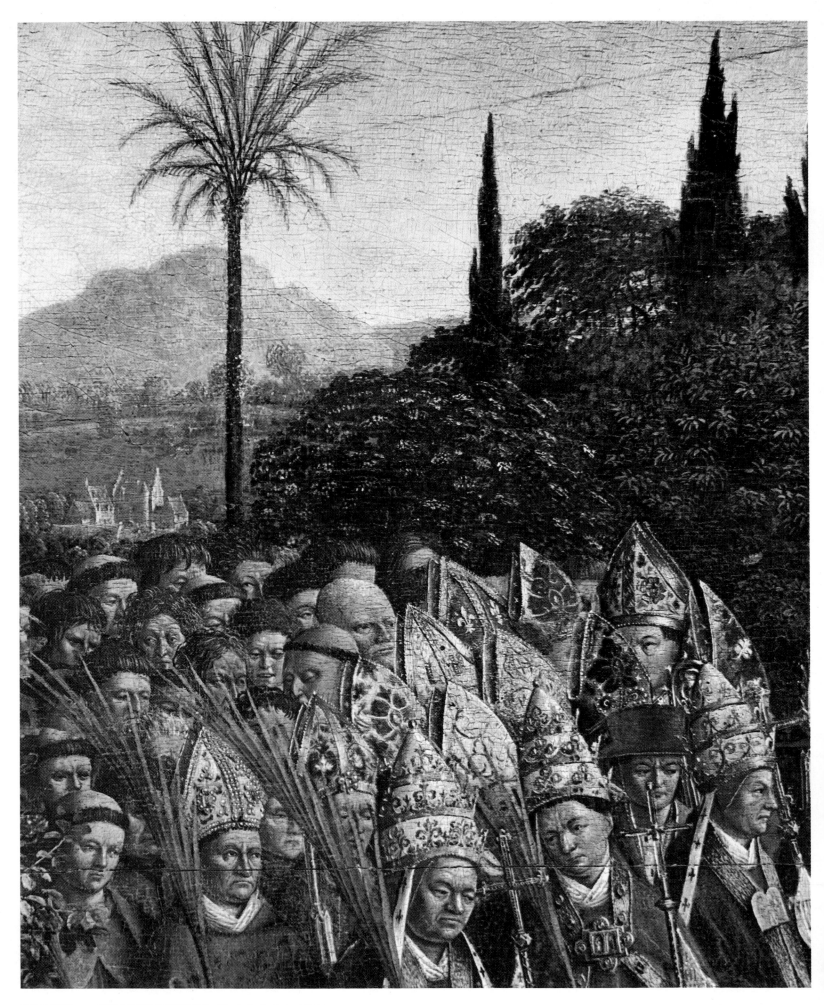

PLATE XXVI THE GHENT POLYPTYCH Ghent, Cathedral of St Bavon
Detail of the *Adoration of the Lamb* (actual size)

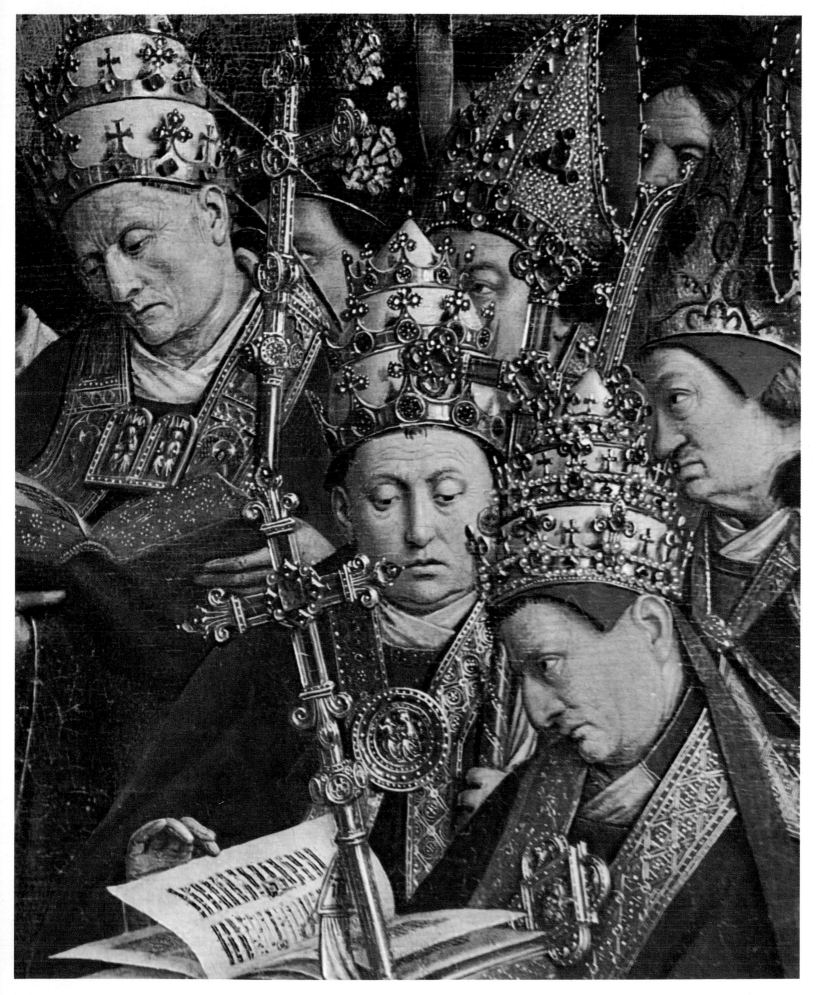

PLATE XXVII THE GHENT POLYPTYCH Ghent, Cathedral of St Bavon
Detail of the *Adoration of the Lamb* (actual size)

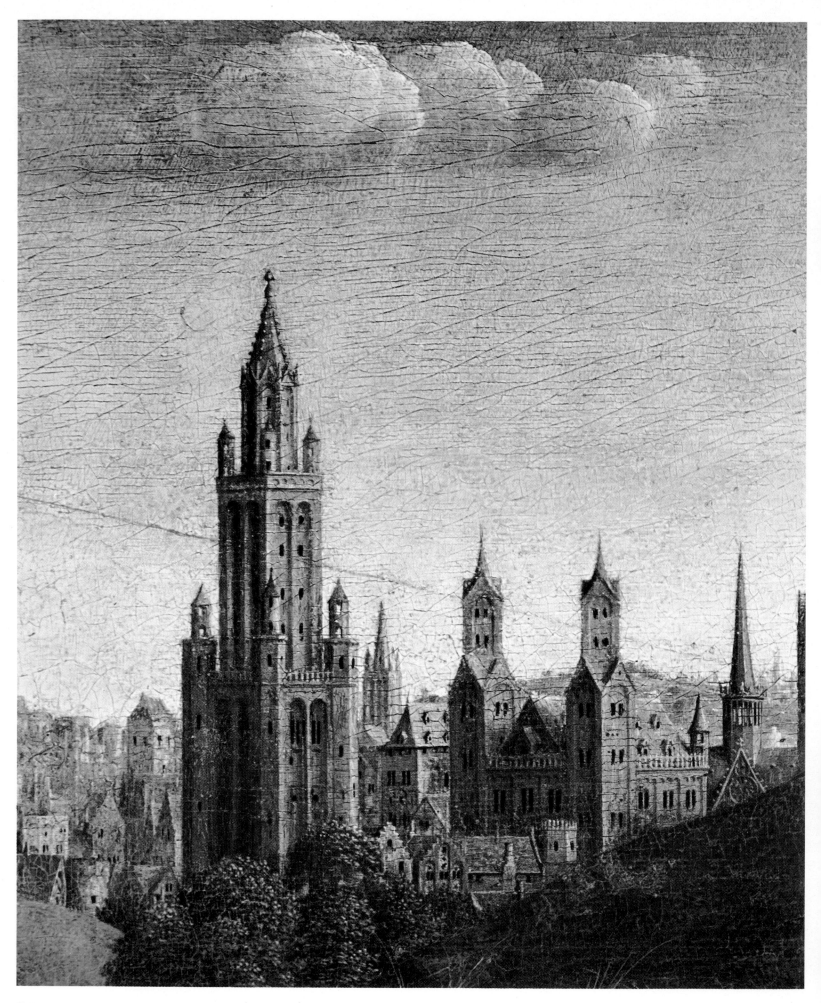

PLATE XXVIII THE GHENT POLYPTYCH Ghent, Cathedral of St Bavon
Detail of the *Adoration of the Lamb* (actual size)

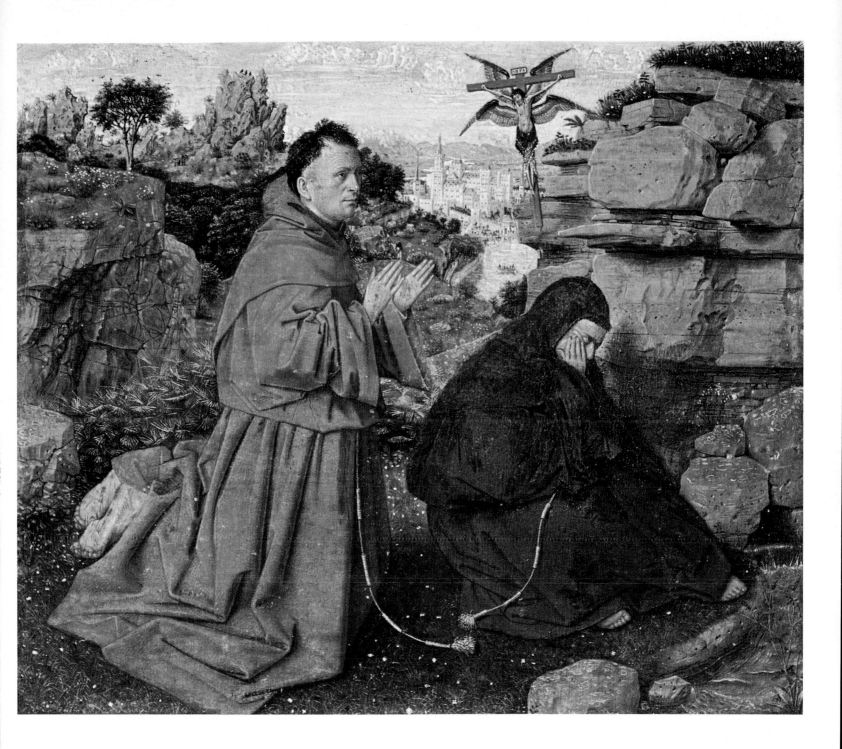

PLATE XXIX ST FRANCIS RECEIVING THE STIGMATA Philadelphia, John G. Johnson Collection
Whole (14.5 cm.; photographed larger than actual size)

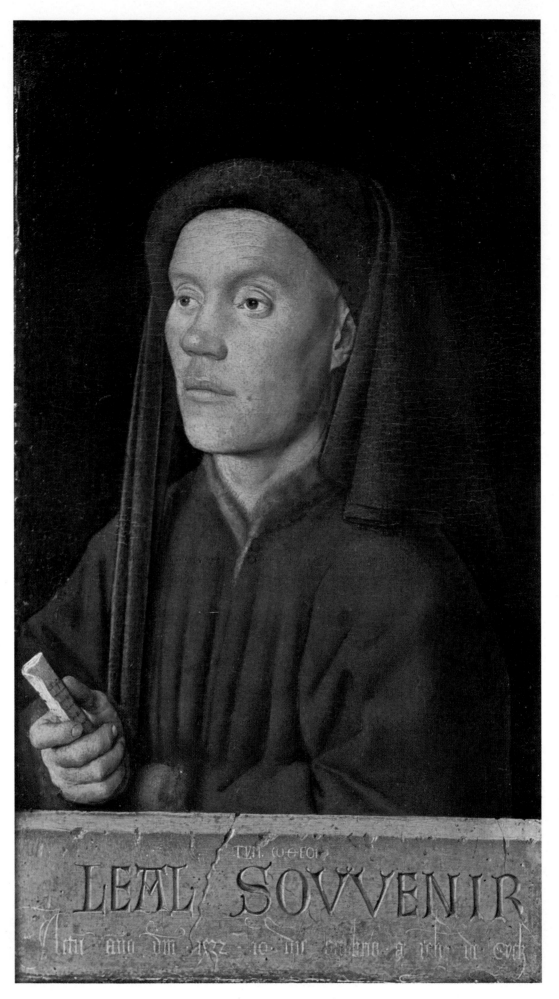

PLATE XXX

TIMOTHEOS London, National Gallery
Whole (20 cm.)

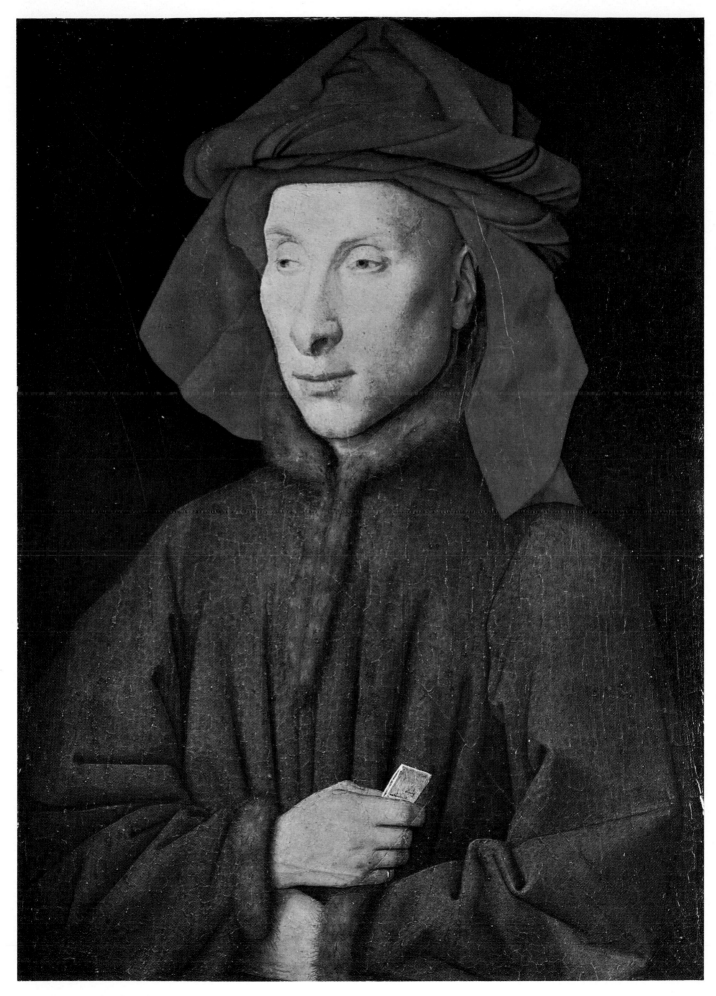

PLATE XXXI PORTRAIT OF GIOVANNI ARNOLFINI Berlin, Staatliche Museen, Gemäldegalerie-Dahlem
Whole (20 cm.)

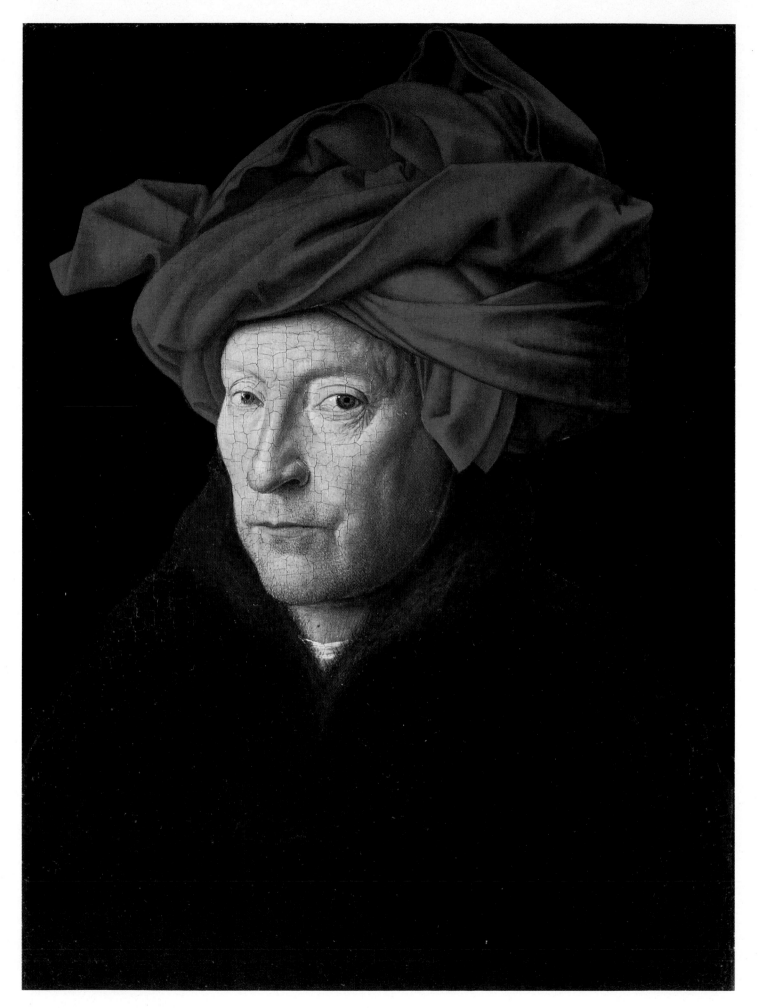

PLATE XXXII THE MAN WITH THE RED TURBAN London, National Gallery
Whole (19 cm.)

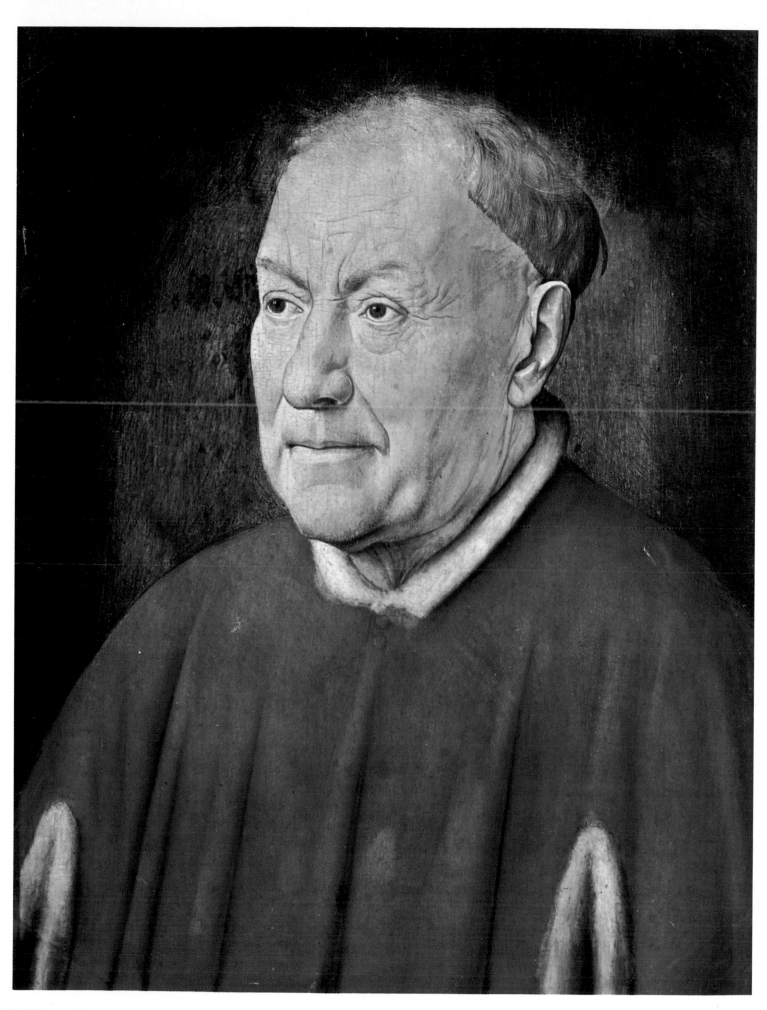

PLATE XXXIII PORTRAIT OF CARDINAL NICOLAS ALBERGATI Vienna, Kunsthistorisches Museum
Whole (27.5 cm.)

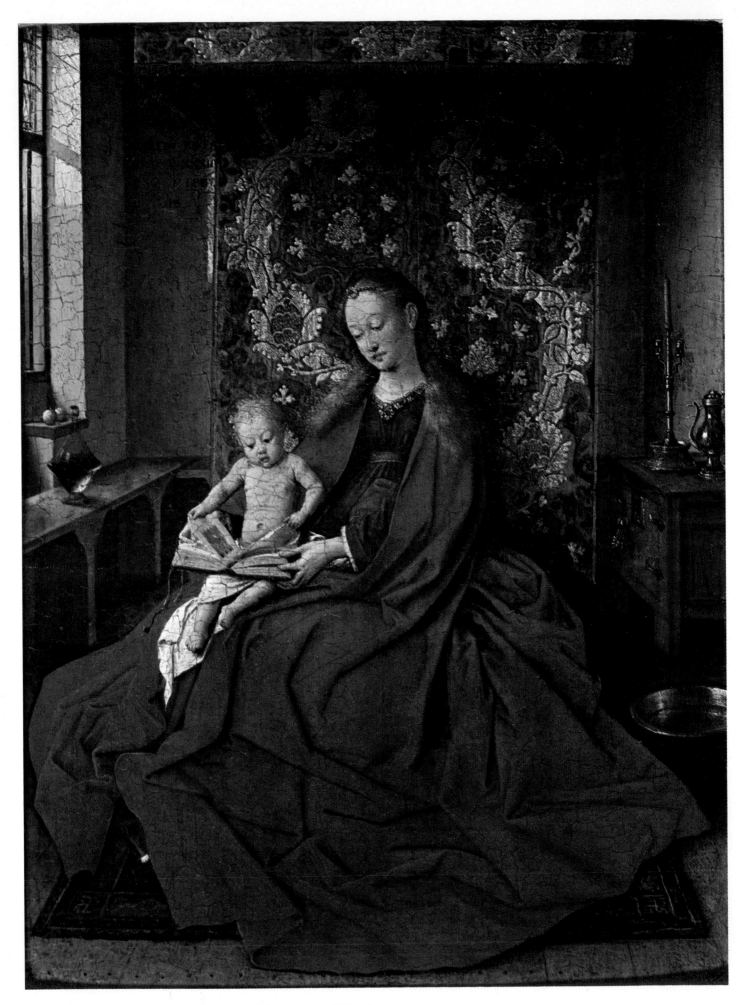

PLATE XXXIV THE INCE HALL MADONNA Melbourne, National Gallery of Victoria
Whole (19.5 cm.)

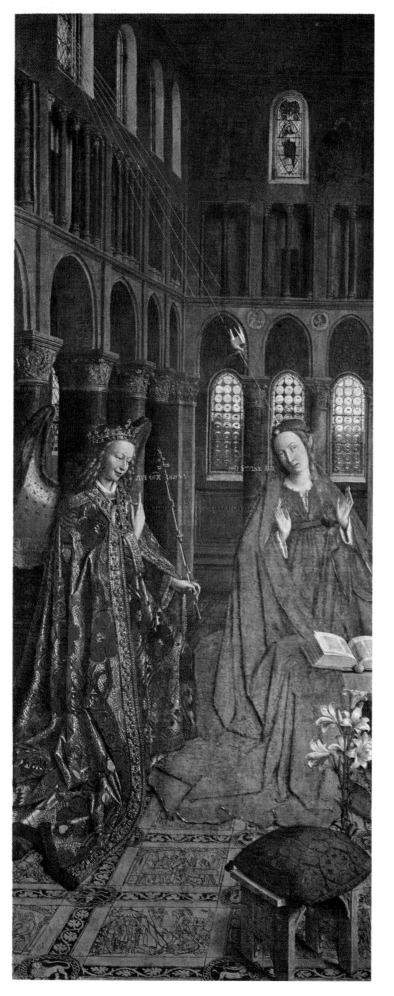

THE ANNUNCIATION Washington, National Gallery
Whole (37 cm.)

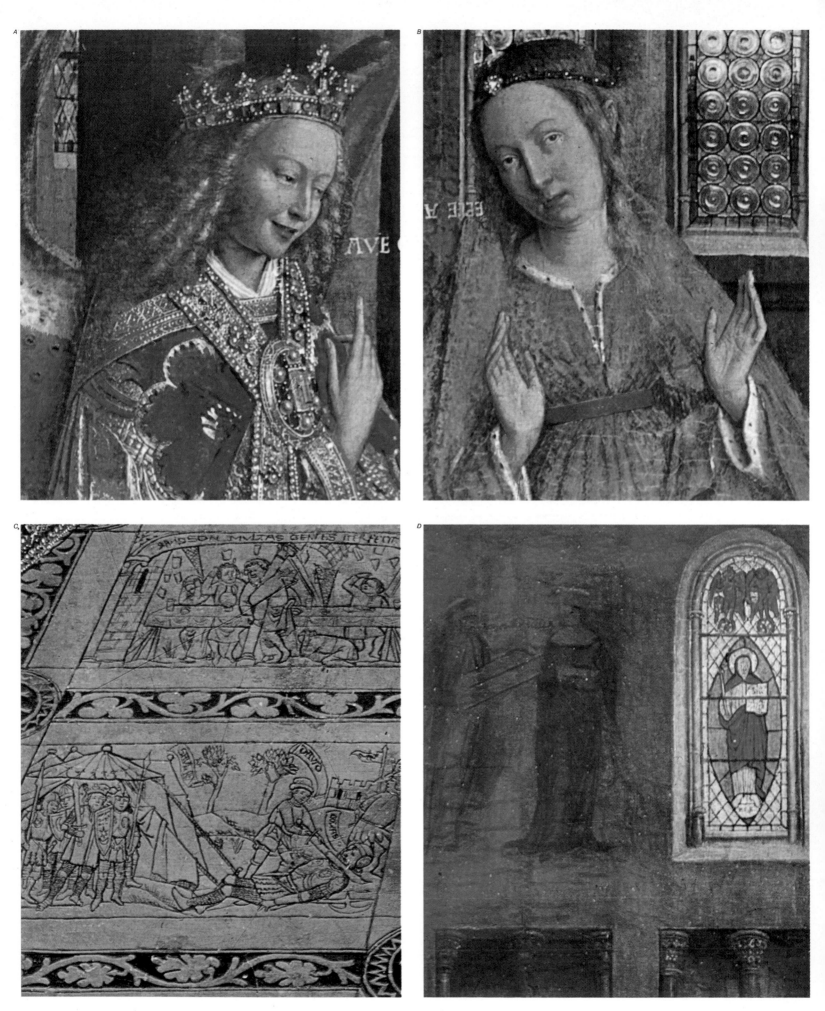

PLATE XXXVI THE ANNUNCIATION Washington, National Gallery
Details (each, actual size)

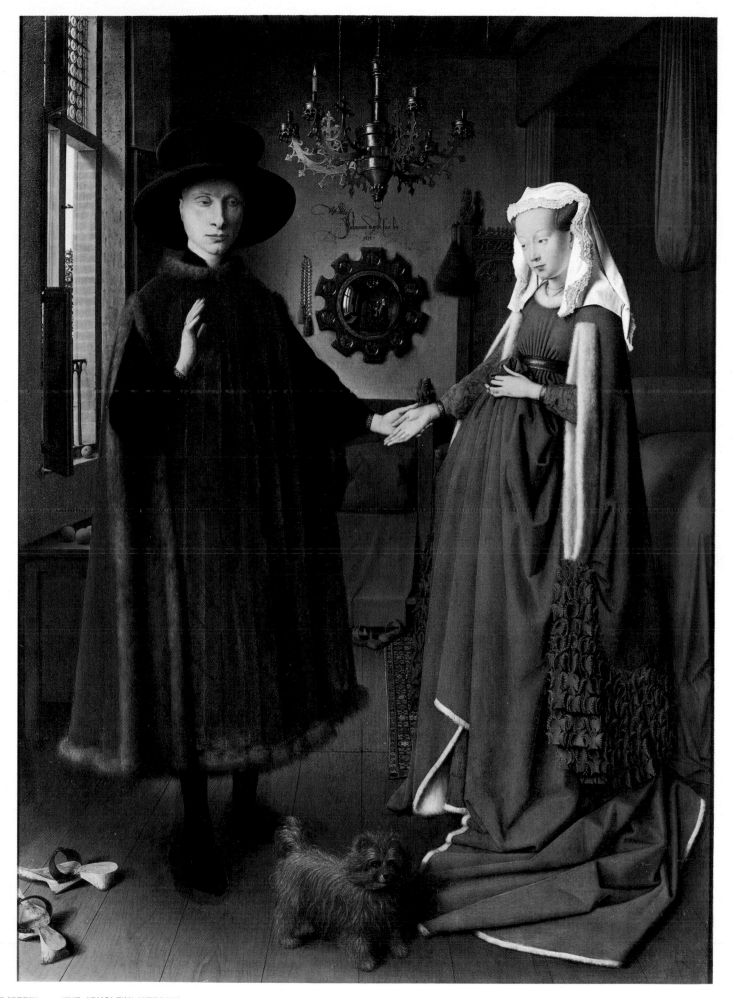

PLATE XXXVII THE ARNOLFINI WEDDING London, National Gallery
Whole (59.5 cm.)

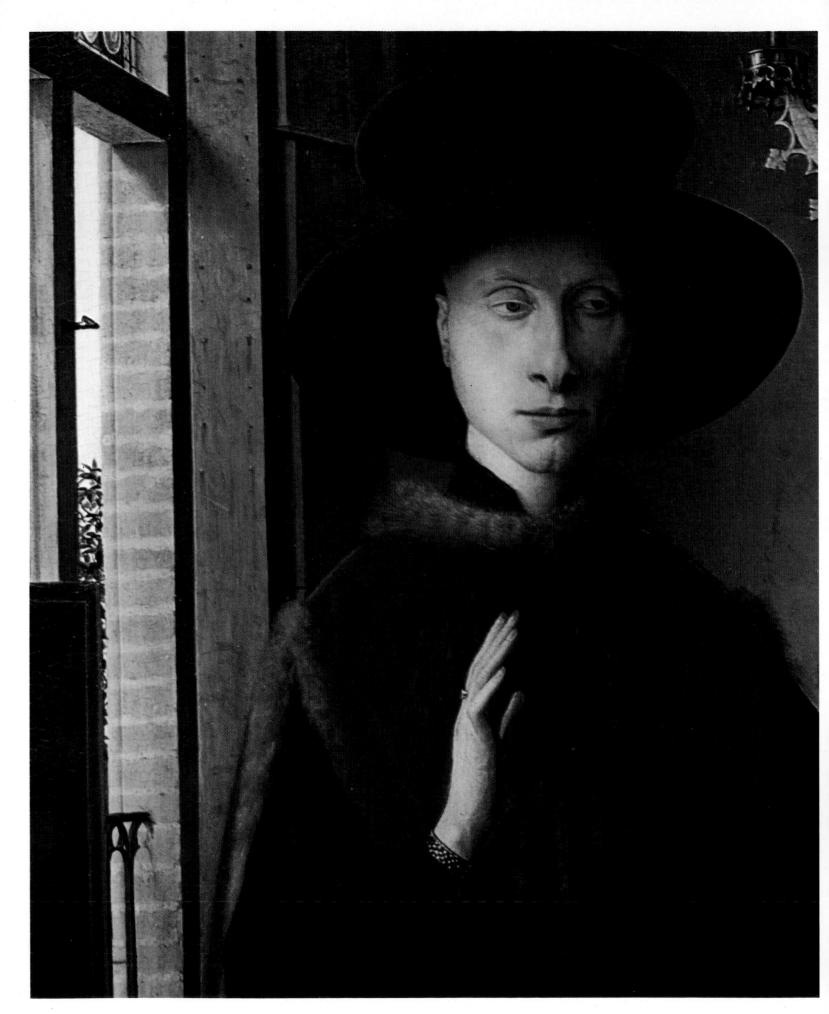

PLATE XXXVIII THE ARNOLFINI WEDDING London, National Gallery
Detail (actual size)

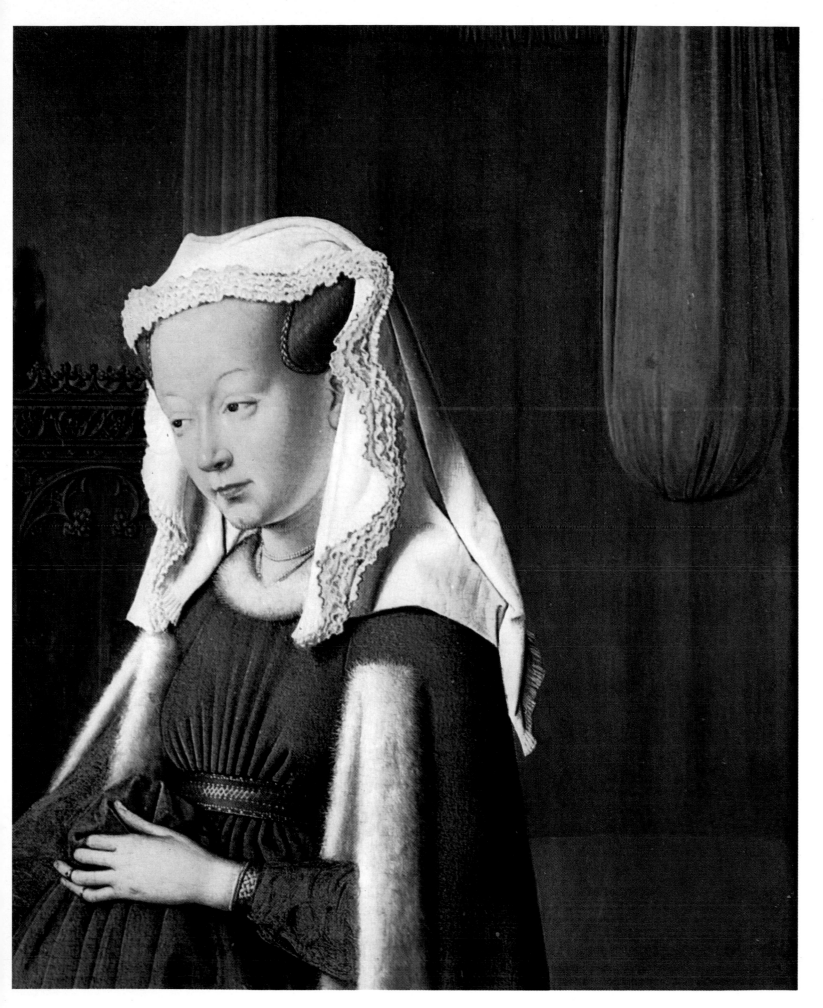

PLATE XXXIX THE ARNOLFINI WEDDING London, National Gallery
Detail (actual size)

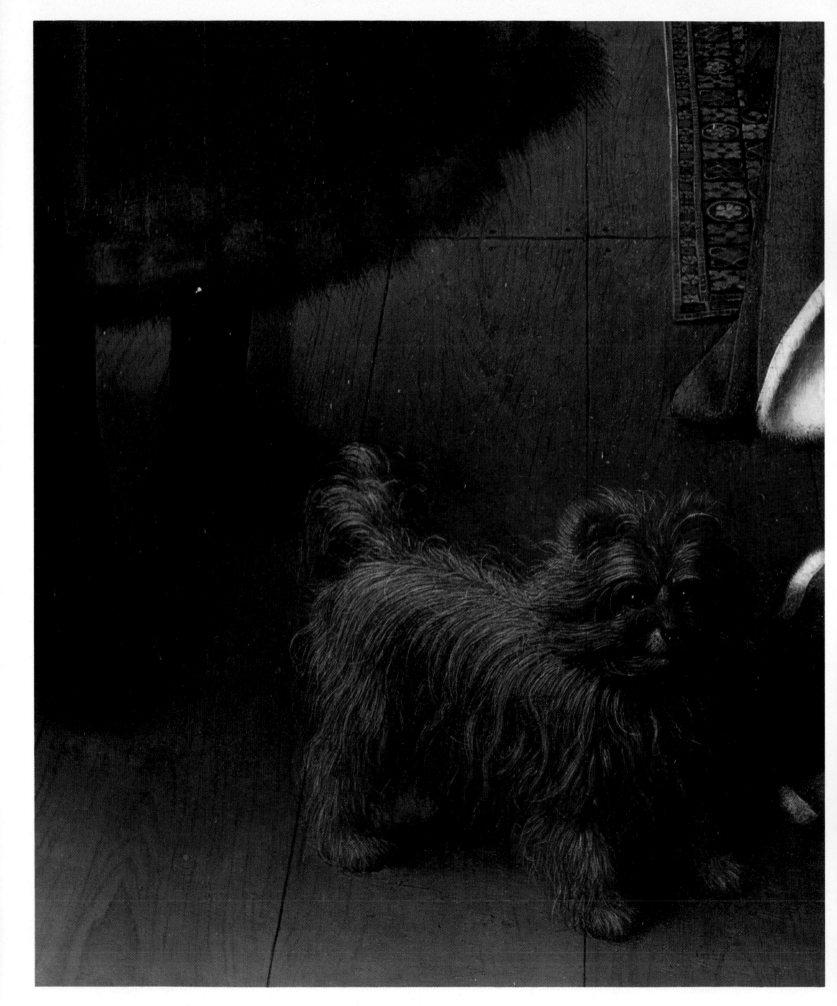

PLATE XL THE ARNOLFINI WEDDING London, National Gallery
Detail (actual size)

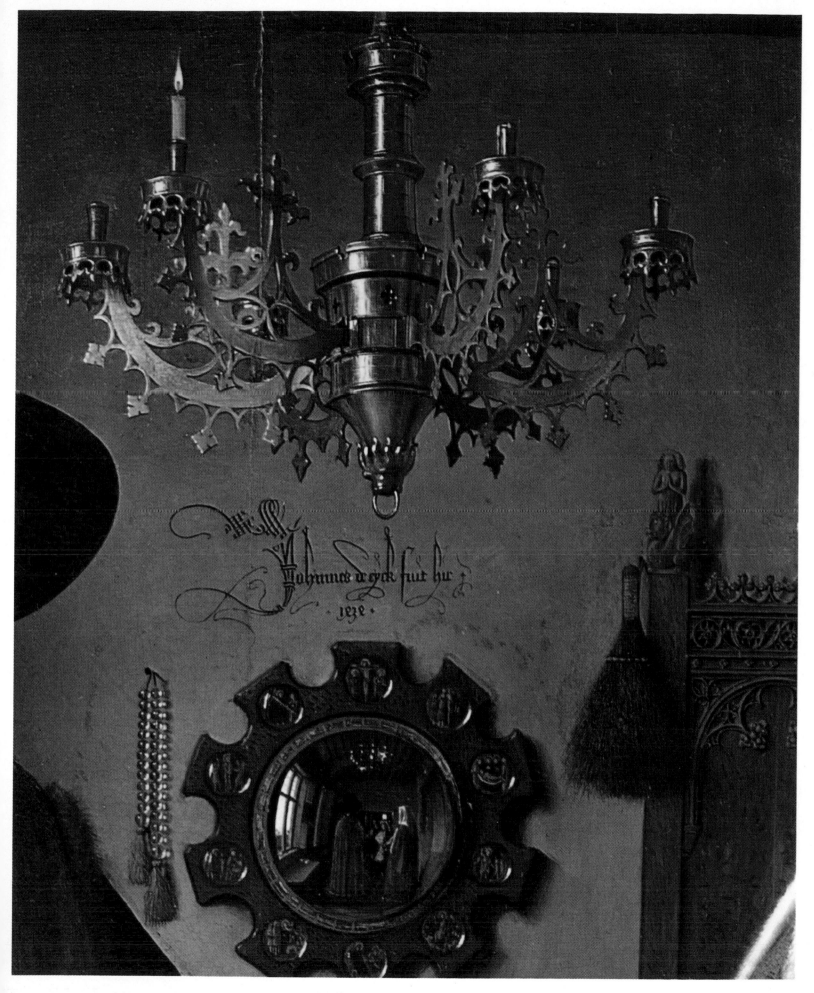

PLATE XLI THE ARNOLFINI WEDDING London, National Gallery
Detail (actual size)

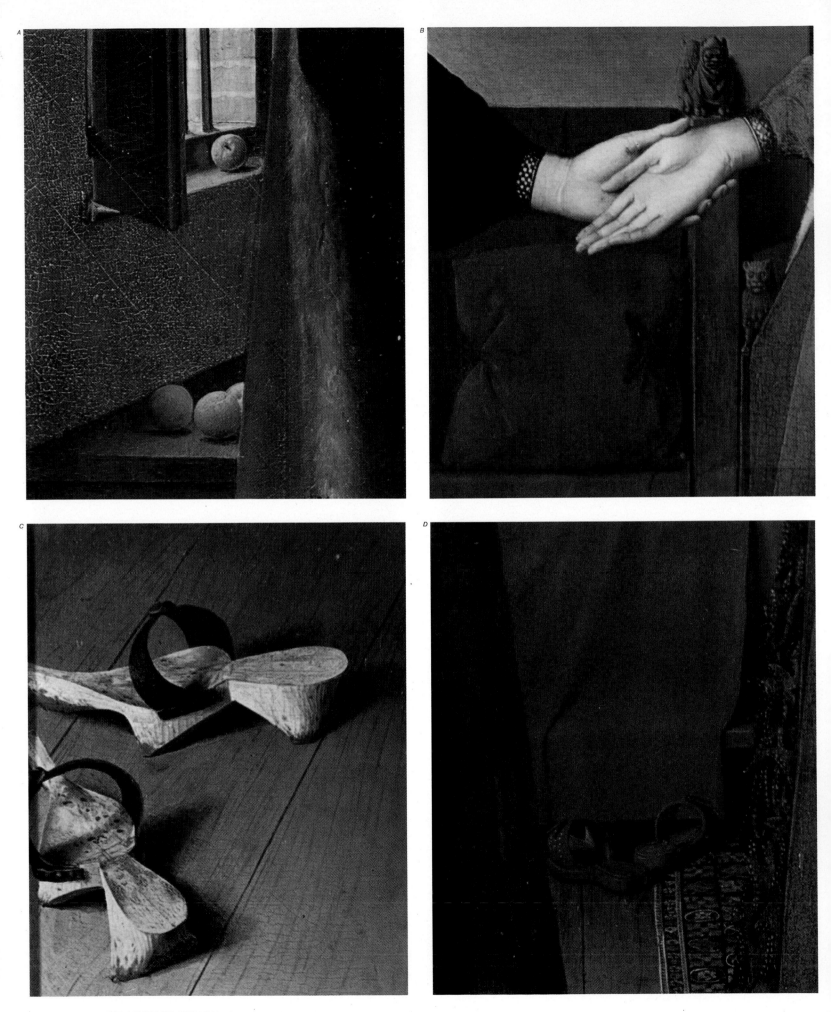

PLATE XLII THE ARNOLFINI WEDDING London, National Gallery
Details (each, actual size)

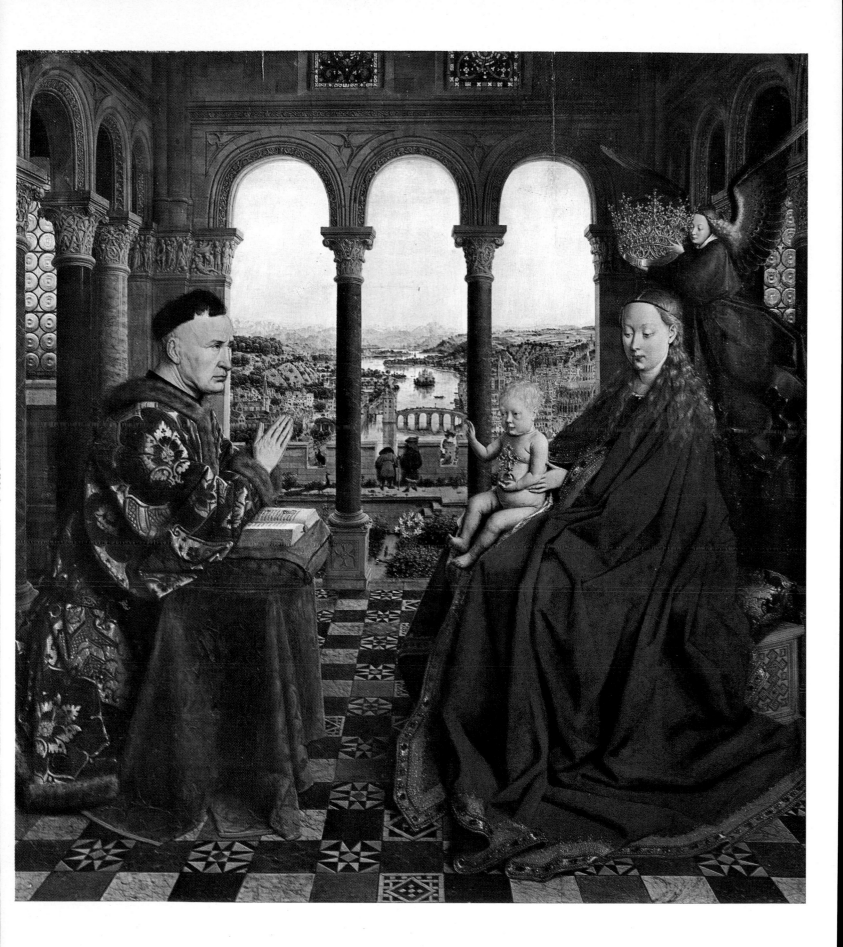

PLATE XLIII THE MADONNA WITH CHANCELLOR ROLIN Paris, Louvre
Whole (62 cm.)

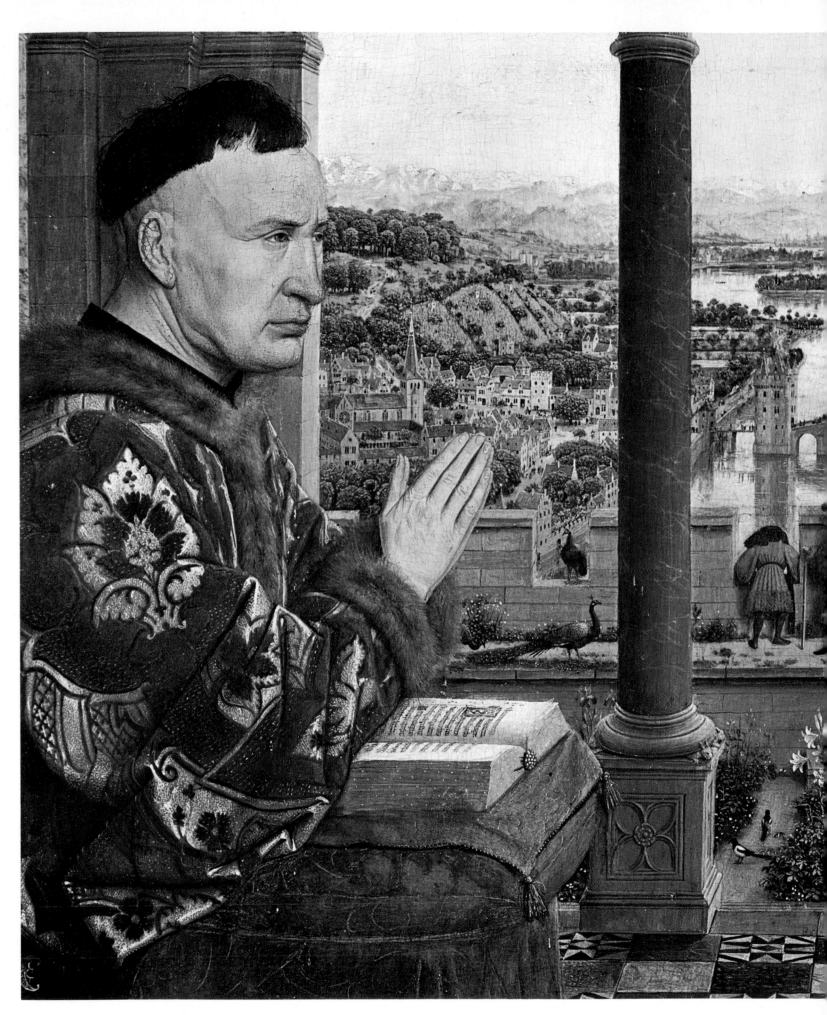

PLATES XLIV-XLV THE MADONNA WITH CHANCELLOR ROLIN Paris, Louvre
Detail (actual size)

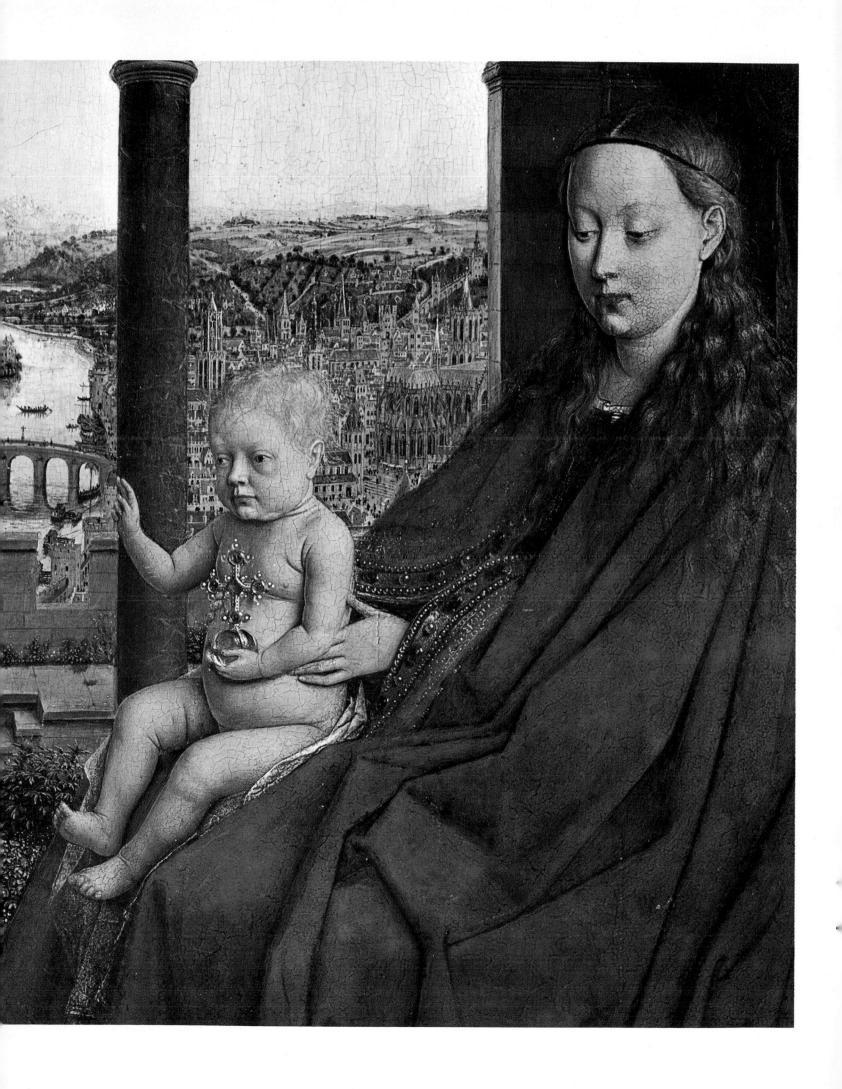

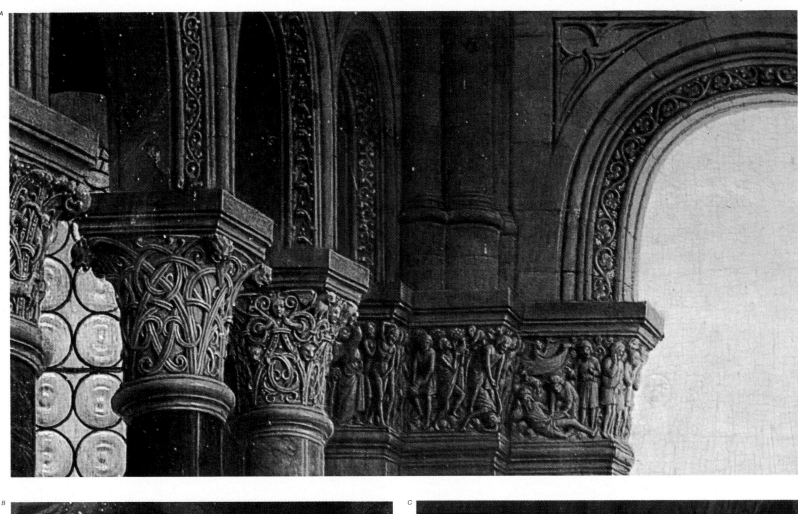

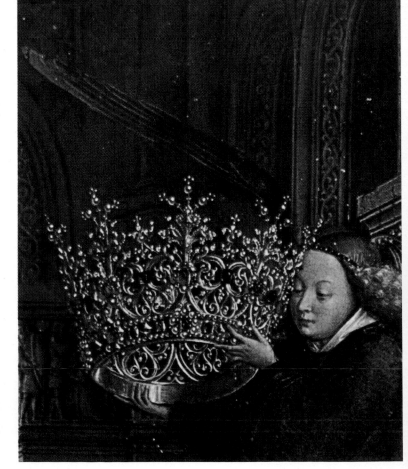

PLATE XLVI THE MADONNA WITH CHANCELLOR ROLIN Paris, Louvre
Details (each, actual size)

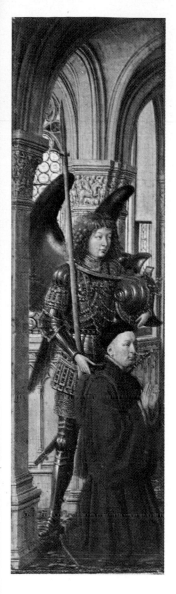
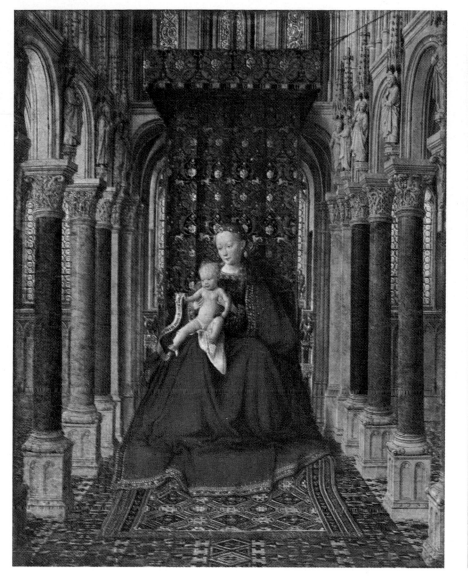
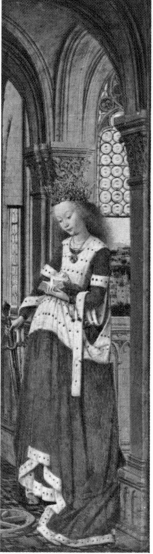

PLATE XLVII THE DRESDEN TRIPTYCH Dresden, Gemäldegalerie
Whole of the open triptych (37.5 cm.)

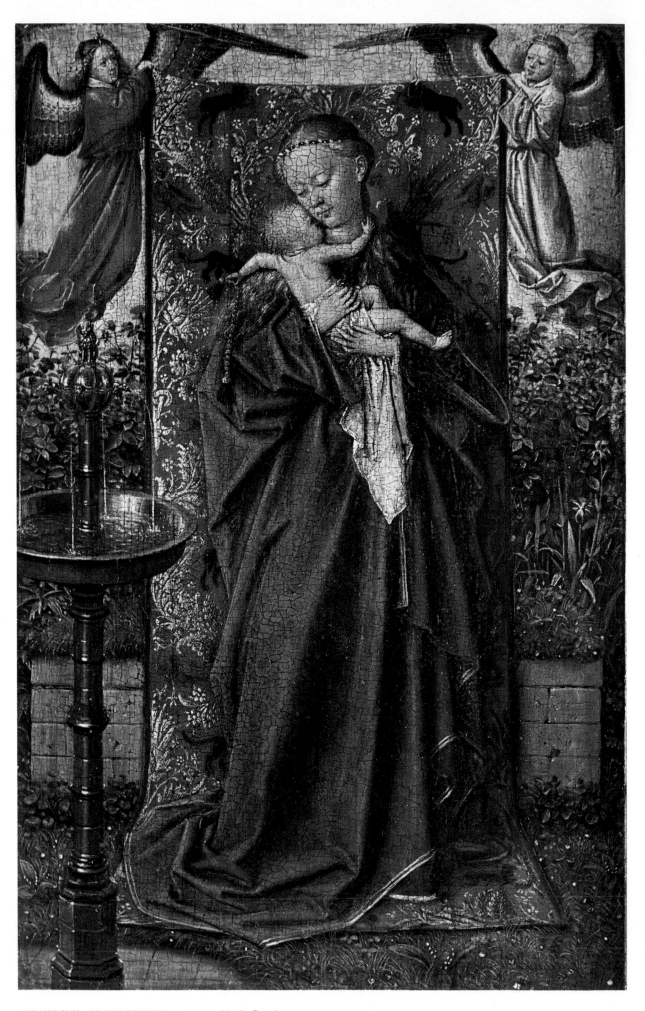

PLATE XLVIII THE MADONNA AT THE FOUNTAIN Antwerp, Musée Royal
Whole (12 cm.; photographed larger than actual size)

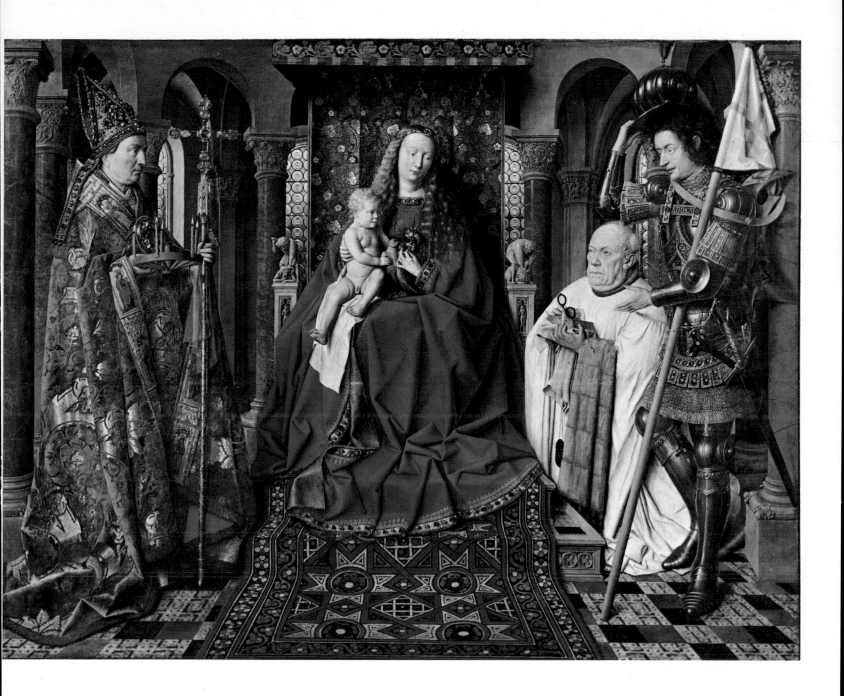

PLATE XLIX THE MADONNA WITH CANON VAN DER PAELE Bruges, Musée Communal des Beaux-Arts
Whole (157 cm.)

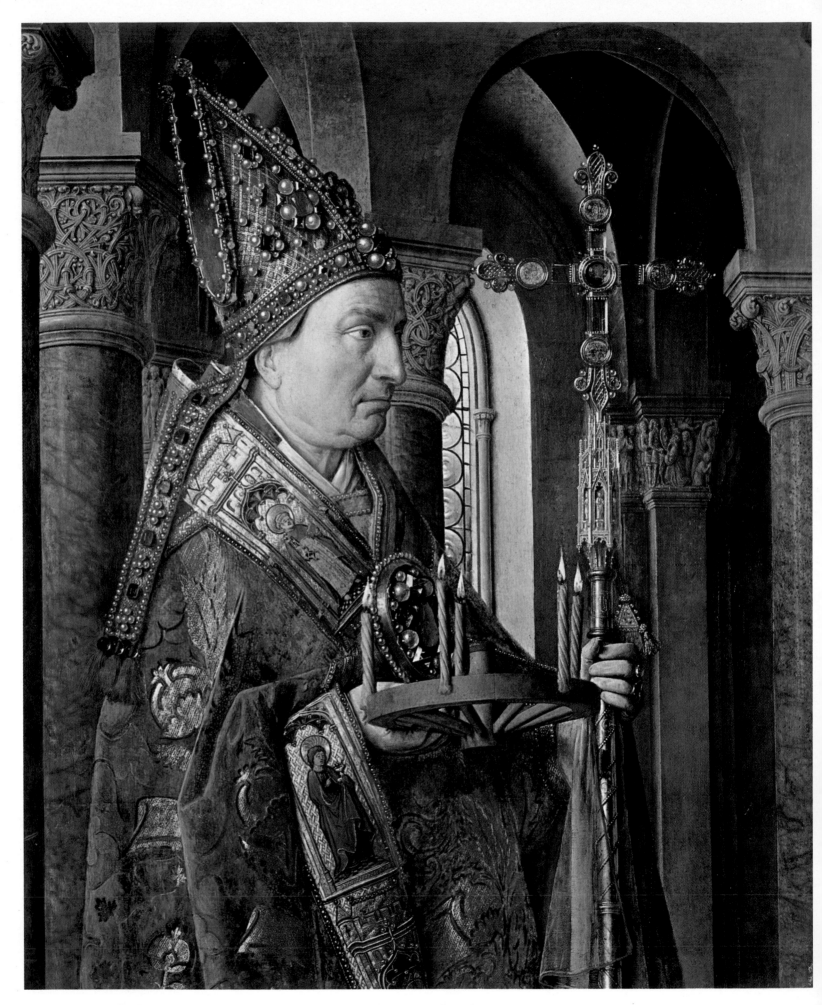

PLATE L THE MADONNA WITH CANON VAN DER PAELE Bruges, Musée Communal des Beaux-Arts
Detail (47 cm.)

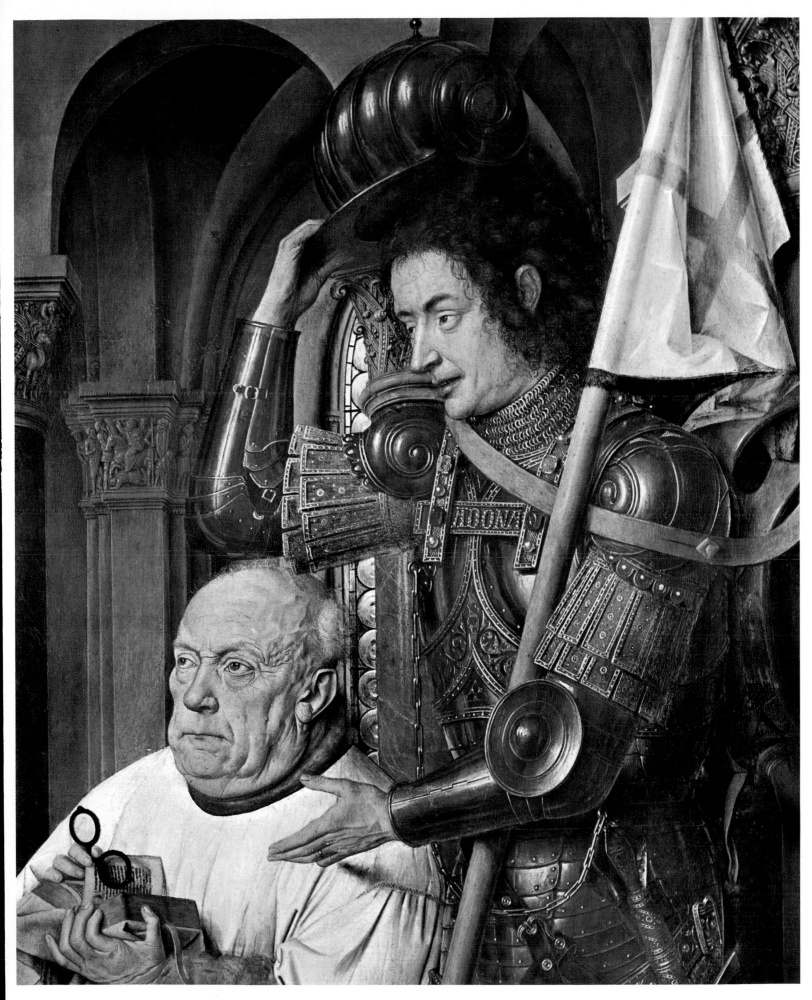

PLATE LI THE MADONNA WITH CANON VAN DER PAELE Bruges, Musée Communal des Beaux-Arts
Detail (47 cm.)

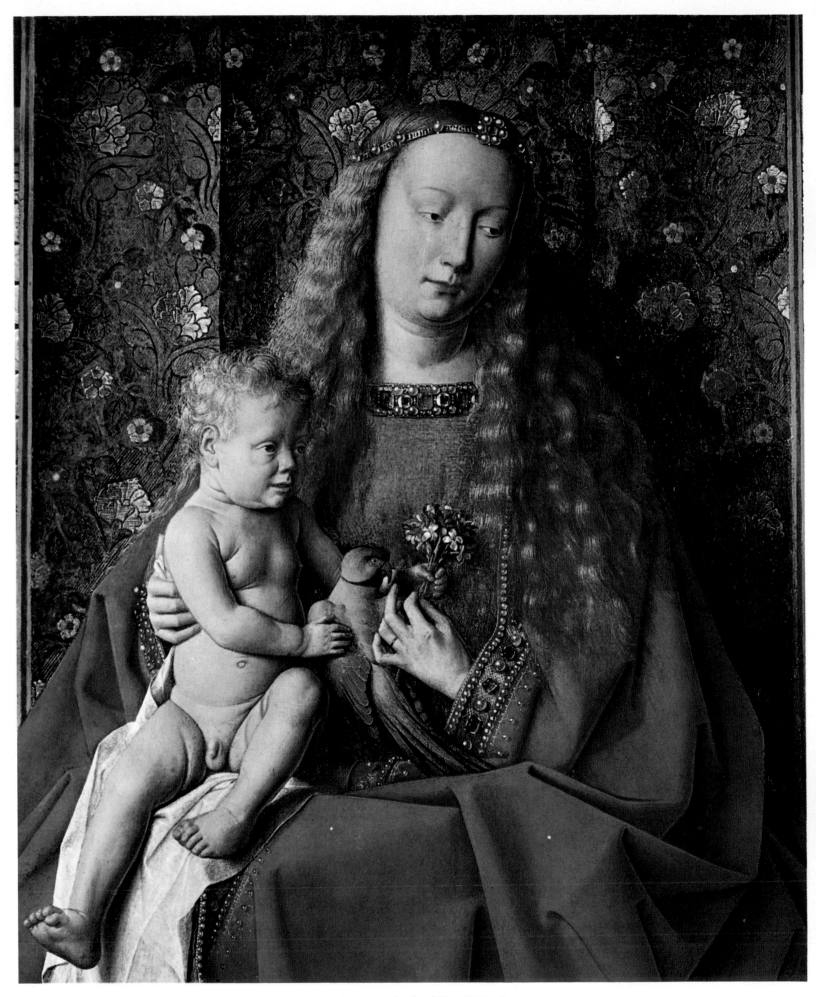

PLATE LII THE MADONNA WITH CANON VAN DER PAELE Bruges, Musée Communal des Beaux-Arts
Detail (39.5 cm.)

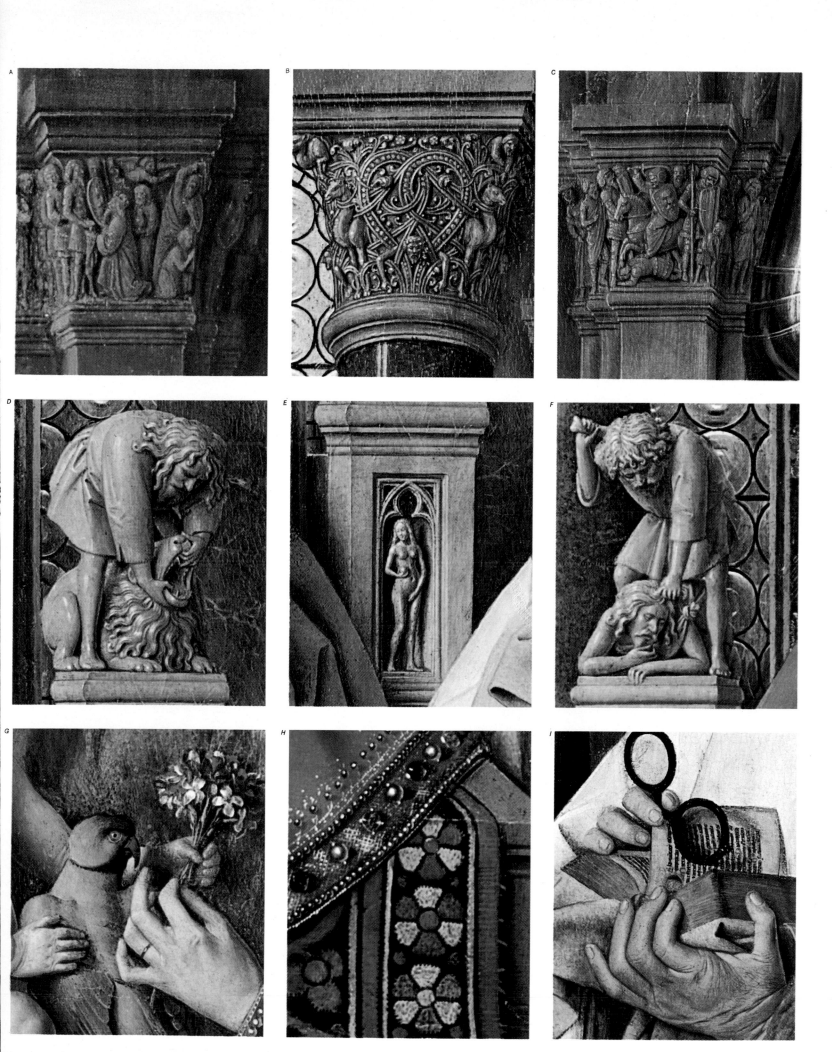

PLATE LIII THE MADONNA WITH CANON VAN DER PAELE Bruges, Musée Communal des Beaux-Arts
Details (each, 7.5 cm.)

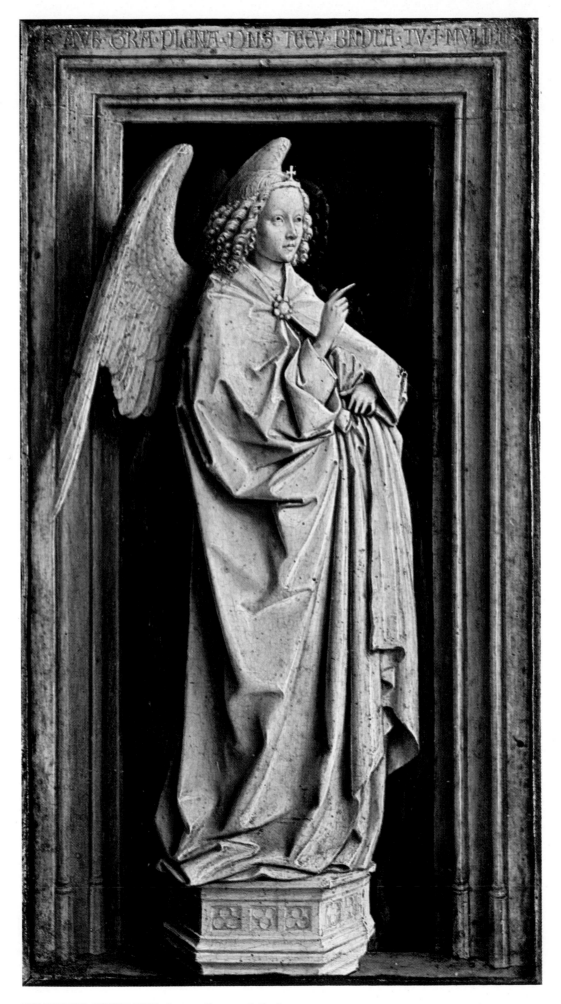

PLATE LIV THE THYSSEN ANNUNCIATION Lugano, Thyssen Collection
The *Angel of the Annunciation* (24 cm.)

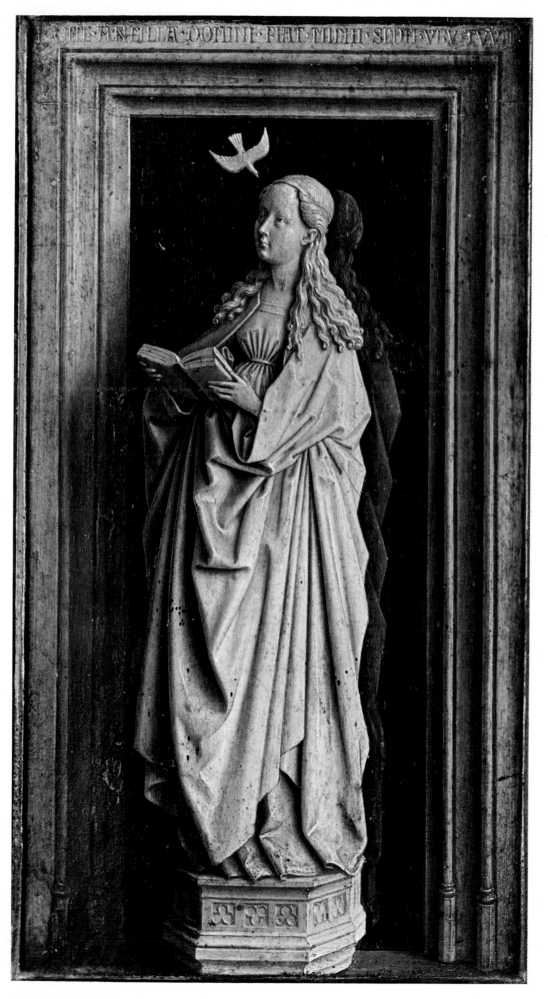

PLATE LV

THE THYSSEN ANNUNCIATION Lugano, Thyssen Collection
The *Angel of the Annunciation* (24 cm.)

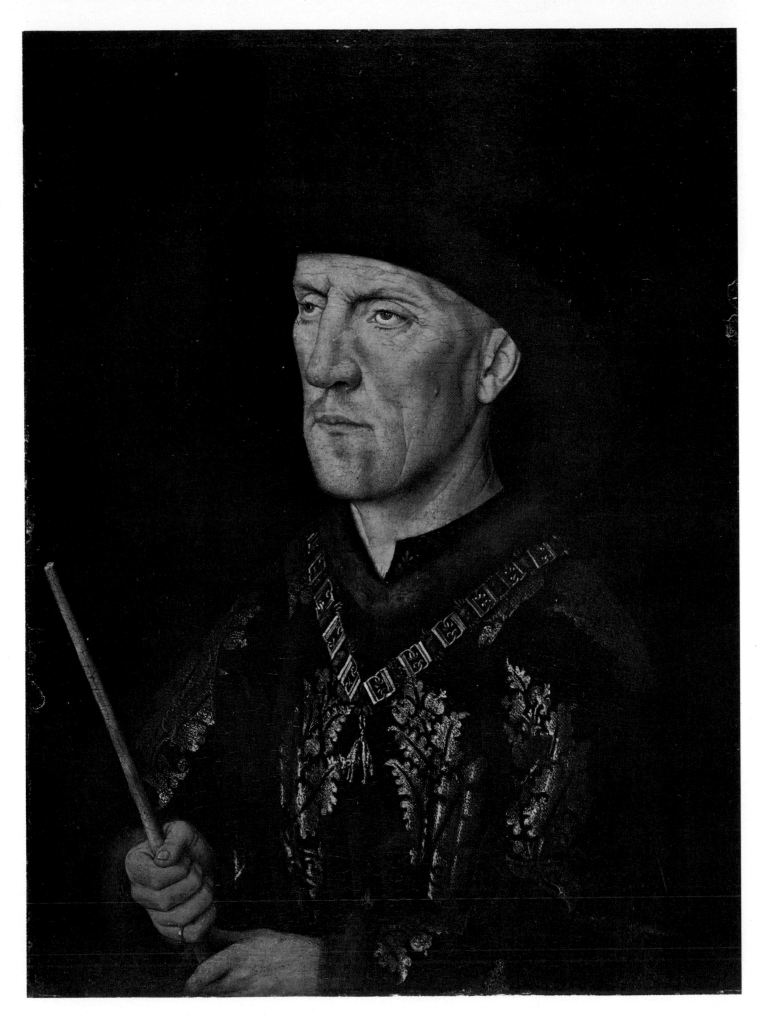

PLATE LVI PORTRAIT OF BAUDOUIN DE LANNOY· Berlin, Staatliche Museen, Gemäldegalerie-Dahlem
Whole (20 cm.)

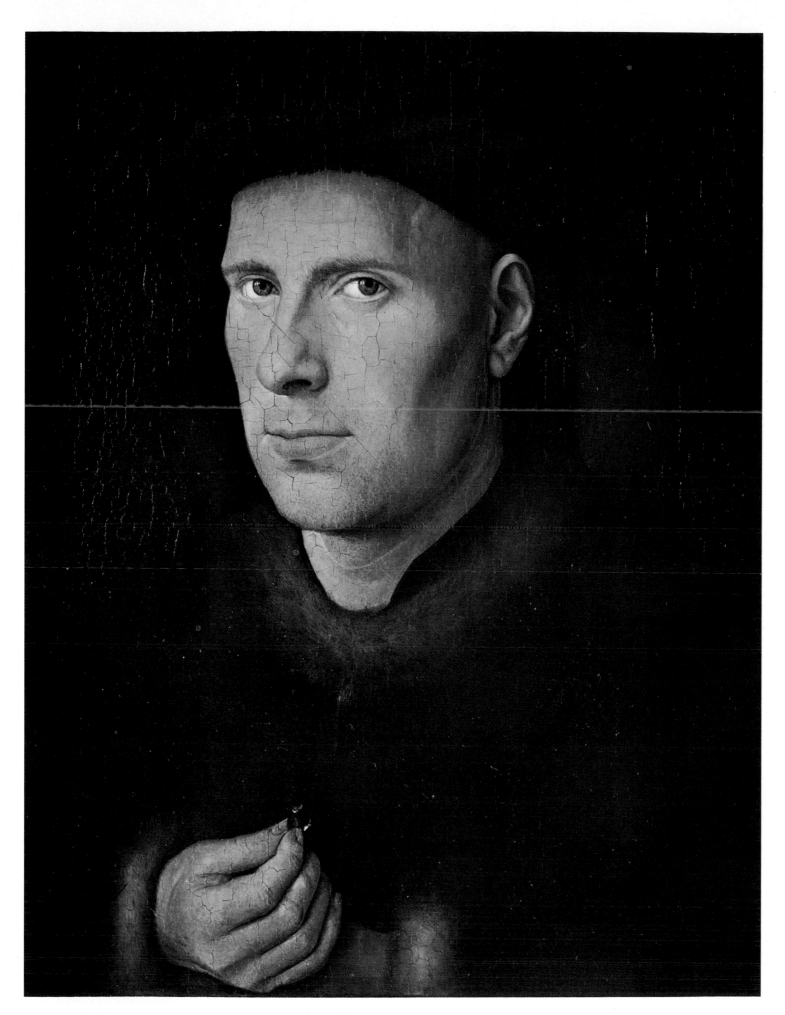

PLATE LVII PORTRAIT OF JAN DE LEEUW Vienna, Kunsthistorisches Museum
Whole (19 cm.)

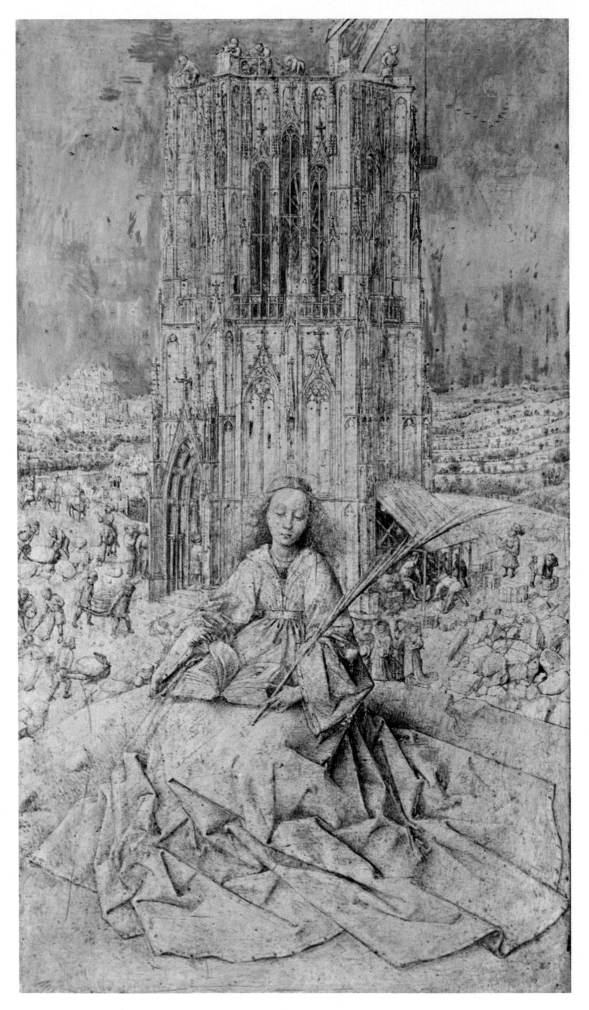

PLATE LVIII ST BARBARA Antwerp, Musée Royal
Whole (18.5 cm.)

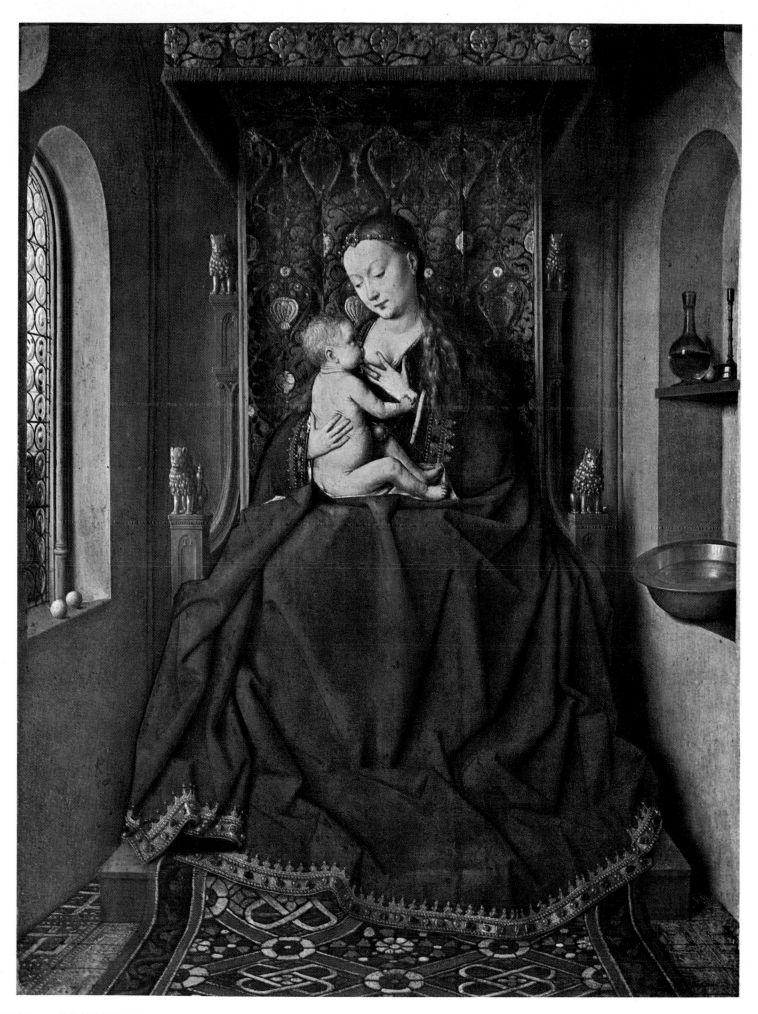

PLATE LIX THE MADONNA IN AN INTERIOR Frankfurt, Städelsches Kunstinstitut
Whole (49.5 cm.)

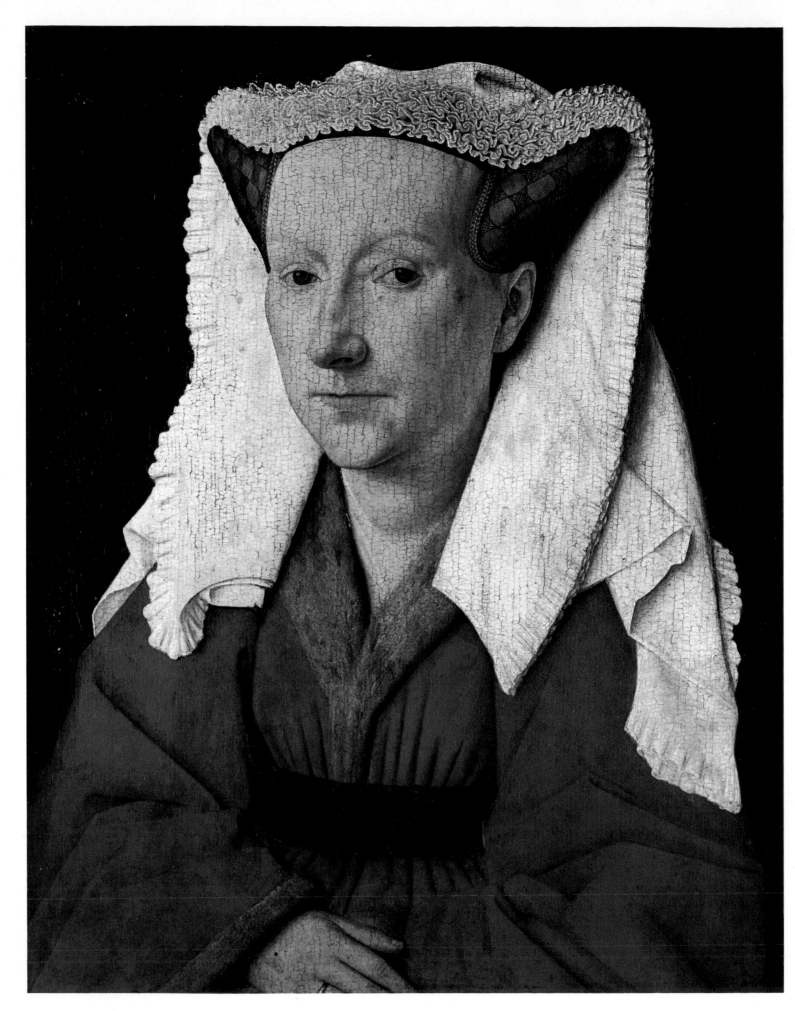

PLATE LX MARGARETHA VAN EYCK Bruges, Musée Communal des Beaux-Arts
Whole (26 cm.)

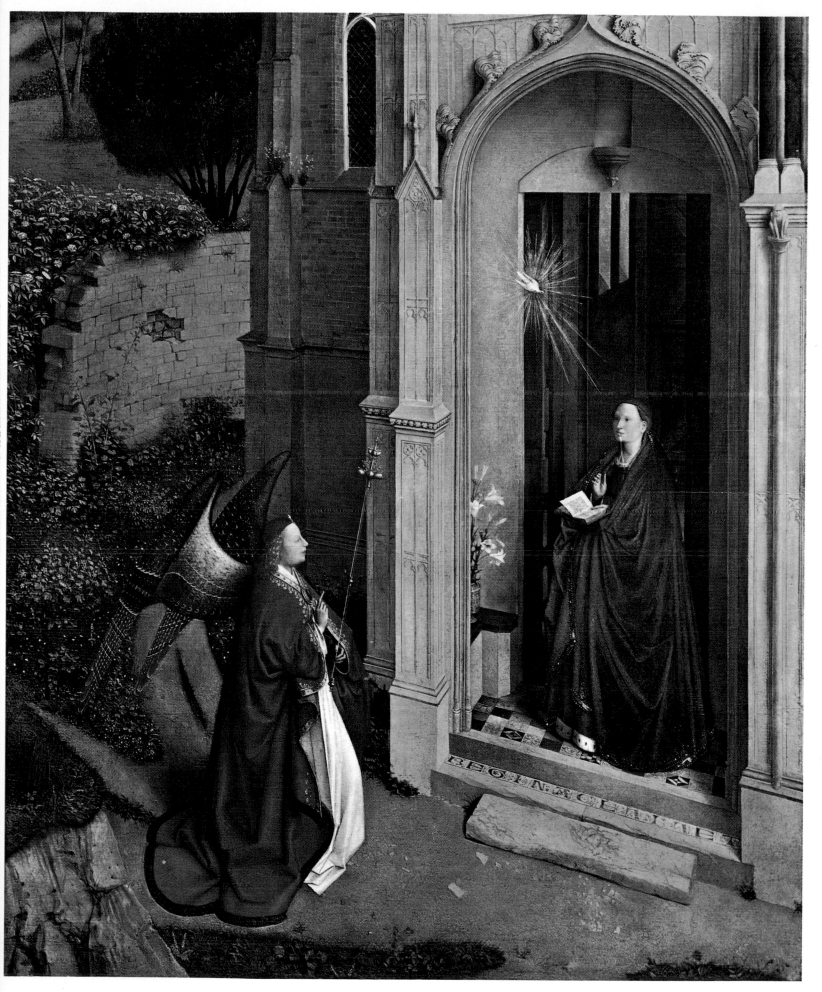

PLATE LXI THE ANNUNCIATION New York, Metropolitan Museum
Whole (66.5 cm.)

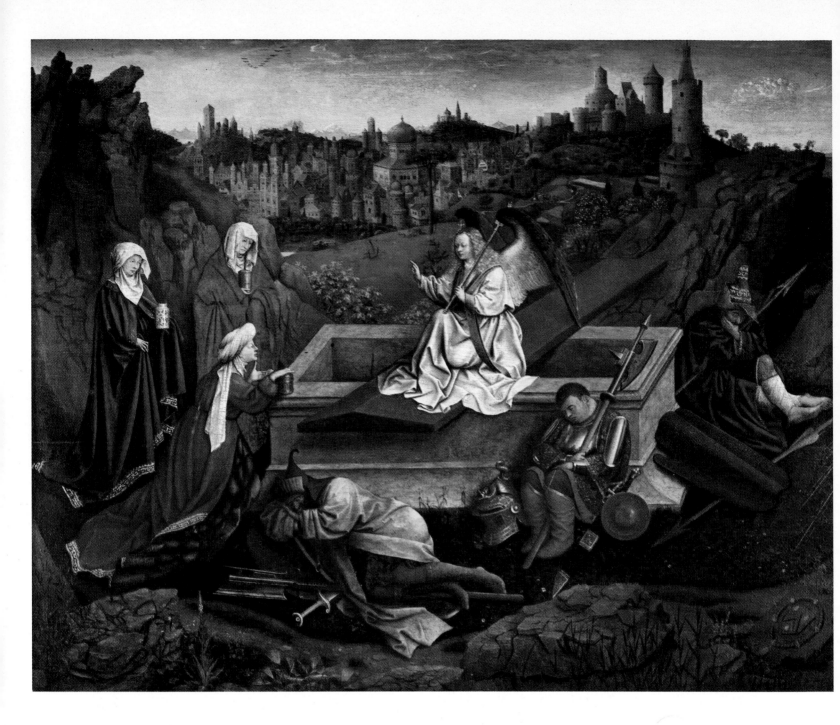

PLATE LXII THE THREE MARYS AT THE SEPULCHRE Rotterdam, Museum Boymans - van Beuningen
Whole (89 cm.)

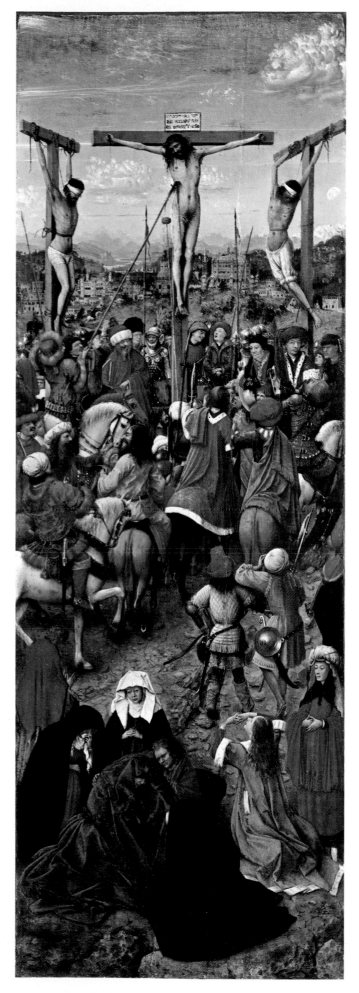
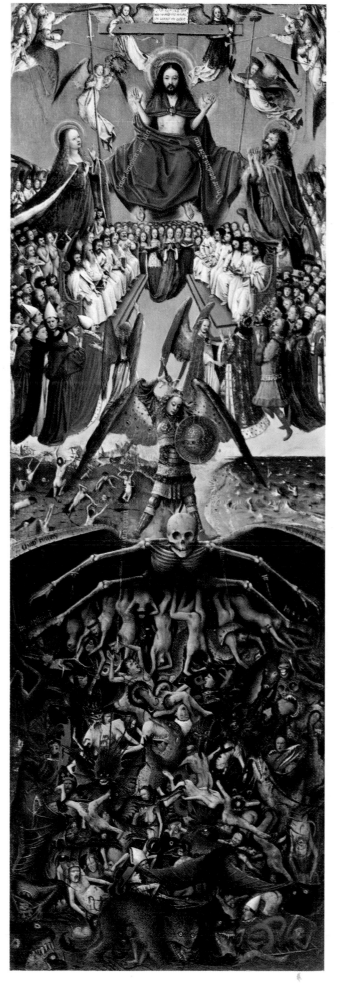

PLATE LXIII THE NEW YORK PANELS New York, Metropolitan Museum
The *Crucifixion* and the *Last Judgment* (each, 19.5 cm.)

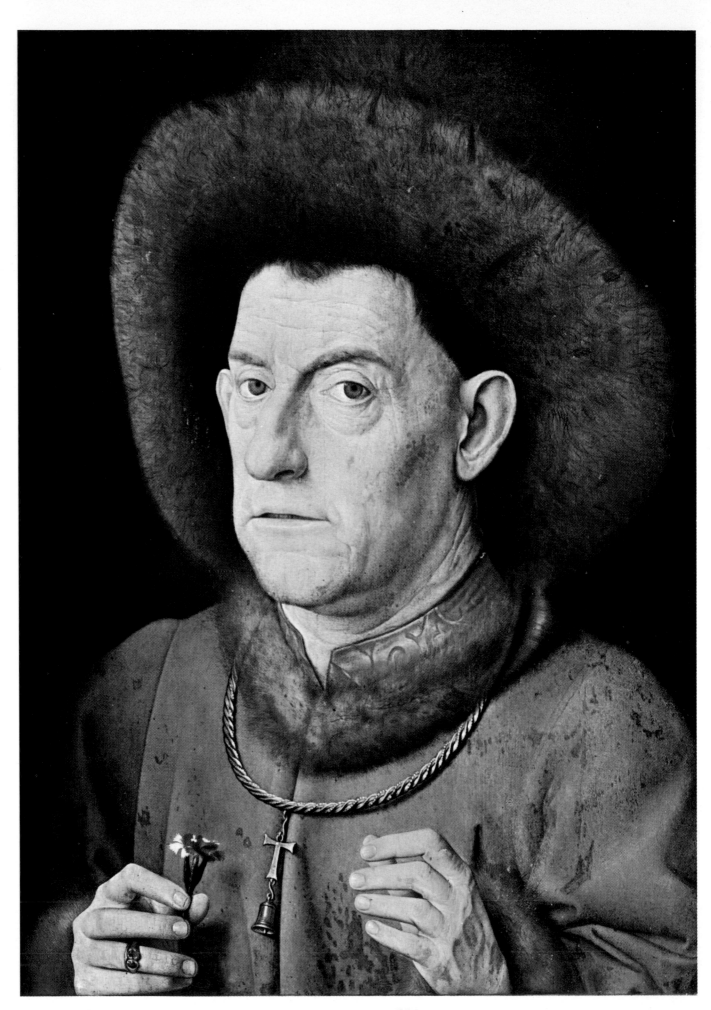

PLATE LXIV THE MAN WITH A PINK Berlin, Staatliche Museen, Gemäldegalerie-Dahlem
Whole (31 cm.)

The Works

Key to symbols used

In order to provide, in readily accessible form, a guide to the basic elements of each work, all items of the Catalogue are preceded by a number (which refers to the chronological position of the work in the painter's activity, and is used throughout this publication for purposes of identification), and by a series of symbols denoting the following:
1 execution of the work, i.e. to what extent it is the artist's own work
2 medium
3 base
4 location
5 other information such as: whether the work is signed or dated; whether it is now complete; whether it was originally finished. The remaining numerals denote respectively the size, in centimetres, of the painting (height x width) and the date. These figures are preceded or followed by an asterisk in all cases in which the information given is approximate only. All such data are based on the general consensus of opinion in the field of modern art history. Outstanding differences of opinion and any further relevant data are discussed in the text.

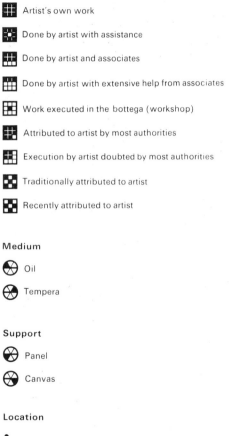

Execution

Artist's own work

Done by artist with assistance

Done by artist and associates

Done by artist with extensive help from associates

Work executed in the bottega (workshop)

Attributed to artist by most authorities

Execution by artist doubted by most authorities

Traditionally attributed to artist

Recently attributed to artist

Medium

Oil

Tempera

Support

Panel

Canvas

Location

Premises open to the public

Private collection

Whereabouts unknown

Work lost

Other data

Work signed

Work dated

Work incomplete or now fragmentary

Work unfinished

Key to these symbols provided in text

Selected Bibliography

For the earliest references C. DE' PIZZICOLLI (ca. 1450), B. FACIO (1454–5), FILARETE (1464), G. SANTI (ca. 1485), H. MÜNZER (1495), J. LEMAIRE DE BELGES (1504), A. DE BEATIS (1517), A. DÜRER (1521), P. SUMMONTE (1524), G. VASARI (*Le vite*, Florence, 1550; 1568, 2nd ed.), L. DE HEERE ("Ode to the Ghent Polyptych," 1559, in *Den hof en boomgaerd der poësien*, Ghent, 1565), M. VAN VAERNEWYCK (*Nieu tractaet ende curte beschryvinghe van dat edel graefscap van Vlaenderen*, Ghent, 1562; *Spieghel der Nederlandsche Audtheydt*, Ghent, 1568; *Van die beroerlike tijden in die Nederlanden*, 1566–8, (ms.), 1569), L. LOMBARD (Letter to Vasari, 27 April, 1565), L. GUICCIARDINI (*Descrittione di tutti i Paesi Bassi*, 1567), K. VAN MANDER (*Het Schilderboeck*, Haarlem, 1604), etc., see W. H. J. WEALE (*Hubert and John van Eyck, Their Life and Work*, London and New York, 1908, with an exhaustive bibliography) and L. SCHEEWE's special treatise (*Hubert und Jan van Eyck, Ihre Literarische Würdigung bis ins 18. Jahrh.*, The Hague, 1933). For more recent bibliography a useful reference book is H. VAN HALL's book (*Repertorium voor de geschiedenis der Nederlandse schilder -en graveerkunst*, The Hague, I, 1936; II, 1949) supplemented by the bibliographical references of the Rijksbureau voor kunsthistorische documentatie in The Hague (*Bibliography of the Netherlands Institute for Art History*, The Hague, I, 1943–5, and ff.; the latest volume to appear is for 1964).

Of monographs written during the Romantic period, mention should be made of J. H. SCHOPENHAUER (*Johann van Eyck und seine Nachfolger*, Frankfurt am Main, 1822) and G. F. WAAGEN (*Über Hubert und Johann van Eyck*, Breslau, 1822);

for a survey of nineteenth-century criticism, see the work of H. W. VON LOHNEYSEN (*Die ältere Niederländische Malerei, Künstler und Kritik*, Eisenach and Kassel, 1956). Among the more important monographs and studies to appear in the last seventy years, worthy of mention are L. KÄMMERER (*Hubert und Jan van Eyck*, Bielefeld, 1898), K. VOLL (*Die Werke des Jan van Eyck. Eine kritische Studie*, Strasbourg, 1900), P. DURRIEU (*Heures de Turin*, Paris, 1902), G. J. KERN (*Die Grundzüge der linear perspektivischen Darstellung in der Kunst der Gebrüder Van Eyck und ihrer Schule*, Leipzig, 1904), M. DVOŘÁK *Das Rätsel der Kunst der Brüder van Eyck, JW* (for this abbreviation and others used in the volume, see below) 1904; printed as a separate volume, Munich, 1925, G. HULIN DE LOO (*Heures de Milan*, Paris–Brussels, 1911);, H. FIERENS-GEVAERT (*Études sur l'art flamand. La Renaissance septentrionale et les premiers maîtres des Flandres*, Brussels, 1905), W. H. J. WEALE (see above), W. H. J. Weale and M. W. BROCKWELL (*The Van Eycks and Their Art*, London 1912), M. CONWAY (*The Van Eycks and Their Followers*, London, 1921), A. SCHMARSOW (*Hubert und Jan van Eyck*, Leipzig, 1924), F. WINKLER (*Die Altniederländische Malerei*, Berlin 1924), M. J. Friedländer (*Die altniederländische Malerei*, I, Berlin 1924 and XIV, Leiden 1937; English trans.: *Early Netherlandish Painting. 1. The Van Eycks – Petrus Christus*, Comments and Notes by N. VERONEE-VERHAEGEN, Leiden and Brussels, 1967), C DE TOLNAY (*Le retable de l'Agneau Mystique des Van Eyck*, Brussels, 1938; *Le Maître de Flémalle et les Frères Van Eyck*, Brussels, 1939), H. BEENKEN (*Hubert und Jan van Eyck*, Munich, 1941), L. BALDASS (*Jan van Eyck*, London, 1952), P. (*Jan van Eyck*, London, 1952), P.

COREMANS (*L'Agneau Mystique au Laboratoire*, Antwerp, 1953), E. PANOFSKY (*Early Netherlandish Painting. Its Origins and Character*, Cambridge, Mass., 1953), V. DENIS (*Tutta la pittura di Jan van Eyck*, Milan, 1954), M. DAVIES (Early Netherlandish School, National Gallery Catalogue, London, 1955), J. BRUYN (*Van Eyck-problemen*, Utrecht, 1957, *Le Siècle des Primitifs Flamands* (Catalogue of the exhibition at Bruges, 1960), G. FAGGIN (*Van Eyck*, Milan, 1961). O. KURZ ('Hubert and Jan van Eyck', *Encyclopedia of World Art*, V, 1961), S. THALHEIMER (*Der Gentner Altar*, Munich, 1967), M. WHINNEY (*Early Flemish Painting*, London, 1968).

References in the text to Weale, Tolnay, Baldass and Panofsky are to the books mentioned above, unless a different reference is given.

The references to Held and Pächt are, unless otherwise stated, to their two important reviews of Panofsky's *Early Netherlandish Painting*; Held in *Art Bulletin* 1955, pp. 205 ff; Pacht in *The Burlington Magazine*, 1956, pp. 267–79.

Among more recent books are: L. B. PHILIP (*The Ghent Altarpiece and the Art of Jan van Eyck*, Princeton 1971), J. LEJEUNE (*Jean et Marguerite van Eyck et le roman des Arnolfini*, Liège 1972), H. ROOSEN-RUNGE (*Die Rolin-Madonna des Jan van Eyck. Form und Inhalt*, Wiesbaden 1972), E. DHANENS (*Van Eyck: The Ghent Altarpiece*, London 1973; *Hubert and Jan van Eyck*, New York [1980], with bibliography; *De iconografie der Van Eycks*, Bruges 1982); C. J. PURTLE (*The Marian Paintings of Jan van Eyck*, Princeton 1982).

List of abbreviations

A : L'arte
AB : The Art Bulletin
ABB : Amtliche berichte aus den Berliner Museen
ADG : Album discipulorum J. G. van Gelder (1963)
AHAH : Acta historiae artium Academiae scientiarum Hungaricae
AMB : Annuaire des Musées Royaux des Beaux-Arts de Belgique
AP : Apollo
AQ : The Art Quarterly
ARQ : Artworkers' Quarterly
ASA : Archivio storico dell'arte
ASEB : Annales de la Société d'émulation de Bruges
ASPPH : Annuaire de la Société pour le progrès des études philosophiques et historiques
B : Belvedere
BDI : The Bulletin of the Detroit Institute of Arts
BICR : Bollettino dell' Instituto centrale del restauro (Roma)
BM : The Burlington Magazine
BMRB : Bulletin des Musées

Royaux des Beaux-Arts de Belgique
BRI : The Bulletin of the Rhode Island School of Design
C : The Connoisseur
CB : Cahiers de Bordeaux. Journées internationales d'études d'art (1954)
CdA : Chronique des Arts
DG : Dresdner Galerieblättner
DM : Das Münster
FF : Festschrift für M. J. Friedländer (1921)
GBA : Gazette des Beaux-Arts
JP : Jahrbuch der preussischen Kunstsammlungen
JSK : Jahrbuch Staatliche Kunstsammlungen (Dresden)
JW : Jahrbuch der kunsthistorischen Sammlungen des allerhochsten Kaiserhauses (Vienna)
JWCI : Journal of the Warburg and the Courtauld Institutes
K : Kunstblatt
KW : Kunstwanderer
LS : Le Soir (Brussels)
MHL : Mélanges Hulin de Loo (1931)

NKJ : Nederlandsch Kunsthistorisch Jaarboek
OH : Oud Holland
P : Pantheon
PM : La Presse médicale (Brussels)
RBAH : Revue belge d'Archéologie et d'Histoire de l'art
RBPH : Revue belge de Philologie et d'Histoire
RdA : La Revue des Arts
RdE : Revue d'Esthétique
RfK : Repertorium für Kunstwissenschaft
SA : SeleArte
SBdCG : Studies on Art and Literature for Bella da Costa Green (1954)
VC : Veu de Catalunya (Barcelona)
VVAB : Verhandelingen van de Koninklijke Vlaamsche Academie voor Wetenschap, Letteren en Schoone Kunsten van België
W : Die Weltkunst
WRJ : Wallraf-Richartz Jahrbuch
ZK : Zeitschrift für Kunstgeschichte

Outline Biography

c. 1390 Although Jan van Eyck's date of birth is unknown, and despite the total absence of any information that could provide even an approximate date, many scholars believe that it is not an unreasonable hypothesis to consider the period around 1390 as that in which the artist was most probably born. But it is with some certainty that Jan's place of birth can be identified as Limbourg, the area of the eastern Low Countries which was a veritable cradle of art in the Middle Ages. (Suffice to mention the famous miniaturists, the brothers Limbourg.) In the preparatory drawing for the portrait of Cardinal Albergati, (see Catalogue 11), Jan wrote his notes concerning the colors to be used in the Low German patois of his homeland rather than in the "literary" Netherlandish of Flanders, in which he had already been living for some time. The tradition according to which he was born in the Limbourg city of Maeseyck seems to date from the sixteenth century (Lucas de Heere, 1559) and can be considered an easy inference from the artist's surname and nothing more. The fact that the artist's daughter Livinia entered a convent in Maeseyck in 1450 cannot be considered proof that the painter was born in that city. It is most likely that Jan was born in Maastricht. In fact, Duverger (*CH*, 1932; *Handelingen van hetze congres voor algemene kunstgeschiedenis*, Ghent, 1936) found a document of 1435–6 among the accounts of Philip the Good in which the artist is referred to as "Johannes van Tricht (i.e., of Maastricht)"; and Lyna (*Les peintres van Eyck et l'École de Maastricht*, Brussels, 1926) states that he found in archives concerning Maastricht traces of some thirty people named "Van Eyck" who lived before the year 1400. There is considerable literature on the question on the Van Eycks' provenance; notable works are by Jean Lejeune *Les Van Eyck, peintres de Liège et de sa cathédrale*, Liège, 1955, and Joseph Philippe, *Van Eyck et la Genèse Mosane de la*

peinture des anciens Pays-Bas (Liège, 1960)

As for Hubert van Eyck, Jan's brother and presumably older than Jan, nothing is known of his birth or of most of his life. Nevertheless, the few biographical details brought to light by scholars are referred to below.

1417, 31 May William VI, Count of Holland, Zeeland and Hainaut, died. Since one of the miniatures in *The Turin Hours* attributed to Jan (see p. 85) seems to depict William VI on horseback, it has been thought that Van Eyck was at The Hague in the duke's service about 1415–7. That would have been the period in which Jan executed the miniature in question, which does contain some archaic elements (the dogs and the old man in the foreground), and in which he painted *The Kiss of Judas*, likewise "primitive" in certain respects. Hubert van Eyck may have been in The Hague, too, about 1415–7, if two other miniatures in *The Turin Hours*, *Virgo inter virgines* and *The Finding of the True Cross* are by him. Weale, too (1908), thought that Hubert had been in The Hague and that he left, at the latest, on the death of William VI (1417) when many artisans went to Flanders, where they could enjoy greater security. Although some critics are reluctant to accept such an early date for the miniatures mentioned above, the discovery of an important drawing tinted with watercolor depicting a *Fishing Party at the Court of William VI* (O. Kurz, *OH*, 1956) and containing a portrait of the count adds weight to the pre-1417 argument.

1422–4 The first certain evidence of Jan's activity. He was working during these years at The Hague, at the court of John of Bavaria, Count of Holland and brother of William VI. This has been deduced from three documents which indicate that the artist was employed in the decoration of the count's palace from 24 October 1422 until 11 September 1424 (Weale, 1908). One of the documents

indicates that two of Jan's assistants were paid along with him. Count John, called the Pitiless, had a rather adventurous career. He was elected Prince-bishop of Liège in 1390, although he was not an ecclesiastic. After the death of his older brother, William VI (1417), he made war on William's daughter and legitimate heir, Jacqueline of Bavaria, and managed to install himself in The Hague in 1419. On John's death (5 January 1425), civil war broke out, and this was certainly the cause that drove Jan to leave Holland and seek refuge in Flanders, where Hubert had already moved.

1425 On 19 May Jan van Eyck was in Bruges. On that date Philip III, Duke of Burgundy (called The Good), took Jan into his service as painter and *valet de chambre* with all the *honneurs, prérogatives, franchises, droits, prouffis et émoluments* proper to the appointment. It is known from documents that Philip had already heard the artist's talents praised and that he personally had had occasion to appreciate Jan's genius. What was the exact nature of the concessions of Jan's post cannot be indicated, but they probably concerned board and lodging at court, exemption from taxes, the right of keeping a servant in livery as well as a horse, etc., (Weale, 1908). As court painter Jan received a fixed salary (100 *livres parisis* per year). Thus the duke assured himself absolute priority in the artist's production.

Shortly before 2 August Jan moved from Bruges to Lille, where he settled.

1426 By 14 July, Jan van Eyck had taken part in a pilgrimage on behalf of the duke.

The death of Hubert is confirmed by a document preserved in the communal archives in Ghent concerning the taxes on his property that had to be paid by his heirs (Weale, 1908).

In August, Jan was sent by the duke on a secret mission. (The relevant document mentions a *certain loingtain*

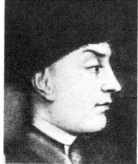

(Above) Presumed portraits of Jan van Eyck in painting 9 P (fourth figure from bottom) and in 36 (figure in second row towards the left).

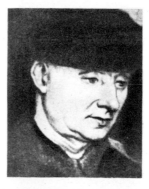

(Left) Another possible portrait of Jan, also in 36 (extreme left, foreground).

(Below) Possible portraits of Hubert van Eyck, in 9 P (figure in foreground) and in 36 (front row, left).

voiage secret.) On his return, Jan's expenses were reimbursed (27 October).

1427, 18 October He was sent on a second secret mission to Tournai, where he was offered wine as a sign of honor. Since 18 October is the feast of St Luke, patron saint of painters, Jan certainly witnessed the celebration of the local guild and had occasion to meet Robert Campin, Roger de la Pasture (who came to be known later as Rogier van der Weyden), and Jacques Daret

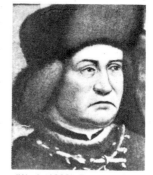

(Weale, 1908). The meeting with Campin (the painter who has been identified as the Master of Flémalle), who was certainly older than Jan and was a master in Tournai by 1406, must have been stimulating for the younger artist (Tolnay, 1939; Baldass, 1952). Jan returned from this mission in February 1428.

1428, 19 October The third mission for Duke Philip. In the autumn of 1428 Philip had decided to send an embassy to the King of Portugal, John I, to

seek the hand of his daughter Isabella. The envoys left from Sluis (the port near Bruges) on 19 October, and Jan was among them.

1429, 13 January The meeting with the King of Portugal took place at Aviz. Jan painted a portrait of the princess. As soon as this was completed, the ambassadors of Philip sent messengers to their lord. Two were sent by sea and two by land, each pair bearing a portrait of Isabella and an account of the dealings under way. While awaiting the duke's reply, the "Burgundian" gentlemen made a pilgrimage to Santiago de Compostela. Then they went to the province of Valladolid, where they visited John II, King of Castile. The Duke of Arjona, Mohammed, King of Granada, and other nobles received the homage of the envoys of the powerful Duke of Burgundy, who crossed Andalusia and returned to Lisbon at the end of May. When the marriage contract was finally drawn up, the "Burgundians" and a great number of Portuguese (a total of two thousand people) embarked on 8 October in fourteen large vessels that headed for Flanders. The Infanta arrived at Sluis on 25 December, and the wedding took place with extraordinary splendor on 7 January 1430. All Europe talked of the marvelous festivities that marked the occasion. We do not

entrust him with certain undertakings. Subsequently Jan returned to Bruges.

1431, 8–11 December Cardinal Nicola Albergati, whom the Pope had sent with the aim of fostering a general peace in the north, stayed at the charterhouse of Bruges. It may have been during this stay that Jan drew his portrait (*Catalogue* 11).

In March of the same year a document had been prepared concerning Hubert van Eyck (see p. 86).

1432 Jan bought a house in Bruges, where between 17 July and 16 August, he received the visit of the burgomaster and other civic authorities.

On 6 May, the polyptych of *The Adoration of the Lamb* was set up in the Church of St John (now Cathedral of St Bavon), Ghent. This is confirmed by the quatrain painted on the lower frame of the exterior panels of the altarpiece (*Catalogue,* 9, and *The Question of Hubert,* p. 86).

On 10 October Jan signed and dated his *Portrait of a Young Man (Timotheos)* now in London (*Catalogue,* 12). This is his earliest signed work.

1433 Jan painted the *Ince Hall Madonna,* now in Melbourne (*Catalogue,* 14). Shortly before 19 February, Duke Philip visited Jan's studio in Bruges. On 21 October Jan signed and dated *The Man with the*

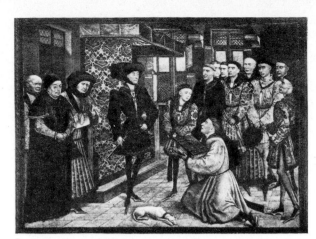

Miniature from the Chronique de Hainaut *(Brussels, Bibliothèque Royale), the design of which is attributed to Rogier van der Weyden. Philip the Good, Duke of Burgundy, is depicted with dignitaries of his court (to Philip's left is Chancellor Rolin, see* Catalogue 16*) as he receives the* Hainaut Codex. *This illustration may give some idea of the milieu in which Jan van Eyck spent a long period of his career.*

represented by Pierre de Beaufremont, Lord of Chargny. On this occasion the duke gave Jan six silver cups, which he had commissioned from the goldsmith Jean Peutin of Bruges.

On 10 October Jan signed and dated the double portrait of Giovanni Arnolfini and his wife in their wedding chamber (*Catalogue,* 15).

1435 Jan's salary was increased from 100 to 360 *livres,* but the Lille treasury

pour certains grans ouvraiges, en quoy l'entendons occuper cy après et que nous trouverions point le pareil à nostre gré ni si excellent en son art et science …

Jan undertook to color in polychrome several sculptures together with their tabernacles. These were six of the eight statues of counts and countesses of Flanders which the Bruges municipal authorities had commissioned in 1434 from the sculptors Jacob van Oost,

1436 Jan completed *The Madonna with Canon van der Paele (Catalogue,* 21) and painted his *Portrait of the Goldsmith Jan de Leeuw* (22).

The duke sent Jan on a secret mission to a "distant" place, not identified in the documents.

In November René of Anjou was taken prisoner by Duke Philip and was held in Lille until 11 February 1437. It was probably during this period that Jan was allowed to visit the prisoner and probably instructed him in the technique of oil painting.

1437 Jan put his name and the date on the frame of the Dresden Triptych (*Catalogue,* 25). He also signed and dated the Antwerp *St Barbara* (26).

1438, 31 January He may have signed and dated a lost *Christ, King of Kings* (see *Catalogue,* 30) if the existing version is not a forgery.

1439 He signed and dated *The Madonna at the Fountain,* now in Antwerp (*Catalogue,* 39), but it may have been painted several years earlier. He also painted his *Portrait of Margaretha van Eyck* (28), now in Bruges, which he completed on 17 June. In this year the duke reimbursed Jan for money he had paid to a Bruges miniaturist who had done work for the duke.

1440, 30 January He probably signed and dated a second *Christ, King of Kings,* which is also now lost (see *Catalogue,* 30).

1441, 9 July Jan died in Bruges and was buried "within the precinct" of the Church of St Donatian. On 21 March of the following year Lambert van Eyck, the brother of the deceased, requested the church chapter to exhume Jan's body and bury it within the church itself, next to the baptismal font. Lambert's request was granted, *salvo iure anniversari et fabrice.* The tomb inscription has been passed on by Van Vaernewyck (1568).

Jan left important works unfinished at his death: the large panel for Nicolaes van Maelbeke, provost of St Martin-à-Ieper (*Catalogue,* 31), and a painting for the Carthusian Jan Vos, which was later completed by Petrus Christus (*Catalogue,* 32), and perhaps also the picture of St Jerome (*Catalogue,* 33). For information concerning the request for transferring the painter's remains, see p. 86.

Signatures, dates and similar writings that appear in Jan van Eyck's works, generally (except where indicated) on the original frames of the pictures. (Left, from above) Inscriptions from works described in

the Catalogue 15 *(the inscription is in the painting itself), and* 12. *(Right, from above) Inscriptions from works* 13, 26, 28 *and* 29.

know whether Jan did any painting other than the portrait of Isabella (lost) while he was in Spain and Portugal. It is possible that he painted the original of *The Fountain of Life* (36).

1430 Jan seems to have been residing in Bruges. Duke Philip called him to Hesdin to

Red Turban, now in London (*Catalogue,* 13).

1434 Jan had married and his first son was born. All that we know of his wife, of whom he painted a portrait in 1439, is her baptismal name, Margaretha. Duke Philip was the boy's godfather. At the child's baptism the duke was

refused to pay the painter. He threatened to leave Philip's service, and the duke sent a reproving letter (2 March) from Dijon to his accountants in Lille. He wrote that if Jan were not paid his salary, *le conviendra, à cette cause, laisser nostre service, en quoy prendrions très grant desplaisir, car nous le voulons entretenir*

Geeraert Mettertee, and Jacob van Cutseghem for the façade of the Stadhuis (the communal palace) of that city. (The remaining statues were entrusted to the painters Willem van Tonghere and Jan van den Driessche for coloring.) Weale (1908) supposes that Jan also provided the design for the eight sculptures.

Catalogue of works

An exposition of the development of early Flemish painting and, in particular, an analysis of how the artistic climate of the early fifteenth century in the Netherlands gave birth to a Jan van Eyck, would be very long and very detailed. Only the slightest sketch can be given here. For full studies of the subject, the reader should look at Max Friedländer's *Early Flemish Painting* (shorter version, London, 1956), in three volumes, translated from the original German, Leyden 1967; and Erwin Panofsky's equally important work *Early Netherlandish Painting, its Origins and Character*, Cambridge (Mass.) 1953. Dr Margaret Whinney has also written a concise book *Early Flemish Painting*, London, 1968.

There he will find discussed the all-important question of the understanding of space and perspective by the Franco-Flemish painters of c. 1390–1410. It was the change of interest from the two-dimensional world of insubstantial figures set against flat backgrounds to the three dimensions and solidity of the real world that was the essential characteristic and achievement of Robert Campin (or the Master of Flémalle), and of Hubert and Jan van Eyck. Before them, we can see the struggle to render this new vision in the works, above all, of the miniature-painters who worked for the dukes of Berry and the house of Burgundy. Not a great deal of panel-painting has survived, the interesting work of Melchior Broederlarn being a partial exception. Dvořák first pointed out the great importance of understanding this earlier art and Hulin de Loo's work on the Turin-Milan Hours has since led to much intense study of miniature painting as the theater of the development of painting in France and the Netherlands. Jacquemart de Hesdin (*Très Belles Heures,* Ms. 11060–61, Bibliothèque Royale, Brussels), the Master of the Hours of the Maréchal Boucicant (Musée Jacquemart-André, Paris), the Limbourg Brothers (especially *Très Riches Heures du Duc de Berry,* Musée Condé, Chantilly) are only the most famous names among many remarkable miniature-painters. The books of hours cited all contain examples, often very beautiful, of determined attempts to show the perspective of interiors (churches, bedrooms, halls), the convincing placing of figures within interiors, the life of the fields and the peasants, with the vegetation and land-scape, in as natural and as realistic a manner as possible. As has often been pointed out, we can see in many of these miniatures the "filtering through" of the achievements made in Italy by Giotto, and by such Sienese followers as Orcagna.

From the miniaturists we must turn to the very interesting painter who is known as the Master of Flémalle (or Mérode), or more commonly nowadays as Robert Campin (on his identity see the above-mentioned works). The paintings ascribed to him are full of the excitement of bold and new achievement. We can watch the painter, in different works, setting himself the task of representing the real world with its real inhabitants – and these problems are, in the end, almost surmounted (only Jan van Eyck could, however, thoroughly solve them). The greatest attraction that Campin has for us today is perhaps his rendering of intimate and everyday life: his charming *Madonna of the Firescreen* (National Gallery, London) and *The Mérode Altarpiece* (New York) are famous examples. In them, the painter grapples with the problem of the perspective of the interior, and he places the holy scenes within an ordinary Flemish house, instead of within the traditional formal and unreal setting. All this and much more is of the greatest interest for the student of Van Eyck (it should be added that it is likely that not only did Campin influence Van Eyck, but was in turn influenced by the younger man; (cf. *St Barbara,* which must reflect the Arnolfini double portrait).

When we come to consider the body of work that is ascribed to the Van Eycks, three major problems present themselves: 1) Which works are by Hubert and which are by Jan? 2) Who is the author of the Eyckian miniatures in *The Turin Hours*? 3) How is *The Ghent Altarpiece* to be understood, iconographically, and in view of its inscription? The second two questions grow out of the first.

Let it be said at once that these problems are incapable of being solved with solid proof until and unless fresh historical evidence is discovered. It is because there is so little evidence that most views and arguments can be little more than hypotheses; scholars have worked with the greatest ingenuity and application on the Eyckian question for decades; the literature is vast and labyrinthine. This account cannot pretend to have taken every view into consideration, nor will it go into every detail.

We have some few pieces of historical evidence about Hubert van Eyck. The most important is the inscription on *The Ghent Altarpiece,* which reads:
(Pictor) Hubertus eyck – maior quo nemo repertus Incepit – pondus-q(ue) Johannes arte secundus (Frater perfunctus) – Judoci Vijd prece fretus Versu sexter mai – vos collocat acta tueri
"The painter Hubert van Eyck, than whom none was found greater began (this) and the weight Jan, his brother, second in art, having finished it at the expense of Judocus Vijd, invites you to gaze on the 6 May at what has been done." The last line is a chronogram and gives the year as 1432.

Thus we learn that Hubert van Eyck, of whom later ages remembered nothing, was called the greatest painter, and that Jan was second to him. The technical examination of the inscription carried out by Coremans *(L'Agneau mystique en Laboratoire,* Brussels, 1953) affirms its authenticity (nobody claims that Jan himself wrote it: the important thing is that it should be contemporaneous with the picture).

Another echo of Hubert's one-time fame comes from Antonio de Beatis, a member of the party of Cardinal Louis d'Aragon who was shown the painting on 1 August 1517 and was told by the Canons of Ghent Cathedral that it was painted by a master *de la Magna Alta decto Roberto* (a master from Germany called Robert), about a hundred years ago. It has been shown (e.g. by Panofsky, Philips) that the reference to Germany may very well be to the eastern Netherlands, whence the brothers may have come (cf. Philips). Roberto and Hubert might well have been confused. The Canons went on to say that the picture was "finished by his brother, who was also a great painter". Thus the brothers were clearly separated in 1517. Another trace of Hubert's brief posthumous fame is to be found: in 1495 a sightseer called Hieronymous Münzer was shown the grave of the master of the altarpiece in Ghent Cathedral – Jan was buried in Bruges.

The documentation of Hubert's life is the following: In 1424–5 "meester Luberecht" was paid by the magistrates of Ghent for two designs for an altarpiece. In 1425–6 the assistants of "meester Ubrechts" were given a small payment by the same magistrates. On 9 March 1426 "meester Hubrechte de Schildere" had in his shop an image of St Anthony and other works which were to be part of the furnishing of the chapel in St Sauveur, where Robert Poortier and his wife were to be buried.

Furthermore, in 1426, tax was paid by the heirs of Lubrecht van Heyke on the deceased's property (these four documents are in the Ghent archives). The date of Hubert's death was 18 September 1426 according to the inscription on his tomb (destroyed but transcribed).

Thus the historian is faced with a mysterious painter who unquestionably existed (it would seem that Renders [*Hubert van Eyck – Personnage de Légende,* Paris, Brussels, 1933; *Jean van Eyck,* Bruges, 1935; *Jean van Eyck et le Polyptique-deux problèmes resolus,* Brussels, 1950] makes a basic error in historical method by refusing to believe the evidence and inventing complicated theories to account for it (e.g. the city of Ghent is jealous of Jan's reputation, established chiefly in Bruges; therefore they invent another, better Van Eyck). Hubert existed, and was admired as a great painter (Guicciardini and Vasari mention him when speaking of Jan, but they clearly have no idea of his work). No works have come down to us with the attribution to Hubert other than *The Ghent Altarpiece.* How are we to discover his artistic identity, especially when we have a sure *œuvre* (signed and dated) for Jan, whose fame and extraordinary achievements have never been forgotten for very long, and who was yet described in his prime as second to his brother?

It must be pointed out that all attempts to reconstruct Hubert's work are based on entirely subjective premises and that most of the arguments are ultimately circular. The process is on the whole like this:

We can observe and understand the style of Jan van Eyck on the basis of his undisputed works (all after 1432); there is a body of "Eyckian" work other than the signed and dated pictures of Jan. Those works, or parts of works, which are stylistically out of tune with the established work of Jan are either Hubert's or by the young Jan, working perhaps with Hubert.

One of the greatest difficulties is that Jan's style is assessed on the basis of the mature works; could his style have been different in his youth? Among the most striking aspects of Jan's established style are the silence and immobility that pervade his pictures. Movement is arrested, there is no story to tell; time seems to stand still. Several of the "Eyckian" works, however, such as *The Crucifixion* and *The Judgment* in New York, or *The Three Marys,* are a narration of events. The figures gesticulate, express their emotions, they are not objects for contemplation, but invite us to follow their story. This very basic difference in approach has been one of the main criteria for distinguishing the brothers, e.g. Baldass, Pächt. Panofsky, however, while recognizing the fact, would say that Jan disciplined himself in later years to repress all passion.

The *juvenilia* (setting outside for the moment *The Ghent Altarpiece*) out of which so much of the discussion arises, are the paintings mentioned above, *The Friedsam Annunciation, The Madonna in the Church* (Berlin) and some of the miniatures in the *Très Belles Heures de Notre Dame* of the Duc de Berry. In 1902 Paul Durrieu published for the first time that part of *The Hours* which was then in the Library in Turin, and he pointed out the interest and beauty of some pages in particular (the book was illustrated by many different hands, over an extended period, cf. Durrieu, Hulin de Loo, Panofsky).

In 1904 there was a fire in the Turin Library and Durrieu's *Trivulzio* miniatures were destroyed (fortunately they had been photographed). In 1911 the great Belgian art historian Georges Hulin de Loo published his *Heures de Milan.* He had, independently, been interested in the Turin pages and he discovered that another part of the *Très Belles Heures* was in the possession of Prince Trivulzio in Milan. He was able to compare the two sets, before the fire. In his book, Hulin discusses in detail the question of Eyckian authorship. Before giving a brief idea of these miniatures, it must be said that Jan was described in 1524 as *"gran maestro Johannes que prima fe" "arte diminaire, sive ut hodie loquimvr miniare"* (Summonte in a letter to M. Michiel); this clue therefore, and the wonderful esthetic quality of the miniatures, particularly in such Eyckian aspects as landscape, light and air, imaginative and accomplished interiors, easy relationship of figures and surroundings, were good grounds for thinking that the youthful Jan was trained as a miniaturist.

The miniatures in question are generally divided into two groups, following Hulin's lead:
(1) *The Lord enthroned*
(2) *The Agony in the Garden*
(3) *The Pietà*
(4) *The Crucifixion with the Virgin and St John*
These four were assigned to 'Hand H' by Hulin, whom he equated with the youthful Jan van Eyck. The next seven Hulin assigned to 'Hand G' or Hubert van Eyck:
(5) *The Betrayal of Christ* (a night-scene)
(6) *St Julian and his Wife* (probably not St Martha) *ferrying Christ*
(7) *The Virgo inter Virgines*
(8) *The Prayer on the Shore*
(9) *The Birth of St John the Baptist*
(10) *The Mass of the Dead*
(11) *The Finding of the True Cross*
Several of these have remarkable *bas-de-pages,* especially *The Prayer on the Shore (The Watchers on the Marshes),* and *The Birth of the Baptist (The Baptism of Christ).*

The *Virgo inter Virgines* and *The Finding of the True Cross* have been removed from the

The seven illuminated pages of The Turin Hours (*the first four were formerly in Turin, Biblioteca Nazionale, but were destroyed by fire; the other three are in Turin, Museo Civico*). *The main subjects of the pages are (from left to right):* The Kiss of Judas, The Voyage of St Julian, Virgo inter Virgines, Cavalcade by the Seashore, Birth of St John the Baptist, Mass for the Dead, *and* The Finding of the True Cross.

"G" group by many scholars as having a certain archaicism, and because the figures are on quite a different scale (cf. e.g. A Chatelet, "Les Enluminures Eyckiennes des Mss.·de Turin et de Milan-Turin," *Revue des Arts*, 1957, p. 155 ff.).

Hulin's "Hand H" miniatures, which he assigned to Jan, have been relegated by most scholars (Baldass, Panofsky, Held, Pächt) to a follower of Jan's probably basing himself on designs by Jan, as in the case of *The Crucifixion*. There is much room for argument on this subject, but we must confine ourselves here to a brief discussion of the "Hand G" miniatures. These are the most beautiful and the most interesting, being the most "Eyckian."

An important clue to the dating of the miniatures is *The Prayer on the Shore*. From the arms on the banner it was concluded by Durrieu and Hulin de Loo, that a personnage of the House of Holland-Bavaria was represented. They concluded that it was Count William VI, who made a journey back from England in 1416 (which, it is argued, would be the subject of this picture, as beneath it is a prayer which can be interpreted as a safe journey, cf. Chatelet, (op. cit., 1956, p. 201), and who died in 1417. This would be the *terminus ante quem* for this miniature, and an approximate date for the others. Kurz claims that this argument is given convincing proof by a similar portrait of William VI in a drawing now in the Louvre (O. Kurz, "A Fishing Party at the Court of William VI," *Oud-Holland,* 1956).

The point, however, is not settled: Chatelet (q.v.) claims that the royal rider is John of Bavaria, brother and successor of William, reigning from 1419–35. In fact, whether it is either of these, the miniatures are still extraordinarily early for the very high degree of

accomplishment they show. As Hulin remarked, nothing like them was to be seen again until the seventeenth century.

There are two main schools of thought as to their authorship. One considers that they are not by either Jan or Hubert, but a third party: for Tolnay this is Albert van Ouwerter, working in the 1430s, and for Baldass it is a "Master of the Turin Hours" working at about the same time. On the other hand, there are those who would like to see in the miniatures either Jan's *juvenilia*, or works of the mysterious Hubert; Hulin was the first champion of Hubert's authorship and was followed by Winkler; more recently, Pächt and Held have upheld this view. Friedländer, Panofsky and Chatelet would give the five miniatures to Jan.

All are agreed on the perfection of the landscapes and the subtle use of tones and half-tones to render light and shade. The perspective of the interior of the room in *The Birth of the Baptist* is not quite correct (compare the vanishing points of the ceiling and the table), but it is all the same a wonderful glimpse of a real room, with all the incidentals of such a scene – the view through the open door to other rooms, the furniture, the clogs kicked off, and the little dogs (the comparison with the room of the Arnolfini portrait cannot be avoided). What is not in such accord with the known work of Jan is the narrative element and the "old-fashioned" rendering of the figures: slim, insubstantial, with draperies that cling to them almost like wet clothes. The triangular faces of the Virgins are not Jan's Madonna faces, but compare them to the face of the Virgin in the New York *Judgment* (as Hulin advised). Thus, there is a discrepancy within the paintings themselves: they are both absolutely modern and very much a part of the late fourteenth-century Gothic manner. Hulin considered that

it was a case of a new vision in man trained up in the old ways. Panofsky thought that we are seeing the work of the still immature Jan and dismissed Hubert on the grounds that Hubert is not recorded as having any connection with the princely house of Holland-Bavaria, whereas Jan worked for William's brother John from 1422; and furthermore all the motifs link up with Jan's later work, e.g. the church in *The Mass of the Dead* and the Berlin *Virgin in the Church*.

However, Held and Pächt in their interesting reviews of Panofsky's book, point out that his argument is not very conclusive because we do not know that Hubert worked for the house of Holland-Bavaria and we cannot conclude that he did not. They would favor Hubert as the author of the miniatures. The present writer would, with great diffidence, put forward a suggestion which does not seem so far to have been made. Can the miniatures be more clearly understood if they are thought of as the product of collaboration between the brothers? The older and famous Hubert would have done the figures, the most important element in the picture up to that moment in time. His young brother, whom he was training, or at least advising, he allowed to do the backgrounds and accessories. The relations between motifs and characteristics in the miniatures and in Eyckian panel paintings can then largely be explained. The obvious similarities between *The Mass of the Dead* and *The Virgin in the Church, The Birth of the Baptist* and *The Arnolfini Portrait* are certainly because Jan was the painter of the two interiors in the miniatures. But while the scene of *The Birth* is full of liveliness and movement, *The Arnolfini Portrait* is the perfection of stillness and this is simply explained because it was not

Jan, but Hubert who conceived and painted the events and actions of the former. Chatelet's comparisons of landscapes in the miniatures (e.g. the river in the *bas-de-page Baptism of Christ*) with those in Jan's paintings (e.g. the river in the background of the *Rolin Madonna*) reinforces the argument. The "archaic" Virgins are linked to the Virgin of the New York *Judgment*, because they are painted by Hubert (the present writer believing Hubert to be the painter of the diptych), and the procession of Virgins is linked to that part of *The Ghent Altarpiece*, the procession of Virgins, which is most archaic and likely to have been painted

A drawing of The Adoration of the Magi *(Amsterdam, Rijksmuseum), perhaps by Hubert van Eyck.*

by Hubert (Panofsky reaches the opposite conclusion). Points could go on being made in favor of this hypothesis, but would not be in place in this sketch of the Hubert/Jan question. Enough idea of the difficulties and gaps in our knowledge has perhaps been given. The remaining great problem, *The Ghent Altarpiece*, had better be examined in the *Catalogue*.

The Technique of Jan van Eyck

Jan van Eyck used to be thought of as the inventor of oil-painting, largely because Vasari said so. In fact, oil had long been used in the Netherlands. The technique of Jan, and such contemporaries as Campin, did, however, seem revolutionary because of the

brilliance of the colors and light and the subtlety of half-tones. The painters of the time did not use canvas but *gesso* (chalk mixed with size) which gives a smooth white surface. The painter then outlined his composition with his brush to a greater or lesser degree of detail, sometimes modeling the whole in a monochrome sketch. Painting then went forward, one coat at a time. Jan van Eyck used a very refined and clear oil as a solvent for his colors (generally made and ground by the artist himself). This, in contrast to the less transparent oil used by predecessors, is partly the foundation of Vasari's notion. The colors were built up, the effect of one upon the other being most carefully studied. Red could "shine through" a darker color above to give a warm tone. Each layer had to dry thoroughly before the next went on: the process was lengthy and carefully thought out. The dried color might well be given a coat of glaze so as to prevent the next one interfering with it. Turpentine, too, was now used so as to thin the paint and give it more lightness and brilliance.

1 ⊞ ✇ 71,5×89 ⊟ ⦂

The Three Marys at The Sepulcher Rotterdam, Museum Boymans-van Beuningen

Some rays of light emanating from a mysterious source painted on the right-hand edge of the painting have suggested that this picture was once part of a larger composition, perhaps a polyptych of which *The Three Marys* was the central panel. The provenance of the work was reconstructed by Weale (1908). It was long part of the Cook Collection, Richmond, until it was purchased by the Dutch collector, D. G. van Beuningen; the museum received it in 1958. In the lower right is a crest surrounded by the order of St Michael. Weale identified it as that of Philips van den Clyte, i.e., Philippe de Commines, who would have commissioned it before 1472, the year he fell

from Charles the Bold's favor. The crest has led some scholars to consider the work later than the Van Eycks (Fierens-Gavaert, 1905; Voll, *Altniederländische Malerei*, Leipzig, 1906; J. Squilbeck, RBAH, 1959), but after recent restoration, as Baldass (1952) says, this position is no longer tenable. This work is generally given to Hubert, rather than Jan. The three female figures have a slenderness, smallness of head which is closer to the Limbourg brothers than is Jan, and as Dr Margaret Whinney points out, there is a narrative interest expressed in these figures and that of the angel that we do not find in the generally accepted works of Jan. Further, as has often been rightly remarked, the artist seems to recall Robert Campin's panel *The Resurrection* (London, Count Seilern), in the motifs of the slab across the tomb, and the grotesque sleeping soldiers. This awkwardness in rendering some details (the perspective of the slab), the uncertain relative positions of the soldiers, especially the one on the right, further incline critics to assign this picture to the earlier painter. These critics include Seeck (*Die charakteristischen Unterschiede der Brüder Van Eyck*, Berlin 1890), Hulin de Loo (ASPPH 1902), Panofsky (AB 1935), Friedländer (1924), Beenken (1941), Baldass (1952), and Whinney (1968).

2 98×130

The way to Calvary
Budapest, Szépművészeti Muzeum
The picture was acquired in 1904 from the Peteri (Ignatz Pfeffer) Collection, Budapest. Scholars unanimously consider it a copy (ca. 1530–60) of a very important lost Eyckian panel. The original is related to the five miniatures of *The Turin Hours* (see p. 85) and the three related paintings (the two New York panels, 3 A and B, and the Berlin *Crucifixion, 7*). The evaluation of the lost original is conditioned by the judgment of these eight works.

Those who attribute them to a follower of Jan, the so-called "Master of the *Heures de Turin*" (Dvořák, JP, 1918; Baldass, 1952; Garás, AHAH, 1954) whom Tolnay (1939) considers to be Albert van Ouwater, also ascribe this work to him. Those who consider the five miniatures as youthful works of Jan also consider this lost work one of Jan's earliest paintings (Winkler, JP, 1916; A. Pigler, *Phoebus*, 1950–51; Panofsky, 1953; D. G. Carter, BRI, 1962). Both Pigler and Friedländer (1924) suggest a very early date for the lost original, ca. 1420. Thirdly, the supporters of Hubert, (explicitly Held in AB 1955) would assign the picture to him. Saxl (B, 1926) thought that the artist must have seen an Italian composition similar to the fresco by Andrea di Bonaiuto in the Spagnoli Chapel in Florence.

In the Brunswick Museum, there is an old drawing of the horsemen on the right, undoubtedly a fifteenth-century copy. Another old drawing, in the Vienna Albertina, published by Panofsky (1953), is based on an Eyckian composition similar to that in Budapest, although the procession is moving in the opposite direction. The fact that Dutch-style derivations of the original of the Budapest painting exist (for miniatures, see Winkler [FF] and De Wit [JP, 1937]; for paintings, suffice it to mention the panel formerly in the Wilczek, Kleinberger, and Pratt Collections and now in the Metropolitan Museum in New York) seems to support the hypothesis that the original was painted by Jan during his stay in the Hague, documented for the period 1422–4. The loss of the original is serious, because it must have been a work in which the stylistic principles so splendidly achieved in the miniatures were also achieved in a large panel painting. This work of Van Eyck, so intensely naturalistic (both in respect of the conception of the landscape, so placid and sober, and in respect of the figures, early

examples of genre), had no real following in fifteenth-century Netherlandish painting. Some (e.g. Zimmerman, ABB 1917) have compared this painting with the work of the so-called Brunswick monogrammist (perhaps Jan van Amstel of Breugel) a century later.

The New York Panels

Tatischev is said to have possessed a central panel depicting an *Adoration of the Magi* which was stolen by a servant. Panofsky (1952) would doubt the authenticity of the lost panel, as such a subject is not known to be juxtaposed

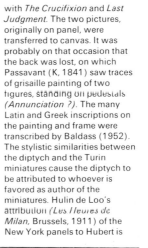

1 (Plate LXII)

with *The Crucifixion* and *Last Judgment*. The two pictures, originally on panel, were transferred to canvas. It was probably on that occasion that the back was lost, on which Passavant (K, 1841) saw traces of grisaille painting of two figures, standing on pedestals *(Annunciation ?)*. The many Latin and Greek inscriptions on the painting and frame were transcribed by Baldass (1952). The stylistic similarities between the diptych and the Turin miniatures cause the diptych to be attributed to whoever is favored as author of the miniatures. Hulin de Loo's attribution *(Les Heures de Milan,* Brussels, 1911) of the New York panels to Hubert is

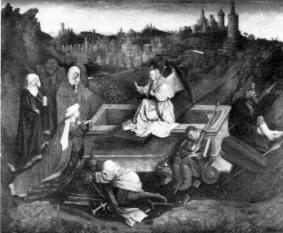

2

accepted by A. L. Mayer (A, 1934), Beenken (1941), H. B. Wehle, and M. Salinger (*A Catalogue of Early Flemish Paintings,* Metropolitan Museum, New York, 1947). The hypothesis that these are early works of Jan (ca. 1420–5) has been accepted by Panofsky (1953). For Dvořák (JP, 1918), Tolnay (1939) and Baldass (1952), they are by an anonymous follower of Jan, almost certainly Dutch (Dvořák) or perhaps Albert van Ouwater (Tolnay). The attribution to Petrus Christus, advanced by some scholars in the nineteenth century, was surely the result of the fact that Christus painted a derivation of *The Last Judgment* (greatly simplified in number of figures and episodes) on a panel now in Berlin, signed and dated 1452. Perhaps a drawing of *The Adoration of the Magi* in Berlin (15 × 12·4 cm), which Panofsky (1953) and others consider a copy of a lost work of the young Jan, might represent the lost central panel, if: a) such iconography can be accepted and b) the panels really did belong to a triptych. Tatische's center panel may have been a late addition. The Duc de Berry is known to have possessed a Judgment diptych.

The symbols reproduced for *The Crucifixion* panel also apply to *The Last Judgment*.

3 56,5×19,5

A The Crucifixion
The frame bore the text from Isaiah (53:6–12): beginning, "All we like sheep have gone astray; we have turned every one to his own way; and the Lord hath laid on him the iniquity of us all." The viewpoint of the spectator is from above, so as best to accommodate the many figures, into the steeply inclined plane. The figures of the holy women in the foreground are detached from the main crowd of jostling spectators. As Baldass observed, they express their grief through their gestures rather than their faces. Panofsky would consider the right-hand woman, dressed in red with a black shawl who shows us a calm face, as she contemplates the sorrow-stricken group, to be the Erythrean Sibyl. He calls our attention to the depiction of the same Sibyl in *The Ghent Polyptych* (Plate II). Baldass considers that the figures in this panel, especially those of the

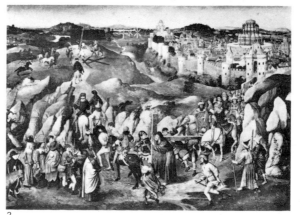

2

A drawing of horsemen (Brunswick, Herzog Anton Ulrich-Museum), derived from 2.

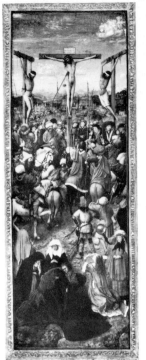

3A (Plate L III)

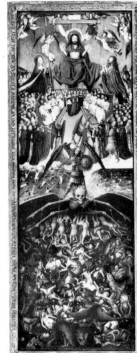

3B (Plate LXIII)

(Above) The Last Judgment *(Berlin, Staatliche Museen) signed and dated (1452) by Petrus Christus, freely based upon the work n.3.B.*

(Below) Drawing of the Adoration of the Magi *(Berlin, Kupferstichkabinett) possibly reproducing the lost painting which originally accompanied 3A + 3B as a central element.*

jeering crowd, are far too expressive and anecdotal in character to be by Jan. Held (AB 1955) makes interesting comparisons between the heads of the crowd here and the heads of the Apostles Hermita and Pilerius in *The Ghent Altarpiece* in support of the argument in favor of Hubert as author of both groups. See, too, his note on the Sibyl (p. 224).

B The Last Judgment
Christ the Judge, turns to the elect; on the right and left appear the same inscription, *Venite, benedicti p(at)ris mei.* St Michael, turning to the reprobate, hurls the malediction repeated on both sides, *Ite, vos maledicti, in ignem eternum.* On the wings of Death below the archangel, are the words *Chaos magnu(m)* and *Umbra mortis.* The frame bore several Biblical texts from Revelation (20:13; 21:3–4) and Deuteronomy (32:23–24).

As in its neighbor, this panel has a division in subject between the upper and lower halves. The souls of the dead are not shown ascending to Heaven and descending into Hell: the segregation for the most part, seems to have taken place already. The dramatic bat-winged Death is an extraordinary and powerful invention, and the St Michael is a beautiful figure who might have been painted by Jan (cf. Panofsky, who gives this panel, like the preceding one, to Jan). There is, however, about most of the figures that unweighty, almost toy-like quality which suggests an execution other than Jan's. Hulin de Loo pointed out the similarity of the waves and shore in this picture to the waves in the St Julian miniature and *The Prayer on the Shore.* According to E. Schiltz (*Van Eyck Studies,* Antwerp, 1960–2) the lower hand of St Michael's cuirass bears the date 1418. This writer's

arguments, however, are supported by very poor photographs, and are not in any case very convincing. He has "found" a mass of dates and signatures hidden in the obscurest details, but it may be wondered if these exist. In the known mottoes, dates and signatures of Jan, the artist is not in the least secretive, but writes with a bold flourish. For all Schiltz's theories see *Bibliography of the Netherlands* Institute for Art History, The Hague, Volumes for 1962–4.

4 ⊞ ❂ 32×14 *1425 ☰ ⁚

The Virgin in a Church
Berlin, Staatliche Museen, Gemäldegalerie-Dahlem
The iconostasis between the nave and the choir is adorned with several sculptures: a statuette of the Madonna and Child on an altar in a niche; a high relief of the Annunciation in the tympanum above; the Crowning of Mary, in the other tympanum.

Most critics have agreed in considering this a very fine early work of Jan, dating it before the completion of *The Ghent Polyptych.* G. Schnaase (*Geschichte der bildenden Kunste im 15 Jarhh,* Stuttgart 1879) defended its authenticity against the doubts of Crowe and Cavascaselle (*Early Flemish Painters,* London 1872). Fierens-Gevaert (1905) thought it a copy. For Beenken (1941), it dates to ca. 1420–5; for Baldass (1952), ca. 1425; for Panofsky (1935) ca. 1425–7. Tolnay (1939) simply sets it before the Ghent works. Hulin de Loo (*Les Heures de Milan,* Brussels, 1911), attributes this work to Hubert. Heidrich (*Altniederländische Malerei,* Jena, 1910) also tends to this view.

The Berlin Museum catalogue carries the Latin inscriptions formerly on the frame (MATER HEC EST FILIA PATER · HI(C) EST NATUS QVIS AVDIVIT TALIA DEVS HOMO NATVS), which was lost in a theft. This painting may have been the left panel of a diptych, the right of which probably depicted a donor. The copy by the Bruges Master of 1499, now in the Musée Royal des Beaux-Arts, Antwerp (No. 255) is joined to a panel (dated 1499) with the portrait of a kneeling worshiper in an interior. Kurz (1961) noted the importance of that panel, which gives an idea of the lost panel. Kurz believes that the copyist generally followed Van Eyck's outlines, only adding the portrait of another commissioner (Christiaen de Hondt). Even the copy (enlarged on the right) in the Galleria Doria, Rome – which Friedländer (*Die altniederländische Malerei,* VIII, 1930) attributed to Gossaert, dating it to 1508 – had another panel, where St Anthony and a donor are depicted in a landscape. Weale (1908) mentions two old drawings deriving from this painting, one in the L. Paar Collection (sold in Vienna, 21 November 1896), and the

other in the J. C. Robinson Collection (reproduced by Kämmerer [1898]).

A striking feature of this picture is the disproportion between the figure and the setting: the Virgin cannot be meant to be literally standing in a church, for she would then be a giantess. Instead, as has been argued by most scholars, she is portrayed as The Church and Queen of Heaven: Panofsky cites more than one test that identifies the Virgin with the Church. We must not forget, however, that the scale of figures to rooms is seldom quite right in Eyckian art: the Arnolfini couple are rather too big for the room, the Angel and the Annunciate on the back of *The*

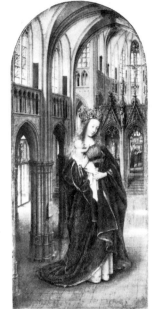

4 (Plate I)

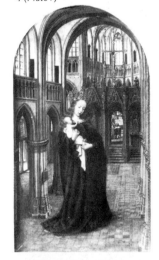

Ghent Altarpiece are strikingly too big for their room, and several of Jan's Enthroned Madonnas would be very large if they stood up. The picture must be compared with *The Mass for the Dead* in *The Turin Hours.* See Panofsky (ch. 5) for a detailed interpretation of the symbolism of light and architecture.

5 ⊞ ❂ 12,5×14,5 ☰ ⁚
1428-29?

St Francis Receiving The Stigmata Philadelphia, John G. Johnson Collection
Weale (1908) drew attention to the fact that the habit worn by the two friars is not the gray one of the Low Countries (where the Franciscans were known as "Gray Friars"), but the brown one of the Reformed Franciscans, who only appeared in the Low Countries just before the end of the fifteenth century; hence the deduction that the work was painted when Jan was in southern Europe (thus, during his stay in the Iberian peninsula, 1428–9). Supporting this theory is the existence of a copy in Spain, which may be dated ca. 1510 (Prado, Madrid). Weale also noted that the kneeling figure does not have the features of St Francis, but those of a robust middle-aged bourgeois.

In his will (1470) Anselm Adornes of Bruges left each of his daughters, who were about to enter different convents, a painting of St Francis by Jan van Eyck (Weale, 1908). It is not known if the two pictures were alike. If they were, one might suppose that the two pictures were the Philadelphia one and the larger version of the same in the Galleria Sabauda,

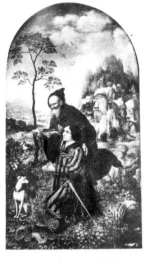

(Above) A copy of painting 4 (left) and a possible copy (St Anthony and a Donor) of the original companion panel (attributed to J. Gossaert; Rome, Galleria Doria).

(Left) Another copy of painting 4 (Madrid, Bauzá de Rodriguez Collection), which might suggest that the hypothetical original was a triptych rather than a diptych.

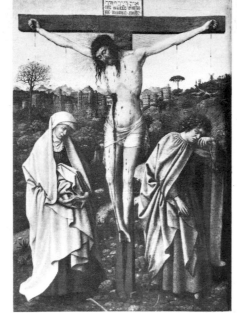

7

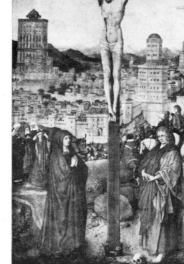

8

Turin, 29 × 33 cm., (G. Aru and E. De Geradon, *La Galerie Sabauda de Turin*, Antwerp, 1952). In the early nineteenth century the painting, now in Turin, was the property of a nun of Casale, and went to the gallery in 1860. It is worth noting that Brother Leo wears a gray habit, while St Francis wears a brown one (gray, according to Weale [1908]). Conway (*Early Flemish Artists and Their Predecessors on the Lower Rhine*, London, 1887) considers the Turin panel the original and the Philadelphia one a copy; Bode agreed (JP, 1901).

This picture, and its counterpart in Turin, presents problems of authenticity despite the will of Anselm Adornes (which is only known through a sixteenth-century copy and has a serious grammatical fault just where the author of the paintings is named [cf. Panofsky, n. 1 to p. 403]). The problems are raised because of the mistaken anatomy of the figures (note the saint's feet and the peculiar legs of Brother Leo), their unconvincing postures and their complete lack of a real relationship with their surroundings. Further, St Francis seems to be quite unmoved by the apparition: indeed, he does not seem to see it. Those who have seen the original say that the color is neither brilliant nor glowing, as it is so markedly in the Berlin *Virgin of the Church*, which, an early work, would belong to the same period as the St Francis, if the latter is accepted.

6 28 × 33

St Francis Receiving The Stigmata Turin, Galleria Sabauda
See 5 above. Probably contemporaneous with No. 5.

7 43 × 26

Christ on the Cross with Mary and St John Berlin, Staatliche Museen, Gemäldegalerie-Dahlem
Originally on panel, this was transferred to canvas. The museum acquired it in 1897 from the English antique dealer, Buttery. Attributed to Jan van Eyck at the end of the nineteenth century (Tschudi, JP, 1898), it has to be discussed in the context of the miniatures of *The Turin Hours*. On the miniatures, Baldass, Tolnay and Panofsky would not admit the Berlin *Crucifixion* into Jan's canon, but would see it as a derivation of the archetype of the Turin *Crucifixion*. Certainly it is hard to believe that this archaic and labored work could possibly have come from the hand of Jan or of Hubert.

8 45 × 30

The Crucifixion Venice, Galleria Franchetti, Ca' d'Oro
Formerly in a private collection, Padua. Baldass (1952) considers it a fifteenth-century Netherlandish copy of a lost original by Jan van Eyck, which also inspired the similar (though much simplified) miniature in *The Turin Hours* (reproductions in Baldass, p. 31 and Panofsky, No. 290). In the Museo Civico, Padua, there is another interesting unfinished copy, published by Schottmüller (JP, 1902). That the landscape in this painting was the model for that in *The Crucifixion* attributed to Nicola di Antonio in the Galleria dell'Accademia, Venice, would prove that our painting was in Italy (perhaps in Padua) as early as ca. 1460. *The Crucifixion* at the Ca' d'Oro has never been considered an original by Jan, yet it is certainly more distinguished than the Berlin painting (No. 7). Wescher (P, 1936) attributes it to Jan's circle; Ragghianti (Catalogue of the exhibition of Flemish and Dutch art, Florence, 1948) to the workshop. J. G. van Gelder's view (BM, 1951), that it is a precious original by Hubert and datable to 1417–20, has had no following. Chatelet (RA, 1957) would give it to his Master H.

The Ghent Altarpiece

It is preserved in the chapel of Joos Vyd, of the Cathedral of St Bavon. It comprises twelve oak panels, the eight folding panels of which are painted on both sides. The subjects of the single panels are described in the entries below. It should be mentioned at once, however, that the outside frame of the polyptych (visible when the panels are closed) bears the famous quatrain in leonine hexameters: *Pictor Hubertus eeyck maior quo nemo repertus / Incepit pondusque Johannes arete secundus / (Frater perfectus) Judoci Vijd prece fetus/VersV seXta MaI Vos CoLLoCat aCta tVerI /* ("Hubert van Eyck, the greatest painter who ever lived, began the work, which his brother Jan, the second in art, finished at the instigation of

Old variant copy of painting 5 or 6 (Madrid, Prado); It is attributed to the Master of Hoogstraeten.

Jodocus Vijdt. With this verse, on 6 May [1432] he invites you to look at this work."). The last line contains a chronogram, for the letters here printed as capitals are written in red in the original and give the year 1432. The first words of the third line are now illegible. C. van Huerne, in the early seventeenth century, emended them as *perfecit Ietus*. Another is *Frater perfecit*, preferred by Kurz (1961), while Waagen (1822) suggested *suscepit Ietus*. In any case, as Weale has noted (1908), the quatrain was not painted by Jan but was painted by order of Joos Vyd.

1458, *4 April* On the occasion of Philip the Good's *joyeuse entrée* into Ghent, the polyptych was represented in a tableau vivant. (Philip had been Jan's protector.) There is a detailed description of the event by a contemporary (see J. de Baets, *Wetenschappelijke tijdingen*, 1958).

1517, *1 August* Antonio de Beatis accompanied Cardinal Louis of Aragon and made a record of their visit to the polyptych. He said that the work had been begun by a master from "Magna Alta" (i.e., Germania Inferior, the Low Countries) named "Roberto" and completed by his brother (see *Critical Outline*).

1521, *10 April* Dürer went to see the work and spoke of it in admiring terms. He was particularly struck by the figures of Eve, the Virgin, and God the Father (see *Critical Outline*).

1550, *15 September* The painters Lansloot Blondeel of Bruges and Jan van Scorel, Canon of Utrecht, cleaned the polyptych "with such love that here and there they planted their kisses on this marvelous work" (M. van Vaernewyck, 1568). It was probably at this time that the tower of Utrecht, standing alone in the background of *The Adoration of the Lamb*, was painted (Coremans, 1953).

1557–9 King Philip II of Spain, who would have wanted to own the original, had it copied by M. Coxcie; it took that painter two years to copy it. The copy is now broken up amongst museums in Brussels, Berlin and Munich.

1559, *23–5 July* On the occasion of the twenty-third "chapter" of the Order of the Golden Fleece, which was held in the Church of St John (now St Bavon) in Ghent, Lucas de Heere, painter and poet, dedicated an ode to the polyptych and affixed it to a wall of the Vyd Chapel. This Netherlandish poem of twenty-three quatrains (with some passages of real beauty) was published later by De Heere himself (1565) and is recorded in altered form by Van Mander (1604).

1566, 10 August, in the Flemish village of Steenvoorde, near the linguistic border, the iconoclastic fury of the Calvinists broke out. It spread like a forest fire throughout the Low Countries and caused incalculable damage to the artistic patrimony of the region. The fanatic bands were in Oudenaarde on the eighteenth. On the nineteenth the polyptych was hidden in the cathedral tower and thus it was saved from destruction by the Calvinists, who two days later broke into the church and did great damage. When the trouble passed, the work was transferred to the city hall, where it ran the risk of being sold to Queen Elizabeth I of England.

1584 The polyptych was returned to the cathedral, and in September 1587, set up in its original chapel again.

1663 It was restored by Antonis van den Heuvel.

1781, *17 June* It is said that, out of respect for an observation made by Emperor Joseph II, who had been distressed at

The main subject (very similar iconographically to painting 8) of an illuminated page in The Turin Hours *(Turin, Museo Civico).*

seeing Adam and Eve naked, those two panels were removed from the church.

1794 The four central panels were taken to Paris by the French Republicans and displayed, on 7 March, in the Musée Central d'Art along with other stolen works. The six side panels (*Adam* and *Eve* still missing) were hidden and then stored in the city hall, and the efforts of Denon, the director of the Musée Central, to obtain them failed.

1816, *10 May* The central

5 (*Plate XXIX*)

6

portion was again set on the altar, but without the side panels, which, during the bishop's absence in December 1816, were sold by the vicar-general and the church administrators to the antique dealer, L. J. Nieuwenhuys. He paid 3,000 florins and sold them to the English collector, Solly, for 100,000 florins. The Berlin museum bought the panel from him for 400,000 florins in 1821.

1822, *11 September* The panels left in Ghent suffered from a fire that broke out in the church. A certain Lorent repaired the damage between 1825 and 1828. These four panels were again restored in 1859 by Donselaer.

1861 The panels of Adam and Eve reappeared. Purchased by the Belgian Government, they were assigned to the Brussels museum.

1920, *6 November* After the Treaty of Versailles, Germany had to return the Berlin panels to Belgium. The Adam and Eve panels returned to Ghent from Brussels. Thus, the polyptych was back together again.

1934, *11 April* The panel bearing *The Just Judges* on one side and *St John the Baptist* on the other was stolen. The thief put the painting of John the Baptist (which had been separated from *The Just Judges* in Berlin) in a baggage deposit and made it known, by revealing the ticket number, that he had the other half in his possession. But the Belgian authorities refused to pay the ransom he asked, and the panel has never been recovered. In its place is an oil copy made in 1943–4. According to Denis (1954), the copier has slightly altered one person's features to make him resemble King Leopold III. (For more details of this sad episode, see K. Martier and N. Kerckhaert [*De diefstal van de Rechtvaardige Rechters*, Antwerp, 1966]).

1950–1 The polyptych was very carefully restored by A. Philippot under the direction of P. Coremans (C. Brandi, BICR, 1951; P. Coremans, 1953).

The Ghent Altarpiece presents a number of difficult problems. The inscription on the frame has been quoted already, the art historian attempts therefore to separate the hands of the brothers in what he sees before him. This is an exercise which the teacher of the great Max Friedländer, Ludwig Scheibner, strongly advised against.

Not only is there the question of hands, there is also the question – how can we explain *The Ghent Altarpiece*, with its twelve different panels, all depicting subjects painted on different scales, whose meaning taken as a whole, is not entirely clear? Was it planned as the whole we now see? Or are the difficulties due to an assemblage of apparently

disparate elements?

The lower series of panels, opened, show on the outer wings, processions of holy persons – pilgrims, hermits, knights and judges, making their way to a flowery meadow, represented in the center panel, where the Holy Lamb and the Fountain of Life are being adored by 1) Prophets and other pre-New Testament persons, 2) Apostles and Fathers of the Church, 3) Virgin Martyrs, 4) Martyrs and Saints. The altar of the lamb is surrounded by winged angels and surmounted by the Dove in a glory. The upper level of the altarpiece shows Adam, musical angels, the Virgin, God Enthroned, St John the Baptist, and Eve. Above Adam and Eve are shown the sacrifice of Abel and his murder of Cain.

On the outside we see the Annunciation on the upper part (surmounted by Prophets and Sibyls), and in the lower, portraits of Jodocus Vyt and his wife, flanking simulated statues of St John the Baptist and St John the Evangelist.

The lower part of the open altarpiece is based on the two following texts: "After this I beheld and lo, a great multitude which no man could number, of all nations and kindreds and people and tongues, stood before the throne and before the Lamb, clothed with white robes and palms in their hands . . ." (Revelation 7: 2–10).

The second text comes from *The Golden Legend*, and describes a vision of the sacristan of St Peter's in Rome after he had asked for the intercession of All Saints: "He saw the King of Kings seated on a lofty throne and all the angels round about Him. Then there came the Virgin of Virgins in a resplendent crown, followed by an innumerable multitude of virgins and chaste persons. Now the King rose and made her sit on a throne beside Him. Then there came one dressed in camel hide, followed by a multitude of venerable elders; after him another, in bishop's robes followed by a great number similarly clothed, and afterwards there advanced a host of knights. After there came an infinite number of people of all sorts (later called confessors). All these came before the throne of the Lord and adored Him on bended knees." (*Legenda Aurea*, Cap. CLXII, *de omnibus sanctis*, Breslau, 1890). Dvořák was the first to draw attention to this text.

Thus we have the theme of All Saints, in glorification of the Trinity – the holy personages

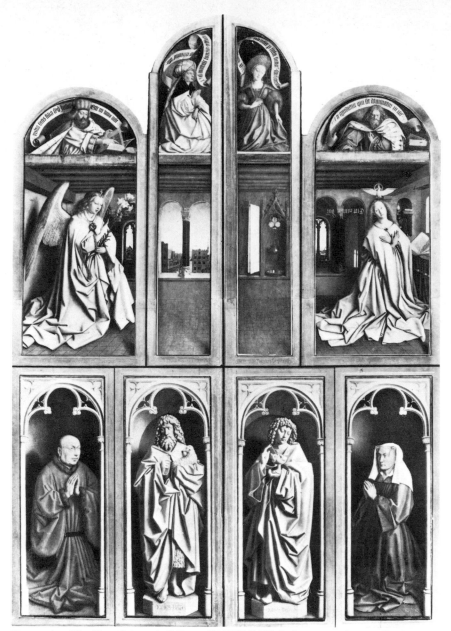

The exterior of The Ghent Polyptych, St Bavon (9) *[PLS. II-XI]. In the upper register, reading from left to right, are the subjects examined under letters A^1 and A^2 (in the first panel, and similarly in succeeding panels), B^1 and B^2, C^1 and C^2, D^1 and D^2; in the lower register, the four figures (also from left to right) described under letters E, F, G and H.*

are placed in a setting which is either an Earthly Paradise or the New Jerusalem. All is radiant; grass, flowers and fruit in their most exquisite forms surround the figures (while the hermits and knights and others of the side panels walk on bare, pebbly paths, as they have not yet quite arrived at the heavenly scene in the center [Panofsky]). Above the Lamb is the Holy Spirit in the form of a Dove; the Dove links the lower to the upper portion, for directly above is the Lord Enthroned. Read vertically, the Trinity is depicted.

The upper panels have caused worry to art historians because they do not appear to be

obviously connected with the lower, and the size of the figures is so enormous in comparison to those below. The three central figures are more or less life-size, five times bigger than the *chori beatorum*. The Virgin and Baptist are an essential part of the description in *The Golden Legend*, and the cathedral was originally dedicated to the Baptist (re-dedicated to St Bavon in 1540). The music-making angels appear in other more or less contemporary All Saints pictures, although they are given unusual prominence here. Adam and Eve do not, strictly speaking, have a place in the iconography, but as has often been remarked, they are perfectly relevant in this great depiction of the joys of Salvation.

Despite particular problems of iconography (e.g. is the enthroned figure God the Father, or is he a personification of the Trinity? [the texts embroidered on his robe, the throne and the cloth behind it refer to God and Christ (cf. Tolnay, no. 4, p. 12)]), the meaning of the Altarpiece is

fairly clear. The outside of the wings again refers to the great theme of Salvation: the prophets and sibyls who foretold it, the Annunciation to Mary, Mother of the Savior, and the figures of the Precursor (John the Baptist) and the Evangelist, whose vision is partly shown within, and whose words are inscribed on the Fountain of Life.

What part of the design is Hubert's and what Jan's? Briefly, a good proportion of opinion assigns to Hubert the design and some of the execution of the lower part, the three main figures of the upper part and in some form, the musical angels. To Jan belongs definitely the design and painting of Adam and Eve on the outside of the polyptych, but the Annunciation may be Hubert's design and much of the execution of Hubert's original panels (especially, for example, the orange trees, palms and cypresses in the central lower panel, which he would have done after his visit to Portugal in 1428). So think Tolnay, Baldass,

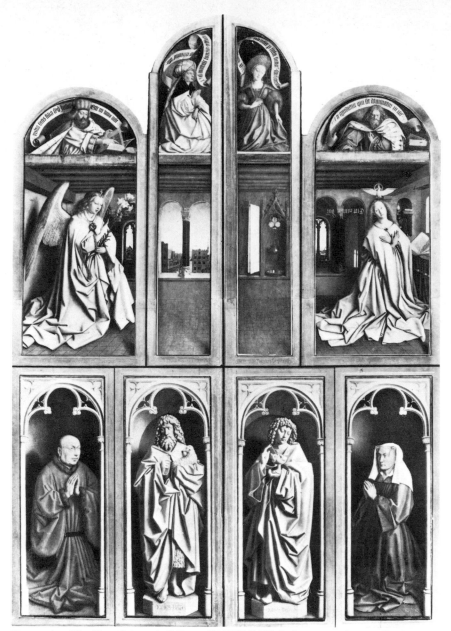

The inscriptions on the frame (exterior side at the bottom) of the polyptych n.9 (for the transcription, see page 89, column five)

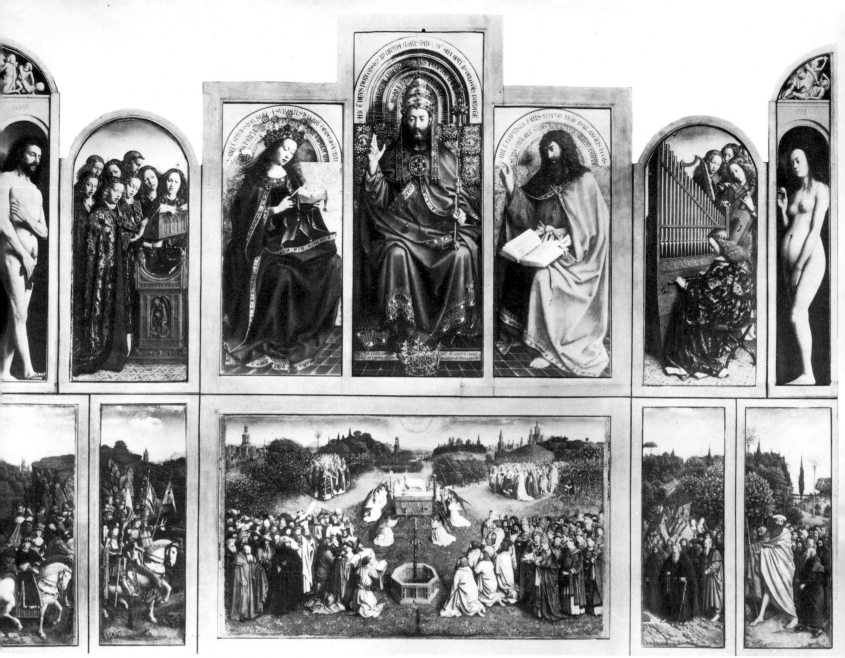

The interior of The Ghent Polyptych *(9) [PLS. XII-XXVIII] open. The depictions in the upper register correspond (from left to right) to I¹ and I² (both in the first panel), J, K, L, M, N, O¹ and O² (both in the same panel); in the lower register (also from left to right) to P, Q, R, S and T.*

Panofsky. For divergencies and more detail, cf. *Catalogue.*

A further question, often raised, is about the assemblage of the panels of the polyptych. The discrepancy in size between the upper and lower panels has been explained (e.g. Panofsky) by the suggestion that Jodocus Vyd bought up a number of panels in Hubert's workshop and had Jan put them together as best he could. The musical angels would have been planned for an organ loft, no doubt, and would have been barely sketched in: the scale of the angels and of Adam and Eve, as we now see them, would be the result of a subtle effort by Jan to distract the eye from the too-large central figures.

It can be doubted if the polyptych needs such accounting for: as Baldass says, we may see the largeness of the Virgin, Baptist and God as a relic of the medieval idea of size being in relation to importance. If it is objected that Jan would be incapable of going along with such archaicism, it can equally be objected that he would be

incapable of carrying out the strange assembly-job that Panofsky proposes. For Baldass, the two-tier structure is an imaginative and daring idea, to be admired for its ambition, even though it falls short of the ambition.

Exterior

9 164,8×71,7 *1432

A¹ The Prophet Zechariah
The symbols given above refer to the entire panel left above, i.e., the panel including the composition described in 9 A² below as well as painting 9 J on the reverse side. The subject of the depressed lunette, like its pendants (9 D¹) is closely related to that of *The Annunciation* (9 A² and D²), the event prophesied by Zechariah and Micah. The scroll of this prophet also refers to Zechariah in its Latin inscription: "Rejoice greatly, O daughter of Zion; shout, O daughter of Jerusalem: behold, thy King cometh unto thee." (Zech. 9:9). On the lower edge of the lunette's frame is the prophet's name.

A² The Angel of The Annunciation
This is the lower part of the first panel, above left. The archangel Gabriel, bearing the symbolic lily, greets the Virgin with the traditional *Ave gratia / plena, D-(omi)nus tec(u)m.* The inscription extends from this panel to the next one (9 B²). Infra-red rays have revealed beneath the beamed ceiling of the final painting an earlier drawing of the composition, showing a series of trilobed arches, very similar to those in the lower register (9 E, F, G, H). Is this a case of Jan's altering Hubert's design, or is Jan correcting himself? If the former, Hubert must have intended the figures to be simulated statues, as with the Saints below, and Jan having perhaps seen *The Mérode Altarpiece* or Madonna (National Gallery, London) in Campin's shop when he visited Tournai in 1427, wanted to paint a similar high chamber with a view of a town. If so, Pächt is right in doubting Panofsky's insistence that the exterior is all Jan's. The further consequence would be that the

music-making angels, who are painted on the back of *The Annunciation* panels, would have always been meant as part of the complex, and would not have had some quite different destination, such as an organ-loft, as Panofsky holds.

9 212,9×37,1 *1432

B¹ The Erythrean Sibyl
The symbols given above refer to the entire panel center left, in the upper register, and including 9 B² and corresponding to that of the painting 9 I¹ and I². Like those of *The Prophets* (9 A¹ and A²), this panel and that of the other sibyl (9 C¹) are also related to *The Annunciation,* which they had predicted. The scroll bears the following inscription in Latin: "Not offering human words, you are inspired by the divinity from on high" (a paraphrase of Virgil's *Aeneid,* VI, 50). On the lower edge of the frame is the sibyl's name in Latin.

Panofsky, followed by Held, would see another version of this same sibyl in the standing woman, lower right hand side of the New York *Crucifixion* (3A). If the authorship of Hubert for that panel is accepted, it follows that he at least designed the figure here.

B² Double-Lighted Window with a View of a Flemish City
The lower part of the panel above (9 B¹). The scene is part of Mary's room; for its relation to Campin's work, cf. 9 A². The inscription is the continuation of Gabriel's greeting (see 9 A²).

9 213,5×36,1 *1432

C¹ The Cumaean Sibyl
The symbols given above refer to the entire panel, center right, upper register, including 9 C² and corresponding, on the other side, to 9 O¹ and O². For the meaning of the Sibyls, see 9 B¹. The Latin inscription on the scroll, "Your king of future centuries is coming (to judge) the flesh," is a paraphrase of St Augustine's *City of God,* XVIII, 23. On the lower edge of the frame is the sibyl's name in Latin.

C² Niche with a Tri-Lobed Window, Wash Basin, Pot and Towel
The lower part of the panel above (9 C¹). Another detail (see 9 B²) of the Virgin's room; the towel, basin and ewer are all emblems of purity (Tolnay, Panofsky) and the Gothic decoration of the niche

would, according to Panofsky, symbolize the New Dispensation.

9 164,8×73 *1432
D¹ The Prophet Micah
The symbols given above refer to the entire panel, as in 9 A¹ (which see, also in regard to *The Prophets*). On the other side of the panel is shown 9 N. The scroll bears the text in Latin of Micah, 5:2, "Out of thee shall he come forth . . . that is to be ruler in Israel." On the lower edge of the frame is the name of the prophet in Latin.

D² The Virgin of The Annunciation
For technical information see 9 D¹; for the setting, see 9 A². Mary's reply to the angelic greeting, dictated by the heavenly dove, is written from right to left and upside down, according to the usage of the time. It is *Ecce ancilla D(omi)ni.*

9 149,1×54,1 *1432
E The Donor
This is the left panel in the lower register. Jodocus Vyt, or Joos Vyd was one of the richest Flemish bourgeois of the time. He was, among other things, Lord of Pamele (in Brabant) and of Leedberghe. In 1433–4 he was elected burgomaster of Ghent.

9 149,1×55,1 *1432
F St John the Baptist
This is the center left panel in the lower register and is painted in grisaille. The saint was then the patron of the cathedral. The work of the great Flemish sculptor, Claus Sluter, has often been mentioned as a stimulant to the genius of Campin and Jan van Eyck, notably in such grisaille "sculptures" as this group.

9 148,7×55,3 *1432
G St John The Evangelist
Companion panel to 9 F (q.v.), center right in the lower register. This saint, according to a very ancient tradition that had already been challenged in the second half of the third century, was believed to have been the author of *Revelation*, which inspired the depiction of *The Adoration of the Lamb* (9 R).

9 148,7×54,2 *1432
H The Donor's Wife
The right panel, lower register. This is a painting of Isabelle Borluut, the wife of Joos Vyd.

Interior

9 212,9×37,1 *1427–29
I¹ The Offering of Abel and Cain
The symbols above refer to the entire panel on the left, upper register, including 9 I². On the opposite side of the panel are 9 B¹ and B². The scene is painted in grisaille (width of this scene, 37 cm). The subject recalls the sinful descent of Adam and Eve (as the inscription on the frame notes: ADAM NOS I(n) MORTE(m)

P(re)CIPITA(vi)T; and symbolizes the Eucharist.

I² Adam
Painted on the same panel as 9 I¹ (q.v.). Above the arch is the word: ADAM. As in the case of Eve, scholars have pointed out that awareness of sin committed, an awareness that appears deeper in Adam than in Eve. This is one of the most remarkable male nudes in the history of art; nothing like it had ever been seen in the North, and scarcely in the South. It has well been compared with the equally fresh achievement of Masaccio (Baldass). The painting is entirely "modern": it belongs to a different world from that of the other figures in the polyptych which is essentially rooted in the Middle Ages. The features and muscles of Adam have been taken from a living model – Jan's extreme realism is to be seen above all in the well-known details of the hands and face being much darker than the rest of the body as they would be in a working man. The achievement of the unusual perspective angle – the "frog's-eye perspective" – is also remarkable.

9 164,5×71,5 *1427–29
J The Angel Singers
Painted on the same panel as 9 A; in the upper register, to the left. Extensively repainted, except for the floor. One can distinguish Christ's monogram, that of the Madonna, the Alpha and Omega, and the abbreviation AGLA (formed by the initial letters of a Hebrew invocation from Isaiah, "You, my Lord, ever strong"), and the Mystic Lamb. On the stand are two statues of prophets, and below, St George and the Dragon.

The figures are Jan's, even if the design is Hubert's (Baldass, Panofsky). Compare the foremost, full-length figure of the angel with Gabriel in the Washington *Annunciation* (18). Panofsky thinks that these Angel panels could not have been meant as part of the original (Hubertian) altarpiece, as they do not deserve, iconographically, such a large place in the design. If we agree, however, with Baldass, Pächt and Held, that *The Annunciation* painted on the other side of the angel panels dates back to a design by Hubert, then it is at least likely that they were an original part of the whole. The angels are very unusual, in the absence of wings. Wings would certainly have been very awkward in such a compact group.

9 168,7×74,9 *1426–27
K The Virgin
In the upper register, left center. The writing on the arch, referring to Mary's immaculate purity, has been altered. The original version is in the *Kronijk van Vlaenderen*. The panel was extensively repainted about the middle of the sixteenth century; before the 1950–1 restoration, her mantle was bluish-green, because of the alteration of the ultramarine that Donselaer added in 1858,

with little or no respect for the modeling of the figure, the only concern being to "cover the cracks."

9 212,2×83,1 *1426–27
L God
In the center of the upper register, as in the case of the immediately preceding panel (q.v.), the text of the inscriptions on the arch (concerning the power and goodness of God) and on the step of the throne (concerning the inevitability of death) have been altered. The examination of the altarpiece in 1953 showed that Jan (?) had placed a layer of silver foil over existing painting and lettering (Hubert's) and had thus begun afresh in this area.

There is some doubt as to the exact nature, theologically speaking, of this central figure. He appears to be God in His triune essence, for He wears the appropriate triple papal crown; behind is a triple moulding; the brocade behind the throne is embroidered with the motif of the pelican feeding its young (symbol of Christ the Savior), the inscriptions (cf. Tolnay, p. 12, n. 4, Panofsky, p. 215) refer to God, Christ and the Trinity (*Rex regum*, and *Dominus dominantium* are, according to St Augustine, phrases describing the Trinity).

9 168,1×75,1 *1426–27
M St John The Baptist
The inscriptions in the arch above the Saint read: "This is John the Baptist, greater than man, equal to the angels, sum of the law, seed of the evangelists, voice of the apostles, silence of the prophets, lamp of the world." In the open book one can see the beginning of Isaiah 40, "Comfort ye," in Latin; this chapter contains the prediction of John the Baptist's work. Except for the figure of St John, the panel was extensively repainted by J. van Scorel and L. Blondeel (1550), probably to correct an earlier, unsuccessful restoration.

9 164,1×72,9 *1427–29
N The Angel Musicians
This painting is on the same panel as 9 D. Like its companion piece (9 J), it has been much repainted, except for the magnificent mantle of the organist and the floor (See 9 J for further details).

9 213,3×32,3 *1427–29
O¹ The Slaying of Abel
The symbols given above refer to the entire panel, right above, including 9 O² and painted on the same panel as 9 C. The subject, of course, is a presage of the death of the Redeemer. On the frame is an inscription from St Augustine's *Incarnatio Christi*, EVA OCCIDENDO OBFVIT.

O² Eve
On the same panel as 9 O¹ (q.v.). Above the arch is written the name EVA. Again, an entirely new and revolutionary nude. The body is rendered with total realism – as

with Adam, there is no attempt to idealize the human form. We are shown a figure from real life (setting aside the late-Gothic convention of the apparently pregnant stomach).

9 145×51
P The Just Judges
In the lower register, to the left, on the same panel as 9 F. This is a modern copy that J. van der Veken painted from the original, which was stolen on the night of 10 April 1934 (see introduction above). The subject is identified by the inscription on the frame, IVSTI IVDICES. In an ode to the polyptych (1559), Lucas de Heere identified the rider in front as being Hubert van Eyck and the fourth rider (the young man facing out of the picture) as his brother Jan. No great store should be set by this. Post (JP, 1921) thought he could identify the judges as Philip the Bold, Louis de Mâle, John the Fearless, and Philip the Good. In the copy of the altarpiece preserved in the Musée Royal des Beaux-Arts, Antwerp, this painting forms a perfect whole with 9 Q, but their positions are reversed, so that 9 Q comes before 9 P. This is also the case of 9 S and T: this corresponds to the first known description of the altarpiece (H. Münzer, 1495), but does not necessarily mean that the pieces were reversed, as one can see from the continuity of the landscape backgrounds (particularly notable in panels S and T) and the positions of the Donors (9 E and H) painted on the reverse of the same panels.

9 149,2×54 *1427–30
Q The Warriors of Christ
In the lower register, towards the left, on the same panel, as 9 E. The subject is identified by the inscription on the frame, CRISTI MILITES. There is another inscription on the shield of the rider in the center, D(ominu)s FORTIS ADONAY SABAOT V. EM(manu)EL I.H.S. XR. AGLA (for this abbreviation see 9 J). The three riders with the standard are generally considered to be Saints Martin (or Victor), George and Sebastian.

9 137,7×242,3 *1425–29
R The Adoration of The Lamb
In the center of the lower register. This is the central painting of the polyptych in theme as well as position, and the entire altarpiece is often referred to by the title of this panel. The central feature of the panel is the Lamb of God, which in the Gospel according to St John stands on the altar and pours out its blood into a chalice, symbolizing Christ's sacrifice. On the altar frontal is the inscription in Latin from John 1:29, "Behold the Lamb of God, which taketh away the sin of the world." Above this to the left is the inscription IHES(us) VIA, and to the right, VITA V (er) ITA(s). Around the altar are angels at prayer. Some bear the instruments of the

Passion and others carry censers. In the foreground is a bronze fountain with a golden statue of an angel; the inscription on the octagonal rim of stone makes it clear that this is the Fountain of Life, symbol of Redemption: HIC EST FONS AQV(a)E VIT(a)E PROCEDENS DE SEDE DEI (et) AGNI ("a pure river of water of life, clear as crystal, proceeding out of the throne of God and of the Lamb," (Revelation, 22:1). The water coming from the fountain forms a stream the bed of which is covered with rubies, pearls, and diamonds. Outside the semi-circle formed by the twelve Prophets on the left and the fourteen Apostles (including Matthew, Paul and Barnabas) on the right, four groups of figures converge towards the double symbol of Sacrifice and Mass from the four corners of the painting. In the left foreground are the patriarchs, one of whom (the bearded figure dressed in white and wearing a crown) is traditionally identified as Virgil. E. Schiltz (*Van Eyck Studien*, Antwerp 1960–2) claims to read the date 1417 on the red pointed hat of a prophet (PL. XXIV, lower left group, a little behind and to the right of the hatless bald head in the crowd. Not the bald man at the outer edge.). If he is right, scholars are confirmed in their guess that Hubert is the author of this group. Behind this group would be the holy bishops and confessors (dressed in blue and bearing palms in their hands). On the right are other saints in red, perhaps martyrs. Among them are Stephen (the deacon bearing stones) and immediately behind him, Lieven, the patron saint of Ghent, with the pincers holding the tongue. In the background are the Virgin saints, including Agnes, Barbara, Dorothy, and Ursula.

Dvořák first divided this panel between Hubert and Jan, giving to the former the two groups of figures in the foreground and the surroundings up to and including the altar of the Lamb (with most of the angels). He first pointed out that the perspective of this front part of the picture is considerably more false than that of the upper part. The ground is meant to slope in a level fashion towards the altar, but instead, seems to be going up. Most scholars would agree with the attribution to Hubert of the design of this part (the most important of the whole complex, and hence created by the original artist).

The landscape background, in its most rich and impressive parts (middle and upper planes) is generally ascribed to Jan (but Beenken would give the landscape and upper two groups of saints and martyrs to Hubert, cf. Wallraf-Richartz Jahrbuch II–III. 1933–4, p. 176 f.) The plants and flowers are painted with such accuracy that all have been identified. The palms, cypresses and orange trees must post-date Jan's Portuguese journey

(1428–9). The buildings represent here the Heavenly Jerusalem, but several can be identified. Pächt pleads for the re-admission of the Utrecht Tower (center, slightly left of altar) to Jan's acknowledged contribution.

The Dove poses iconographic problems for Panofsky: he would believe that in its place there was originally a glory (simply a golden semi-circle emitting rays), which would be more appropriate to an All Saints' picture. Traces were found of raised plaster rays, gilt, in the archaic fashion, and these, he believes, were part of the original design of a glory. Jan would have removed the plaster, but kept to the design.

9 148,6 × 53,9 *1427-30*

S The Holy Hermits
Painted on the same panel as

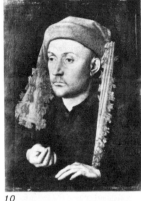

10

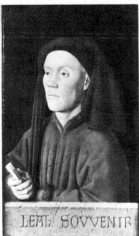

12 (Plate XXX)

9 H. The inscription on the frame reads HEREMITE S(an)C(t)I. The procession is led by St Anthony Abbot. Two female figures look out from behind the rocks; they are probably Mary Magdalene (identified by the vase) and St Mary of Egypt. These figures are Jan's according to Panofsky: compare St Mary of Egypt, however, with the Virgin in the upper register of the altarpiece.

9 148,7 × 54,2 *1427-30*

T The Holy Pilgrims
On the same panel as 9 G. The inscription on the frame reads PE(re)GRINI S(an)C(t)I. A gigantic St Christopher leads the group. The pilgrim with the shell

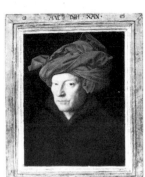

13 (Plate XXXII)

on his hat has been identified as St Jodocus. (For other information, see 9 P and S.)

10 17,5 × 15,5 1430*

Portrait of a Goldsmith
Bucharest, Museul de Artă
It has additions on all four sides and an apocryphal Dürer monogram with the date 1497. Formerly in the collection of Baron Brukenthal (1721–1803), who by his will (1802) turned his palace of Sibiu, Transylvania, into a museum and made provision that on the extinction of his male descendants, the palace would become the property of the local gymnasium. This happened in 1872. Voll, 1900; Fierens-Gevaert, 1905; Meiss, BM, 1952; Ragghianti, SA, 1953; Panofsky, 1953; and Bode, JP, 1901, have doubted the attribution to Jan. Friedländer (1924), Beenken (1941) and Baldass (1952) are in favor of the attribution.

11 34 × 27,5 1431-32

Portrait of Cardinal Nicolas Albergati Vienna, Kunsthistorisches Museum
The painting was listed in the inventory of the collection of Archduke Leopold William, governor general of the Low Countries in the following words (1659): *Ein Contrafait van Oehlfarb auf Holcz des Cardinals von Sancta Cruce, von Johann van Eyckh*. It was Weale (BM, 1904) who identified the subject as Albergati. Albergati was born in Bologna in 1375, entered the Carthusian order and was elected bishop of his city in 1417. When he was made a cardinal by Pope Martin V

(1426), he took as his titular church the Church of the Holy Cross in Jerusalem (in Rome). Noted for zeal and virtue, he was sent on nine embassies from the Vatican. In 1431, he visited the rulers of France and England and the Duke of Burgundy in order to create a general peace among those countries. Between 8 and 11 December 1431, he was in Bruges, at the Carthusians, and it may have been then that he posed for Jan. On the other hand, Albergati paid another visit to the Low Countries in 1435, staying not far away in Arras. Meiss argues, on stylistic grounds, that this portrait cannot be an early work and would place it after this second visit.

Jan first did a silverpoint drawing (in Dresden, Kupferstichkabinett, since 1765), in which he carefully noted in sixteen lines written in his own Limbourg dialect, the various colors to be used in the painting. The drawing has more spontaneity and immediacy than the painting. Weale (1908) commented that the panel was less natural and individual than the drawing, particularly in the handling of the mouth and the lower part of the face. It seemed to Weale that Jan had tried to improve the cardinal's lineaments in the painting and made the head smaller and lighter. Weale's identification was challenged by R. Weiss (BM, 1955). He casts some real doubt on the identification as Albergati, by citing Albergati's old biographers who insist that even when made a cardinal, he never at any time relinquished his monk's habit (he was a Carthusian). The red, fur-lined robe, which appears in both painting and drawing, is therefore, not easy to explain.

12 34,5 × 19 1432

Timotheos, or Portrait of a Young Man London National Gallery
On the painted stone parapet there is an inscription in large letters under the Greek word TYM. Ω EOC, which reads LEAL SOVVENIR (loyal remembrance). Beneath this is the painter's signature:

11 (Plate XXXIII)

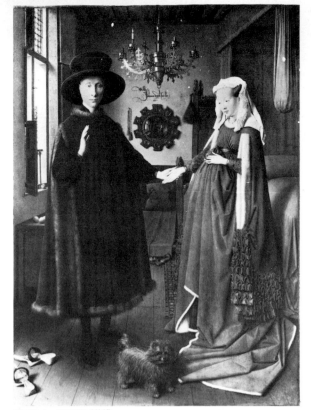

15 (Plates XXXVII–XLII)

Actu(m) *an*(n)*o d*(omi)*ni 1432.10 die octobris, a joh*(anne) *de Eyck*. Panofsky (JWCI, 1949) assumes that the portrait was painted by Jan as a gift to the man portrayed or for a gift that the man intended to make. He proposes, in his interesting essay, an identification of the sitter with Gilles Binchois. Binchois, Dufay and the Englishman Dunstable, were the great musical innovators of the first half of the fifteenth century. Medieval writers on music were aware of the antique fame of Timotheos (c. 400 BC),

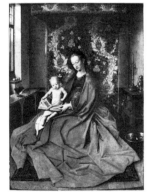

14 (Plate XXXIV)

particularly as the musical trio already mentioned, cites Timotheos in a list of the famous names of old (Orpheus, Arion, etc.). Binchois held a post at the court of Philip the Good, just like Jan; this Burgundian court was aware of the classicizing influences coming from France and Italy, and the Duke was constantly likened to Alexander, Caesar, etc. The French inscription would be appropriate in the case of a Burgundian courtier. Gilles was a poet, too, which is how Panofsky explains the script, rather than music, on the rod he carries. As M. Davies (National Gallery Catalogue, Flemish School 1955, 2nd ed.) remarks, the hypothesis is fascinating but unproven.

13 25,5 × 19 1433

The Man with the Red Turban London, National Gallery
With its original frame, the painting measures 33·5 × 26 cm. On the frame is written JOH(ann)ES DE EYCK ME FECIT AN(n)O MCCCC.33.21. OCTOBRIS. Above is the motto ΑΛC IXH XAN (*als ich kan* — as I can). About the mysterious subject Weale wrote that he seemed to be a wealthy merchant about sixty-five years old. Later, Weale (BM, 1910) and Aulanier (GBA, 1936) supposed him to be Jan's father-in-law, basing their opinion on his resemblance to Margaretha (28).

The picture was described in the 1655 inventory of the Duke of Arundel as "Ritratto di Gio. van Eyck, de manu sua." Meiss, followed by Panofsky, thought it a self-portrait (as did E. Durand-Greville, *Les Arts Anciens de Flandre,* 1905). He argued that this picture is one of the first examples of the sitter looking out of the picture at the spectator: a pose which is natural in the case of a self-portrait. Little weight can be placed on the age of the sitter: we do not know exactly how old Jan was in 1433, and it is in any case notoriously difficult to judge the age of sitters, especially in the Middle Ages and Renaissance.

14 26,5 × 19,5 1433

Madonna and Child (The Ince Hall Madonna) Melbourne National Gallery of Victoria
There is an inscription on the upper part of the wall: COMPLETU(m) AN(n)O D(omini) M CCCC XXXIIJ P(er) JOH(ann)EM DE EYC BRVGIS. To the right is the motto ΑΛC IXH XAN.

In 1893 Tschudi (RfK) noted (and Friedländer agreed [RfK, 1906]) that the inscription is clumsily painted. He assumed that it had been copied from

93

the original frame, which was lost. Notwithstanding the hitherto unquestioned attribution to Jan, doubts about its authenticity were raised in 1956, when the work was lent for an exhibition in Bruges. Some advanced the hypothesis that the work was an excellent fifteenth-century copy (W, 1959; H. Gerson, *Kindlers Malerei-Lexikon*, II, Zurich, 1965).

The picture is small and conveys a simplicity and intimacy which are quite different from Jan's pictures of formal enthroned Madonnas. The fruit, carafe of water, furniture, all indicate the Virgin's private chamber (as in a similar scene by Campin), despite the splendid brocade canopy. The bold assymetry of its pattern echoes the graceful pose of the Virgin and the arrangement of the drapery.

15 ⊞ ⊕ 82×59,5 1434 ▤ ⋮
The Arnolfini Wedding
London, National Gallery
The signature and date are painted on the wall over the mirror: *Johannes de eyck fuit hic* (was here) *1434.* The merchant Giovanni Arnolfini of Lucca settled in Bruges in 1420 and died there in 1472.

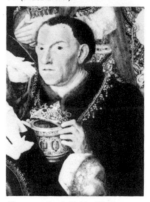

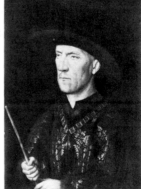

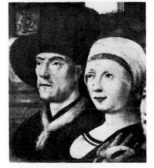

16 (Plates XLIII–XLVI)

Duke Philip the Good made him a knight. His wife, Giovanna Cenami, was also from Lucca, and she was still alive in 1490 according to one tradition. These wealthy Italians were quite at home in the Flemish city, where they had become members of the Confraternity of the Dry Tree, one of whose members was Petrus Christus. The mirror reflects not only the husband and wife and part of the room, but it also shows two people at the threshold of the room, a man dressed in blue (probably the painter) and a young man in red. Around the mirror are ten small round panels with scenes from the Passion, rendered in minute detail (reading from the bottom, counterclockwise): The Agony

in the Garden, The Arrest, Christ before Pilate, the Flagellation, Christ Carrying the Cross, the Crucifixion, the Deposition, the Entombment, the Descent into Hell, the Resurrection. The six-branched candlestick has one lighted candle (but it is broad daylight). Like the statuette of St Margaret that tops the chair back, this is a marriage symbol (Panofsky, Burl. Mag. LXIV 1934, p. 117H). The painting was considered a self-portrait of Jan and his wife Margaretha (who, as in the Bruges portrait [28], had entirely different features). This was the belief of Brockwell (*The Pseudo Arnolfini Portrait. A Case of Mistaken Identity*, London 1952) refused by Desneux (BMRB, 1955). A convincing analysis of the subject is Panofsky's (BM, 1934; JWCI, 1949): despite the absence of a priest, this is a painting of a marriage ceremony. Until the Council of Trent (1560), a priest was not strictly necessary. The two men reflected in the mirror are the two witnesses, including the painter, whose presence is confirmed by his inscription, *Johannes de eyck fuit hic* (but see also the objections of Swillens [NKJ, 1952–7]).

16 ⊞ ⊕ 66×62 *1435 ▤ ⋮
Madonna with Chancellor Rolin Paris, Louvre
Courtépée (*Description du Duché de Bourgogne*, Dijon, 1778) mentions the work as being in the sacristy of Autun Cathedral, in Burgundy. Since Nicolas Rolin came from Autun and his son Jean, was bishop of that city in 1436, it seems a reasonable hypothesis that the painting was donated by the Chancellor or his son to Autun Cathedral. Nicolas Rolin, born in Autun in 1376, was made chancellor of Burgundy and Brabant in 1422; in 1445 he founded the hospital (Hôtel-Dieu) of Beaune, for which he commissioned Rogier van der Weyden to paint the large

polyptych with *The Last Judgment* (1446). Rolin also appears, together with his lord, Duke Philip, in the famous miniatures of the *Croniques de Hainaut* (Brussels, Bibliothèque Royale), which has also been attributed to Rogier. Rolin died in 1462 (Abord, *Nicolas Rolin, chancelier de Bourgogne,* Dijon, 1898; J. Desneux, RdA, 1954). The city in the background has been identified, variously, as Maastricht, Liège, Utrecht, Lyon, Geneva, Autun, and others, but no theory has been found completely satisfactory. Three biblical episodes are depicted on the capitals of the pillars on the left: the Expulsion of Adam and Eve from Eden, the Sacrifice of Cain and Abel, and the Drunkenness of Noah. This painting is usually dated about 1435, but there are some notable exceptions. Seeck (*Die charakteristischen Unterschiede der Brüder Van Eyck*, Berlin, 1899) dated it to ca. 1422, and Voll (*Alterniederländische Malerei,* Leipzig, 1906) dated it to 1425. Weale put it before 1430, Friedländer probably after 1436 (*The Van der Paele Madonna*). This picture is one of Jan's most remarkable. Baldass has well shown the difficulty of the pictorial problem that Jan had to overcome. His donor has decided to appear before Christ and His mother without the hitherto indispensable saints or angels. Two figures then, have to confront each other in motionless poses. Jan carries it off by the charm and originality of the beautiful Romanesque palace (cf. Panofsky, Chapter 5 for symbolism), with its three central arches. These arches and the wonderful view beyond, so fascinate the eye that there is no danger of the two figures becoming merely heavy masses. The figure of the Child, though solemn, is alert and delicate: Baldass would see in him the Creator, as He holds the orb, and all that we see through the arches as Creation.

Just outside the open room is a little garden, full of birds and flowers, especially lilies for the Virgin. The *hortus conclusus,* or garden enclosed, was very often part of the depiction of the Virgin in the Middle Ages. Rogier van der Weyden's panel of *The Madonna with St Luke,* Boston, is closely based on this picture.

17 ⊞ ⊕ 40×31 *1435 ▤ ⋮
Man with a Pink Berlin, Staatliche Museen, Gemäldegalerie-Dahlem
The unknown subject wears the order of St Anthony, founded in 1382 by Albert of Bavaria, Count of Hainaut. It was originally a military order, but in 1420, under John of Bavaria, it was transformed into a pious society. In a chapter ordinance issued on 11 June 1420, it was prescribed that the tau and bell worn by knights and ladies were to be of gilded silver, while those worn by common citizens were to be of silver.

17 (Plate LXIV)

The man depicted in 17 also appears in The Adoration of the Magi *painted by the Master of the Aachen Altar (Mehlem am Rhein, Neuerburg Collection). The fact that the man in* The Adoration *is holding a vessel in his left hand has suggested that the figure was copied from 17. A similar figure in an* Epiphany *(Basel, Kunstmuseum) by B. Bruyn, would seem to support this hypothesis.*

19 (Plate LVI)

The portrait of Baudouin de Lannoy reproduced — among the figures, center right — by an unknown painter about 1500 in the panel of St Bernard and Conrad III *in Cologne (Wallraf-Richartz Museum).*

Schöne, Friedländer (1924), Cornette (*De portretten van Jan van Eyck,* Antwerp 1947) accept the work as Jan's: Schenk (ZK 1949) thought it a self-portrait by Hubert. Modern critics, following Voll, are relucant to include the work in Jan's canon: one of the main objections is the coloring, and the very light tones of the flesh. The open mouth and restless left hand are also out of keeping with the calm and secret effect of Jan's other portraits. According to a botanical expert, the late Mrs Eleanor Marquand, the type of pink was not known before the second half of the fifteenth century (cf. Panofsky, no. 2 for page 201 on p. 438).

18 ⊞ ⊕ 93×37 *1435 ▤ ⋮
The Annunciation
Washington, National Gallery of Art (Mellon Collection)
Transferred from panel to canvas. In all probability it is the left panel of a triptych. The setting of this *Annunciation* is adorned with a variety of decorations. Old Testament scenes are depicted on the floor: Samson Slaying the Philistines, Samson and Delilah, Samson destroying the Temple, David and Goliath, etc. On the medallions are signs of the zodiac (Gemini, Cancer, Leo, Scorpio, Sagittarius, etc.). On the back wall, between the Gothic arches, are two medallions showing Isaac and Jacob. In the stained-glass window Christ is standing on the globe, holding a sceptre and an open book. Next to this are frescoes of the Finding of Moses (left) and Moses receiving the Tablets of the Laws (right).

This picture is another example of two figures in a closed room (cf. *The Arnolfini Marriage* and the *Rolin Madonna*). The "room," however, is a church, and Panofsky usefully compares this picture with the Berlin *Madonna in a Church.* (For the architectural symbolism, cf. Panofsky's Chapter 5). The upright slim figures set in the tall and impressive architecture, the splendor of Gabriel's robes and crown and the similar attire of the Virgin (Berlin) link these two pictures quite closely.

19 ⊞ ⊕ 26×20 *1435* ▤ ⋮
Portrait of Baudouin De Lannoy Berlin, Staatliche Museen, Gemäldegalerie-Dahlem.
Baudouin de Lannoy, known as the Stammerer, Lord of Molembaix, was presented with the collar of the Order of the Golden Fleece, of which order he was made a knight on the very day that Duke Philip the Good founded the order (10 January 1430). Baudouin's collar had been made by the Bruges goldsmith Jean Peutin and was given to Baudouin on St Andrew's Day, 1431 (Weale, 1908). Thus, this portrait was probably painted before that date. Baudouin de Lannoy (1386/7–1474) had

become governor of Lille in 1423, captain of the castle of Mortagne in 1428, and had taken part in the 1428–9 mission to Portugal in which Jan van Eyck also took part (see *Outline Biography*). A pen drawing taken from this portrait is in the well-known Arras Codex, the work of Jacques Leboucq (d. 1573). (This album, which contains pictures of various persons connected with the court of Burgundy, formerly in the Abbey of St Vedast, is now in the Bibliothèque Municipale, Arras.) The drawing bears the following inscription: *Baulduyn de Lannoy dit le Besgue sieur de Molembais*, and this provided the identification of the painting's subject (Dimier, CdA, 1900).

20 ⊞ ✦ 29×20 1435* 目 ⋮
Portrait of Giovanni Arnolfini Berlin, Staatliche Museen, Gemäldegalerie-Dahlem.
For information about Giovanni Arnolfini, see 15. According to Beenken (1941), it may have been painted the year after the double portrait in London; Friedländer (1924) considers the two works approximately contemporary.

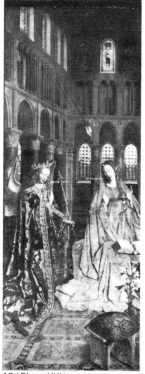

18 (Plates XXXV –XXXVI)

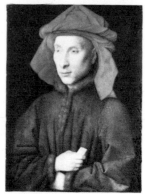

20 (Plate XXXI)

Kämmerer (1898) believes the Berlin painting was done several years after the one in London. Baldass agrees (1952) as does Meiss and dates it ca. 1437–9. At the 1886 auction, the painting was sold as a self-portrait of Jan van Eyck, and this hypothesis was revived by Brockwell (*The Pseudo-Arnolfini Portrait*, London, 1952.).

21 ⊞ ✦ 122×157 1436 目 ⋮
The Madonna with Canon van der Paele Bruges, Musée Communal des Beaux-Arts
Signed and dated on the bottom of the frame: *Hoc op(us)fecit fieri mag(iste)r georgi(u)s de pala hui(u)s ecclesiae canoni(cu)s p(er) johanne(m) de eyck pictore(m): et fundavit hic duas capell(an)ias de gremio chori domini m.cccc.xxxiiij; c(om)p(le)t(um) (an (no) 1436).* The frame also bears a religious inscription (HEC EST SPECIOSIOR SOLE – SVPER OMNEM STELLARVM DISPOSICIONEM. LVCI COMPARATA INVENITVR PRIOR CANDOR EST ENIM LVCIS ETERNE – SPECVLVM SINE MACVLA DEI MAIESTATIS, referring to the Virgin above; and concerning St Donatian on the left, SOLO P(ar)TV NON(u)S FR(atru)m MERS(us) VIV(us) REDDIT(ur) ET RENAT(us) ARCHOS P(at)R(u)M REMIS CONSTITVITVR QVI NV(n)C DEO FRVITVR; on the right and referring to St George: NATVS CAPADOCIA XPO MILITAVIT MVNDI FVGIE(n)S CESVS TRIVMPHAVIT HIC DRACONEM STRVIT. On St George's cuirass is the word ADONAI. Confirming the identity of the saint on the left as St Donatian and of that on the right as St George are the two inscriptions on the edge of the painting below them: S(an)C(tu)S DONATIAN(u)S ARCHIEP(iscopus) S and S(an)C(tu)S GEORGIVS MILES XPI.) In the corners of the frame are the insignia of Canon van der Paele and of the family Carlijns, his mother's family (Weale, 1908). The canon's name was George, hence the choice of saint to present him to the Madonna. Van der Paele became canon in 1410 and died in 1443 at an advanced age, after a serious illness that had lasted at least the last ten years of his life. He was very well-to-do and gave the Church of St Donatian in Bruges this painting and a valuable reliquary (Weale, 1908). The scene of the painting is a round Romanesque structure or the apse of a church (not that, however, of St Donatian in Bruges or any other known church). The two small statues on the throne of the Virgin depict Cain slaying Abel and Samson strangling the lion. In niches below, these statues are Adam and Eve. The main figures in the painting are about two-thirds life size.

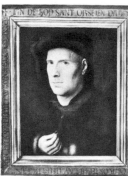

22 (Plate LVII)

Weale (1908) noted the lack of idealization in the faces with some disapproval. We may agree that the Madonna is rather heavy, and that in the Canon we are given an utterly realistic portrait. But although the figures may not charm, they impress. The picture epitomizes that immobility, silence and splendor of inanimate objects (jewels, stuffs, burnished metal) which are Jan's special characteristics. Every detail is rendered with extreme accuracy, but, as Baldass remarks, the construction of the whole does not, therefore, suffer. Note how the images of the mother and child, the light from a window

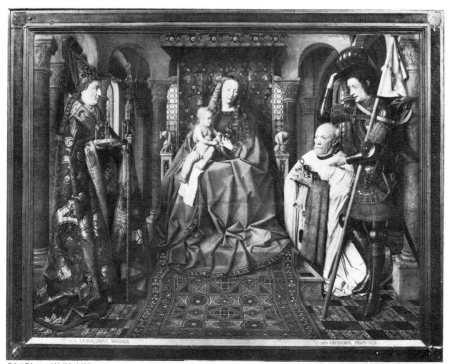

21 (Plates XLIX-LIII)

are reflected in the helmet of St George.

22 ⊞ ✦ 24,5×19 1436 目 ⋮
Portrait of Jan De Leeuw Vienna, Kunsthistorisches Museum
With the original frame the panel measures 33 × 26 cm. On the frame is a Netherlandish inscription: JAN DE (Leeuw) OP SANT ORSELEN DACH DAT CLAER EERST MET OGHEN SACH 1401 GHECONTERFEIT NV HEEFT MI IAN VAN EYCK WEL BLIICT WANNEERT BEGA(n) 1436. ("Jan de Leeuw, who opened his eyes to the light on

which the spectator cannot see, St Ursula's Day in 1401; here I am painted by Jan van Eyck, who depicted me in 1436.") Instead of the goldsmith's name, Jan painted the figure of a small lion (Leeuw), which Weale (1908) says the goldsmith used as his mark. Jan de Leeuw, born – according to the inscription – on 21 October 1401, was one of the most active members of the goldsmith's guild of Bruges. He was elected its deacon in 1441. He was still living in Damme in 1459. This painting (mentioned for the first time in Mechel's catalogue of the Belvedere Gallery [1783]) has suffered some damage, but J. Hajsinek's careful restoration (1949) has notably improved its condition.

23 ⊞ ✦ 65,5×49,5 1436* 目 ⋮
Madonna in an Interior (The Madonna in her Chamber, or the Lucca Madonna) Frankfurt, Städelsches Kunstinstitut
On Mary's throne are four small statues of lions, alluding to those on the throne of Solomon. Critics generally assign the picture to the last five years of Jan's activity: ca. 1435–40 (Wieszäcker, *Katalog der Gemälde des staedelschen Kunstinstituts*, 1900); ca. 1435–6 (Baldass, 1952); ca. 1436–7 (Tolnay, 1939); ca. 1437 (Friedländer, 1924); ca. 1438 (Beenken, 1941); 1436–7, Panofsky.

This picture lends itself naturally to comparison with the other Madonna in her Chamber, *The Ince Hall Madonna* (14). A narrow private chamber is depicted in both, but in the Lucca Madonna the sense of privacy and intimacy is much less strong. The Madonna has a large and imposing throne, there is a canopy above her head, and she and her child both sit very straight. The figure is far larger and more dominating.

In appearance the Madonna is very close to *The Madonna of Canon van de Paele* (21). The face is similar, the hair is bound with the same jewelled fillet, the robe seems to be almost identical, and its folds are arranged in the same kind of heavy geometric mass. These are good reasons for the comparatively late dating.

The Thyssen Annunciation
Consisting of two panels in *grisaille*, this picture is in the Thyssen Collection, Lugano. This work and the St Jerome in Detroit are the only originals by Jan van Eyck to be discovered in the last decades. It was published by Friedländer in 1934 (BM), who considered it the exterior portion of a lost triptych, to be dated between *The Ghent Altarpiece* (9) and the Antwerp *Madonna* (29). But according to the catalogue of the Thyssen Collection (1949) and in the view of Panofsky, they are not panels of a triptych but a complete work, i.e., a portable diptych that folds down the center. The back is covered

Small gold statue (Liège Cathedral) reproducing the two figures on the right in 21.

95

with plaster painted to simulate marble (see also S. Sulzberger [RBAH, 1950]). The attribution to Jan is generally accepted by Baldass (1952), who dates it to ca. 1434–6 and Panofsky c. 1436. It is very well preserved. (The symbols given for the angel also apply to the angel of the Virgin.)

The two panels are remarkable instances of clever *trompe l'oeil*. The figures appear to stand before the frames, which are simulated, and to increase the three-

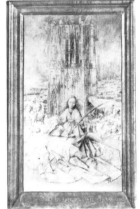

26 (Plate LVIII)

dimensionality and the illusion of their being stone statues. The painter has given them a background of dark marble, polished so highly that the backs of the 'statues' are reflected in it.

24 ⊞ ⊕ 39×24 / 1436* ▤ ⋮

A The Angel of The Annunciation
On the frame is the following inscription: AVE GRA(tia) PLENA D(omi)N(u)S TECV(m) B(e)N(e)D(i)C(t)A TV I(n) MVLIE(ribus).

B The Virgin of The Annunciation
On the frame is the following inscription: ECCE ANCILLA DOMINI FIAT MIHI S(e)C(un) D(u)M V(er)BV(m) TV(um).

The Dresden Triptych

Composed of five elements painted on oak, this very small work measures 27·5 × 21·5 cm closed, and 27·5 × 37·5 cm open. With the original frame, the measurements are 33 × 27·5 and 33 × 53·5 cm respectively. The work is in the Dresden Gemäldegalerie. On the outer panels are the figures of the Annunciation in *grisaille*. Inside, the central panel shows the Madonna Enthroned with Christ in a richly decorated Romanesque church. On the left are St Michael and a donor. On the right is St Catherine. These latter are depicted as being within the same church as the Madonna, in side aisles. The frame bears long Latin inscriptions concerning the various figures depicted in the panels (see the individual entries below). In 1958, when the frame was cleaned, there came to light on the lower edge of the central panel the following inscription: *Johannes de Eyck me fecit et co(m)plevit Anno Domini M CCCC XXX VII* (H. Krauth, DG, 1958; H. Menz, JSK, 1959). Among critics who had proposed dates for this painting, Kämmerer (1898) and Bruyn (1957) turned out to have been right. Others had dated it earlier: 1427–30 (Beenken, 1941); 1430–4, Baldass (1952); ca. 1433, Tolnay (1939); 1434–6, Friedländer (1924).

Because of the grace of the figures and a certain sweetness in the faces, scholars had felt this picture to belong to an earlier phase than the solemn period of the Van de Paele *Madonna* (1436). Thus Panofsky put it c. 1430–1. The slender and delicate *St Catherine* is close to Giovanna Cenami (1432). It would be possible to argue that the "complevit" of the inscription could be interpreted as "completion after some years." However, it is absurd to stick to theories when the evidence goes against them, and undoubtedly Jan was able to paint gracefully or majestically as he chose. It is worth remembering that the *St*

Barbara, dated 1437, is in a very refined and graceful manner.

According to Benoit (CdA, 1899) the triptych is the one listed as No. 266 in the inventory of the E. Jabach Collection, Paris, which was prepared on 17 July 1696. It is certain, in any case, that the work was already in the Royal Gallery in Dresden in 1754 (as a work by Dürer; see the entry by A. Mayer-Meintschel in that gallery's recent catalogue [*Niederländische Malerei, 15. und 16. Jahrhundert*, Dresden, 1966]).

25 ⊞ ⊕ 27,5×8 / *1437 ▤ ⋮

A The Angel of The Annunciation
The outer left panel. The angel is depicted as a statue, painted in *grisaille*. He is a smiling Gabriel and his body conveys movement, in contrast to the Gabriel in the Thyssen-Lugano Collection (24). The symbols given above also apply to the panel of the Virgin.

B The Virgin of The Annunciation
This is the outer right panel. The Annunciate, like Gabriel, is painted, with greater movement than her counterpart of 24. (For other information, see 25A above.)

25 ⊞ ⊕ 27,5×8 / *1437 ▤ ⋮

C St Michael and Donor
This is the inner left panel. The inscription on the frame concerning the archangel reads: HIC EST ARCHANGELUS PRINCEPS MILICIE ANGELORVM CVIVS HONOR PRESTAT BENEFICA P(o)P(u) LORV(m) E(t) OR(aci)O P(er) DVCIT AD REGINA DELORV(m) HI(c) ARCHANGELVS MICHAEL DEI NVNCI(u)S DE A(n)I(m) AB(u)S IVSTIS, GRA(cia) DEI ILLE VICTOR IN CELIS RESEDIT A PACIS. The donor is unidentified. But the crest on this part of the frame has been associated with the Giustiniani family of Genoa by Woerman (Catalogue, 1908) and Weale (1908). Note the youthful, gay character of St Michael in contrast to the St George in 21.

25 ⊞ ⊕ 27,5×21,5 / 1437 ▤ ⋮

D Madonna and Child Enthroned
This is the central panel. The inscription on the frame (aside from that with the artist's signature mentioned above) refers to the "luminous" attributes of the Virgin: HEC EST SPECIOSOR SOLE – SVP(er) O(mn)EM STELLARV(m) DISPOSICIONE(m) LVCI COMPA(ra)TA I(n)VE(n) IT(ur) PRIOR: CA(n)DOR E(st) ENI(m) LVC(i)S ETERNESPEC(u)L(u)M S(ine) MACVLA DEI MAIESTATIS EGO QVASI VITIS FRVCTIFICAVI SVAVITATE(m) ODORIS: E(t) FLORES MEI F(ru)CTVS HONORIS- HONESTATIS

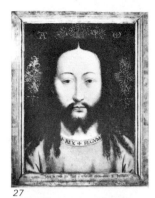

27

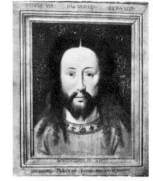

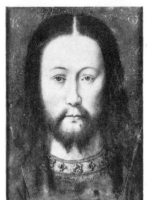

30

·EGO M(ate)R PVLCHRE DIL(e)C(ti)O(n)IS – TIMORIS – MAGNITVDINIS – S(an)C(t)E SPEI. On the scroll in Christ's hand is an inscription in Gothic characters from St Matthew (11:29): "Learn of me; for I am meek and lowly in heart." The charming Romanesque church in which the scene is set has not been identified. Several capitals are carved and all have statues. The throne is decorated with four bronze sculptures: Abraham and Isaac, David and Goliath, the pelican, and the phoenix. The Christ child is one of Jan's most attractive.

25 ⊞ ⊕ 27,5×8 / *1437 ▤ ⋮

E St Catherine of Alexandria
This is the inner right panel of the polyptych. The inscription on the frame refers to St Catherine (who is easily recognized by the crown, the sword and the wheel): VIRGO PRVDENS ANELAVIT AD SEDEM SIDEREA(m) VBI LOCVM P(re)P(ara)VIT, LINQVENS ORBIS AREAM GRANVM SIBI RESERVAVIT VENTILA(n)DO PALEA(m), DISCIPLINIS EST IMBVTA PVELLA CELESTIB(u)S NVDA NVDV(m) E(st) SECVTA CERTIS X(Christi) PASSIB (u)S DV(m) MV(n)DA(n)IS E(st) EXVTA.

26 ⊞ ⊕ 34×18,5 / 1437 ▤ ⋮

St Barbara Antwerp, Musée Royal des Beaux-Arts
Signed and dated on the original frame, below: IOH(ann) ES DE EYCK ME FECIT. 1437. Drawn in brown in brushpoint on a plastered panel. Opinions are divided as to whether this brush drawing is a preparatory study for an oil painting, or

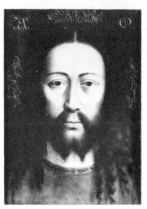

(Above) Head of Christ (Bruges, Musée Communal) copied from Jan van Eyck (30). Another (Munich, Bayerische Staatsgemäldesammlungen), once attributed to Jan (see 30).

whether it is a finished work in itself. Baldass considers it a preparation. Winkler (P 1929) thought that no preliminary drawing would contain such minute detail, and he cites the two fifteenth-century drawings of the Ypres *Madonna*, unfinished at the time of Jan's death. There, the drawing is far less detailed. Panofsky argues on the same lines, pointing further to the carefully made frame and the beautifully lettered inscription by the artist as evidence that the work was meant to stand as it is. As it is a unique example in Jan's *œuvre*, it is not easy to make a final judgment. The blue painted in the sky was added by a later hand.

Van Mander (1604) mentions it as being in the

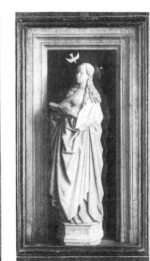

24A (Plate LIV)

24B (Plate LV)

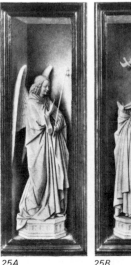

25A

25B

collection of Lucas de Heere, the Ghent painter and poet, a small picture by Jan with "a portrait in a landscape" that was only drawn. Some scholars believe this to have been *St Barbara*. Nevertheless, Van Mander's description is too vague to make this identification certain. This identification has been rejected by such other scholars as A. Sjöblom *(Die koloristische Entwicklung in der niederländischen Malerei*, Berlin, 1928). Weale (1908) mentions copies in the museums of Bruges and Lille, and rightly argues that the work is also important from an historical point of view, because of the information it provides on building techniques in the fifteenth-century. The remarkable beauty of the landscape, so impressive in its treatment of perspective space and with the small figures that seem to anticipate Brueghel the Elder, has been especially noted by F. von Schubert-Soldern *(Von Jan van Eyck bis Hieronymus Bosch. Ein Beitrag zur Geschichte der niederländischen Landschaftsmalerei*, Strasbourg, 1903). The treatment of the theme is entirely original. The Saint was normally shown with her tower in her hand (as e.g. she appears among the first Virgins in *The Adoration of the Lamb* [9 R]); the idea of making the tower into an artistic feature as important as the Saint was quite new. Baldass calls attention to representations of the Tower of Babel, whence the busy workmen and lookers-on are similarly depicted.

27 ⊞ ⊘ 44×32 ⧉ ⦂

Head of Christ Berlin, Staatliche Museen, Gemäldegalerie-Dahlem
This is a copy of a work by Jan van Eyck. See 30 below.

28 ⊞ ⊘ 32,5×26 1439 ⧉ ⦂

Margaretha Van Eyck
Bruges, Musée Communal des Beaux-Arts
There are two inscriptions on the original frame. Above:
CO(n)IVX M(eu)S IOH(ann) ES ME C(om)PLEVIT A(n)NO 1439 17 IVNII. Below:

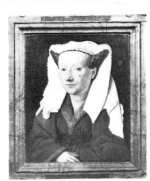

28 (Plate LX)

(A) ETAS MEA TRIGINTA TRIV(m) AN(n) ORV(m) A \C IXH XAN. We know the first name of Jan's wife (thanks to a document of 12 July 1441), but we do not know her family name. Born in 1406, she must have married the painter shortly before 1434, the year in which her first child was born. Although the sitter's face is not attractive, the portrait is superb. The observant, intelligent gaze and the unfathomable personality are impressive. The hallmarks of Jan's portraits are quietness and the sense of the distilled human personality which yet is thoroughly secret. It is on these grounds, as well as on external grounds, that doubts have been felt about *The Man with the Pinks* (17) and *The Goldsmith* (10), in Bucharest

29 ⊞ ⊘ 19×12 1439? ⧉ ⦂

The Madonna at the Fountain Antwerp, Musée Royal des Beaux-Arts
Signed and dated on the original frame. Above: A ΛC IXH XAN. Below: IOH(ann) ES DE EYCK ME FECIT C(om) PLEVIT AN(n)O 1439. This is probably the painting listed in the inventory made in 1516 of the collection of Margaret of Austria, the governor of the Netherlands, as "a small Madonna, done by a good hand, in a garden where there is a fountain." Mechelen's inventory of 1523 probably refers to the same painting as "another small panel of Our Lady holding her Child, Who holds a small paternoster of coral in his hand, very old, and having a fountain before her and

two angels holding a gold-figured drapery behind her." O. Kerber (DM, 1953) considers *The Madonna at the Fountain* a youthful work and considers the date of 1439 on the frame as a later alteration. And, in fact, it is hard to accept the fact that this composition reflects Jan's style two years before his death. But there is no reason to suspect that the autograph inscription has been falsified. The inscription reads *fecit et complevit 1439*: it is possible that the date may only

refer to the completion of the painting. As far as we know, Jan only began to sign and date his works in 1432, and he may in this case have framed and signed in 1439 a youthful painting, one from the period 1425–30. The same possibility exists for Jan's only other similarly inscribed work, *The Dresden Triptych* (25), which also gives an "early" impression. Panofsky maintains that Jan's final period is characterized by a deliberate archaicism.

In the Kupferstichkabinett,

30 ⊞ ⊘ 24×16 1440 ⧉ ⦂

Head of Christ as King of Kings Newcastle-upon-Tyne, Miss J. Swinburne Collection (?)
On the back of this painting is a note with the following inscription: "This head was pain . . . by John van Eyc . . . 30 January 1440 his name and date of the year was written by himself on the frame which (my father) sawed off. T. T. West (1784)." In the Musée Communal, Bruges, there is another version of the same

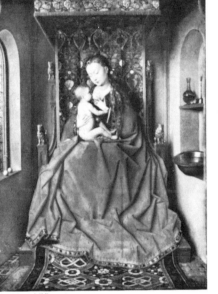

23 (Plate LIX)

An old drawn copy of 29 perhaps by the school of Van Eyck (Berlin, Kupferstichkabinett).

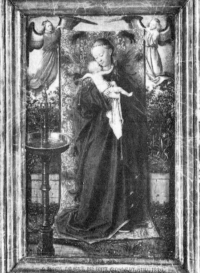

29 (Plate XLVIII)

Berlin, there is an old drawing derived from this painting and published by Weale (1908). According to Weale, there is also a fine copy of *The Madonna at the Fountain* in a Flemish book of hours formerly in the possession of E. H. Lawrence, Abbey Farm Lodge (Hampstead, London). There is an imitation in the second half of the fifteenth century in which the drapery behind the Madonna is missing and is replaced by a background of various plants. It is in the Berlin Museum (no. 525 B). This work has been attributed to Hubert or Jan himself, but as Kämmerer has shown (1898), it is the work of an "unknown imitator" of Van Eyck. There is another imitation that is more interesting and seems older. It belonged to the collection of William II, King of the Netherlands in the nineteenth century, and later passed to English collections before it went to the Metropolitan in New York. In this imitation the Madonna and Child (who also has His left arm around His mother's neck) are in an architectural setting. A fine painting, it is dated about 1450. Its apparent similarities to the style of Petrus Christus have led the authors of the Metropolitan Museum catalogue (1947) to attribute the painting to him. Rogier van der Weyden's standing Madonna, in the Vienna Gemäldegalerie is related to our picture.

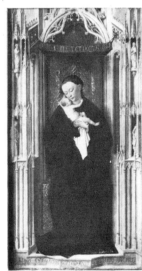

(Above) Copy of 29 (New York, Metropolitan Museum). (Below) Derivation of 29 (Berlin, Staatliche Museen).

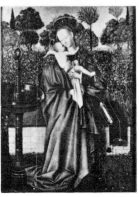

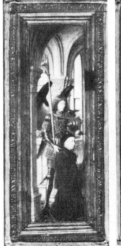
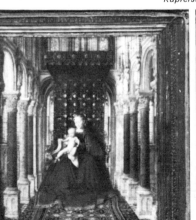
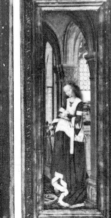

25 C, D & E (Plate XLVII)

97

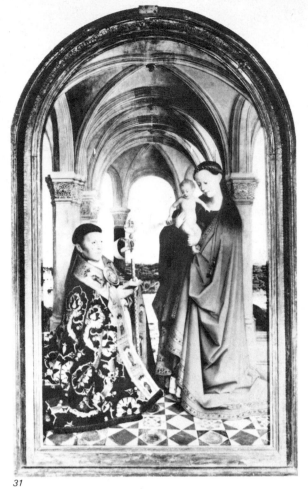

31

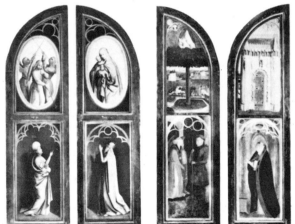

The panels formerly added to painting 31 (Warwick Castle Museum). Left, the exterior of the panels: in the upper register, Angel blowing trumpets *(with the inscription* ara cœli*) and* Madonna and Child *(with the inscription* maria*). In the lower register: a* Sibyl *(sibilla) and a* Prophet *(octavianus). Right, the interior of the panels: above are the* Burning Bush *(rubus ardens et non comburens) and* Ezekiel's Closed Door *(porta ezechielis clausa).*

Old drawn copies of 31 in the unfinished state in which Jan van Eyck left it. The drawing on the left is in Vienna, Albertina; the other is in Nuremberg, Germanisches Nationalmuseum.

composition which appears to be an old copy, in which the date which appeared on the lost frame of the Newcastle painting is copied, together with the painter's signature (*Joh*(ann)*es de eyck Inventor anno 1440 30 Januarij*), his motto (A∧C IXH XAN), and some Latin phrases (SPECIOS(us) FORMA P FILIIS HO(m)I(nu)M and .IHESVS VIA . IHS VERITAS . IHESVA VITA) that appear in the painting itself (A. Janssens de Bisthoven, *Musée Communal des Beaux-Arts*, Bruges, Antwerp, 1959, 2nd ed.). The Swinburne version was published by Conway (BM, 1921) as an original by Jan. Friedländer (1924) and Baldass (1952) agree in principle to this attribution.

In a copy of this presumed original (Berlin), the light comes from the right and the frame is inscribed: *Joh*(ann)*es de eyck me fecit et aplevit* (i.e., *complevit*) *anno 1438 31 Januarij*. AME (i.e., A∧C) IXH XAN. (The errors in the inscription are probably due to the copier's ignorance; he also copied the other Latin inscriptions from the original frame.) A second old copy of this painting, likewise of high quality, is in the Alte Pinakothek, Munich, but without the original frame.

These heads, unfortunately unknown in their originals, inspired, among others, Memling and Quentin Metys.

31 ▦ ⊕ 172×99 / 1441 ▤ ⁝

The Madonna of Maelbeke (The Ypres Madonna) Warwick Castle, Private Collection On the lower edge of the cloak of Provost Nicolaes van Maelbeke, Weale (1908) read the following inscription: ANTE SECVLA CREATA SVM ET VSQVE AD FVTVRVM SECVLVM NON DESINAM ET IN HABITATIONE SANCTA CORAM IPSO MINISTRAVI ET SIC IN SION FIRMATA SVM. On the scroll the Child holds is written *Discite a me quia mitis sum et humilis corde iugum enim suave est et onus meum leve* (''Learn of me; for I am meek and lowly in heart . . . For my yoke is easy, and my burden is light'' [Matthew 11:29–30]). On the frame is a long invocation of the Virgin in Latin that begins: SANCTA MARIA SVCCVRRE MISERIS IVVA PVSILL-ANIMES . . . The work was commissioned from Jan van Eyck by Nicolaes van Maelbeke, the twenty-ninth provost of the Abbey of St Martin in Ypres. He held this post from 1429 until his death in 1445. An old drawing in the Vienna Albertina (27·8 × 18 cm) and one in the Germanisches Museum, Nuremburg (13·5 × 15 cm) confirm that Van Eyck left this painting unfinished. In both drawings the figure of the donor is only sketched and there are no details of landscape. Who colored the figure of the provost and added the rich details of the whole painting is

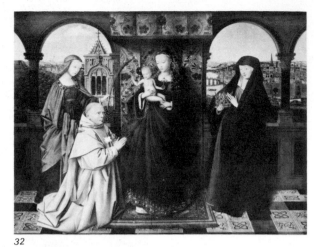

32

Copy of 32, presumably by Petrus Christus, now in Berlin (Staatliche Museen).

now not known. The existence of the two drawings already mentioned suggests that some time passed before another painter dared to put his hand to a painting left unfinished by Jan. Since there is a derivation of the figure of Van Maelbeke in a panel of ca. 1490, published by Weale (*Madonna and Child with a Provost of St Martin at Ypres*, London, Heyman-Ellis Collection), one might infer that the painting had been completed by another artist before the end of the fifteenth century. The two side panels, barely sketched out, that were added to the picture long ago (Friedländer, 1967) have turned out not to be the work of Van Eyck, either. Panofsky would call the design Jan's, and of the execution, only the vaulted roof and capitals. Note that the donor, like Chancellor Rolin, has no saint or angel introduce him to the Virgin's presence.

Derivation of 31, painted about 1490 (London, Heyman-Ellis Collection).

32 ▦ ⊕ 47×61 / 1441-43 ▤ ⁝

Madonna and Child with St Elizabeth of Hungary, St Barbara and Jan Vos (The Jan Vos Madonna) New York, Frick Collection The identity of the donor, whom Weale (1908) mistook for Herman Steenken (d. 1428), was established, thanks to the discovery of important archive documents by H. J. J. Scholtens (OH, 1938). He has shown that the painting was in the Carthusian monastery of Genadedal, near Bruges. It was the gift of Jan Vos, the prior of the monastery from 1441 to 1450. The painting was unveiled by an Irish bishop, Martin of Mayo, on 3 September 1443. In 1450, Vos was transferred to Nieuwlicht, near Utrecht, and took the painting with him. To compensate the monastery of Genadedal in some way, he (according to Scholtens' hypothesis) had Petrus Christus paint a small copy without the figure of St Elizabeth. This panel would be the one by Christus now in Berlin (19 × 14 cm), in which Jan Vos seems some-what older. Van Eyck began his painting no earlier than 30 March 1441 (the day on which Vos' predecessor died). But on Van Eyck's death, 9 July 1441, the picture must still have been in its first stages. Another painter, almost certainly Petrus Christus, finished the work, and it is Christus' fault that the faces are too smooth, the hands not articulated, and the draperies rather wooden, while the landscape (derived from that of *The Rolin Madonna*, 16) does not seem airy. The beautiful composition of the picture, however, is due to Jan van Eyck. In the case of this painting, then, the evidence of documents and stylistic analysis perfectly complement each other.

33 ▦ ⊕ 20×13 / 1442 ▤ ⁝

St Jerome in his Study Detroit Institute of Arts This picture first became known when W. R. Valentinen bought it for the Detroit Museum in 1925. Opinions about it have been various until the cleaning of the panel in 1956. Valentinen thought it by Petrus Christus; so did Friedländer

33

35 (Plate LXI)

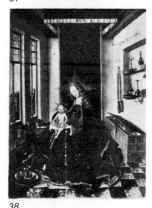

37

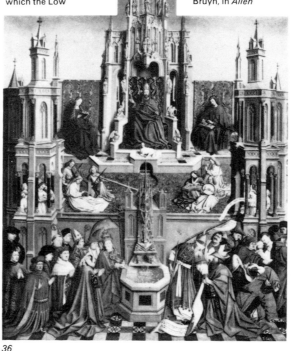

38

(*Kunstwanderer*, VI, 1925; *Apollo I*, 1925); Lambotte (*Apollo* V, 1927); Winkler (*Festschrift für Max J. Friedländer*, Berlin 1927). Winkler thought it based on a design by Jan. Baldass, (*Belvedere*, 1927) made the suggestion that it was a youthful work by Jan. In 1932 Dr Valentinen put forward a new suggestion (unpublished lecture) that the work was by the hands of both Jan and Christus. He had had detailed photographs taken, and for the first time a minutely painted date, 1442, was noticed on the

wall behind Jerome's head (cf. the article by E. P. Richardson in *Art Quarterly* 1956, "The Detroit St Jerome by Jan van Eyck"). As Jan died in 1441, the date would have been added by Christus who would have finished the work.

That Jan certainly was the author of a painting of St Jerome in his study, is known from the inventory of 1492, made for Lorenzo de'Medici in Florence. It lists "a small Flemish panel in oils, in an étui, showing a St Jerome engaged in study, with a bookcase containing several books in perspective and a lion at his feet: a work of Master John of Bruges' (from Weale-Brockwell, p. 201).

Before the cleaning of the picture, the robe in particular, and the lion, seemed so badly painted that an attribution to Jan seemed doubtful. Richardson (q.v.) says that over-painting was particularly heavy in these areas. The refinement of the whole conception, the intelligent reflective face of the reading saint, his beautifully painted hand, the fingers keeping places in the book all indicate a painter of great intelligence and great skill. No one c. 1442 seems to answer this description other than Jan van Eyck. A. Chatelet's hypothesis of a Dutch painter, responsible for the "Hand H" miniatures of the *Turin-Milan Hours*, for the New York panels, for the *St Francis* and for our picture, carries little conviction (A. Chatelet, "Les Enluminures eyckiennes des Mss. de Turin," *Revue des Arts*, 1956 and 1957).

Panofsky *(Studies in Art and Literature for Belle da Costa Greene*, Princeton, 1954, pp. 102–8) persuasively argues that the Detroit picture was commissioned by Cardinal Albergati (cf. 11). He gives the text of the letter on the table: *Reverendissimo in Christo patri et domino, domino Jeronimo, tituli Sancte Cruci's in Jerusalem presbytero Cardinali* ("To the Lord Jerome, most reverend father and lord in Christ, Cardinal priest of the Church of the Holy Cross in Jerusalem").

The reference is to the church of Sta Croce in Gerusalemme, in Rome, which was the titular church of Albergati. According to Panofsky, Jerome has no "known connection with this church"; the mention of it could only be a reference to Albergati. Albergati died in Siena in 1443, and was buried near Florence. That Cosimo de Medici obtained the painting soon after the cardinal's death is a possible hypothesis.

34 ⊞ ✇ 33×16 *1443*? 目 ⦂

Architectural Detail Paris, Musée des Arts Decoratifs
This is evidently a fragment of a very large composition that probably comprized a Madonna enthroned in a niche. It was published by P. Quarré (RdA, 1957) and its attribution to Jan van Eyck, which seems

plausible, is shared by Veronee-Verhaegen (Friedländer, 1967).

35 ⊞ ✇ 77,5×66,5 目 ⦂

The Annunciation New York, Metropolitan Museum (M. Friedsam)
The panel was probably cut off at the top. It was formerly in the following collections: Prince Charleroi, "Duke of Burgundy"; Parent and Countess O'Gorman, Paris, P. Lehman and M. Friedsam, New York. This fascinating painting was first considered in relation to Van Eyck in 1935, when Panofsky (AB) published it as a work by Hubert van Eyck. He made his attribution on the basis of stylistic comparisons with *The Three Marys at the Sepulcher*, Rotterdam (1), a comparison that, in the view of the present writer, is not conclusive. Baldass (AQ, 1950; and 1952) agreed with Panofsky, with qualifications; he thought the composition might have been Hubert's but not the execution. Beenken (AB, 1937), also thought the composition might be Hubert's, but for him the New York panel was probably a copy by Petrus Christus. Friedländer also thought it was by Petrus Christus, while Tolnay (1939) did not take a position on the authorship of the work.

36 ⊞ ✇ 181×116 目 ⦂

The Fountain of Life Madrid, Prado
This painting was in the Gerosolimite Convent of Our Lady of Parral, Segovia. It was transferred to Madrid from the sacristy of that church in 1838 and put in the Museo Nacional. It has been in the Prado since 1872. The composition of the work in superimposed planes made Weale (1908) think of Netherlandish sculptured altarpieces and of the holy representations for which the Low

34

Countries were famous. It is an extremely interesting picture, but the problems it presents have not yet been solved. Is it an original, or a copy? Was it painted before or after *The Ghent Altarpiece*? Ponz *(Viaje de España*, XI, Madrid, 1783) described a painting in the Chapel of St Jerome in the Cathedral of Palencia that corresponds to *The Fountain of Life*. Ponz wrote that the painting was extremely original, well preserved, and painted with great detail. He went on to say that it was a work of very rare quality, copies of which he had also seen in Castille, but which were much inferior in quality to this one. It is probable that the Prado painting is one of the copies mentioned by Ponz. Furthermore, there is a careful version (180·5 × 115·5 cm) of this subject in the Allen Memorial Art Museum, Oberlin (Ohio), that does not seem to be inferior in quality to the Prado panel (cf. Bruyn, in *Allen*

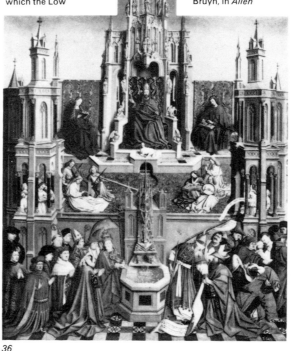

36

Memorial Art Museum Bulletin, XVI, 1958). Some scholars, including Winkler (P, 1931) have suggested that the Prado panel is a copy of a lost original by Jan. For Baldass (1952) it is derived from a work by a follower of Jan. Bruyn (*Van Eyck Problemen*, Utrecht, 1957) thinks it is probably an original painting by an artist who was a follower of Jan van Eyck, executed not earlier than 1440. Bruyn has also attributed to this "Rhine artist of about 1430," a drawing of *Representatives of the Synagogue* (formerly in the Speck von Sternburg Collection and now in the Leipzig Museum), which is clearly related to the similar group in the Madrid panel. Kurz, on the other hand, (1962) asserts that *The Fountain of Life*, both stylistically and iconographically, seems to be an earlier version of the central panel of *The Ghent Altarpiece*. Pächt had suggested (BM, 1956) that the Prado panel reflects an original by Jan, executed during his stay in Spain. Post (JP, 1922) considers it an early work, dating it to ca. 1420. Kämmerer (1898) wondered whether the "dogmatic" appearance of the picture did not suggest that it was commissioned by some Iberian magnate, an interesting idea that was taken up by Bruyn (op. cit.). As Jan spent a not inconsiderable time in Spain and Portugal, and as copies of the presumed archtype existed in Spain during the fifteenth century, there seems to be some ground for supposing that he executed the original in Spain.

37 ⊞ ✇ 11,5×9 目 ⦂

Head of a Man Berlin, Staatliche Museen, Gemäldegalerie-Dahlem
Purchased (1895) in the Florence antique market. Bode (JP, 1901) was the first perhaps to see that this was the same person who is depicted, albeit with his head turned the other way, in the Prado *Fountain of Life* (36). Weale (1908) wondered if this painting were a fragment of a larger work. Both Friedländer (1924) and Tolnay (1939) recognized the evident Van Eyckian character of the work, but neither committed himself to an attribution to Jan. For Baldass (1952) it is the work of an unknown Netherlandish artist between 1430 and 1440. Another possibility should be borne in mind: that the painting may be a nineteenth-century forgery derived from *The Fountain of Life*.

38 ⊞ ✇ 65×49 目 ⦂

Madonna and Child in an Interior Covarrubias (Burgos), Collegiate Church
This interesting painting was brought to light by S. Reinach (BM, 1923). He reasonably conjectured that it was a copy

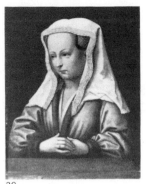

39

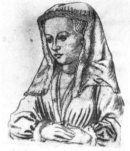

Portrait of Bonne of Artois *(see 39), in a drawing in Arras (Bibliothèque Municipale).*

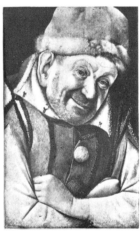

40

of a lost original by Jan that must have resembled the *Ince Hall Madonna* (14). Reinach thought that Petrus Christus might have been the author. But the execution of the painting seems too unsophisticated for a painter of such skill as Petrus Christus. It seems more plausible that the copyist was a Spanish artist.

39 ⊞ ⊗ 22×16 ▤ ⦂

Portrait of Bonne of Artois (?) Berlin, Staatliche Museen, Gemäldegalerie-Dahlem
On the sill in the painting is the inscription: DAME BONE D'ARTOIS DVCHESSE DE BORGOGVNE (sic). This work seems to have been painted in the sixteenth century. Is this really a portrait of Bonne of Artois (who became Philip the Good's second wife on 30 November 1424 and died 17 September 1425) ? and is it a copy of a lost original by Jan van Eyck ? Winkler (P, 1931) believed that the close resemblance to the portrait of

Giovanna Cenami in *The Arnolfini Wedding* (15) leads one to suspect that the so-called "Bone" is a later imitation. But Musper (*Untersuchungen zu Rogier van der Weyden und Jan van Eyck*, Stuttgart, 1948) does not agree. That the portrait is included as that of Bonne of Artois in the Arras Codex of the mid-sixteenth century (see 19) is not sufficient evidence to confirm this identification having some weight in the argument. Baldass thinks that the lady depicted here was called "Bonne d'Artois" because of her resemblance to Arnolfini's wife, who, according to Baldass, was identified in the first half of the sixteenth century as Bonne of Artois.

The Clown Gonnella Vienna, Kunsthistorisches Museum
In the inventory of 1659 of the picture gallery of Archduke Leopold William, governor-general of the Netherlands, the work is described in the

following way: *Ein klein Contrefait von Öhlfarb auf Holcz desz Narren Jonnellae mit gancz gestutztem Barth und rothen Hauben, in einem rothen und gelben Klaidt . . . Auff Albrecht Dürer Manier von Johanne Belino Original.* R. J. M. Begeer (OH, 1952) reproduced an Italian derivation of about 1600 of this painting. The derivation, in a private collection in Ferrara, bears the following inscription: IL VERO RITRATO DEL GONELA ("the true portrait of Gonela"). This would confirm the identity of this curious figure, who, according to Bergeer was the second Gonnella, i.e., the one who was in the service of Niccolò III of Este (1393–1441) and who is mentioned by Bandello. This fact suggests Ferrara, but Begeer's theory – that the *Gonnella* is a work of Jan van Eyck's which was probably executed in the city of the Este family – seems highly doubtful. The painting may be by an Italian painter, even if it is not Giovanni Bellini, as the seventeenth-century inventory supposed.

Other Works recorded in the sources or attributed to the Van Eycks

Because of the impossibility of attempting a chronological listing of these works, they are grouped by subjects.

Religious Subjects

41 Madonna
A small painting indicated as an autograph work of Jan van Eyck in the 1649 inventory of the possessions of Abraham Matthys of Antwerp. Although there are no facts to prove the work's attribution, it is possible that this is the painting listed as 4 in the catalogue above.

42 Madonna and Child
This was in the Jabach picture gallery in Cologne in 1696 and was attributed to Hubert van Eyck.

43 Madonna and Child with an Angel and St Bernard
Mentioned (1595) in the picture collection of Archduke Ernest of Austria as a work by "Rupert (Hubert?) van Heyck."

44 The Nativity
Sold (1660) by the merchants Forchoudt of Antwerp as an autograph work of Hubert van Eyck.

45 St George and The Dragon
In addition to the Lomellino Triptych (46), Alfonso V of Aragon owned a *St George* by Jan van Eyck, for which he paid 2,000 sueldos on 25 June 1445 (Casellas, VC, 1906).

46 The Lomellino Triptych
Described by Facio (1454–5) as an autograph by Jan van Eyck in the possession of Alfonso V, King of Naples (see *Critical Outline*). On the outside were the figures of the donors, Battista Lomellino and

his wife; inside, there was an *Annunciation* in the center, and on the sides a *St John the Baptist* and a *St Jerome in his Cell.* The Lomellinos came from Genoa, and a Girolamo Lomellino was living in Bruges in 1392 (Weale, 1908).
An *Annunciation* by Jan is also mentioned in the inventory (1675 ?) of the merchants Forchoudt of Antwerp, but its dimensions (86·5 × 65 cm) make it certain that this is not the painting now in Washington (18).

Portraits

47 A Portuguese Lady (*La Belle Portugaloise*)
In the 1516 inventory of the possessions of Margaret of Austria, governor of the Netherlands, it was described as *Ung moien tableau de la face d'une Portugaloise que Madame a eu de Don Diego. Fait de la main de Iohannes, et est fait sans huelle et sur toile, sans couverte ne feullet.* The same picture is described in a later inventory of the same owner prepared at Malines in 1523: *Ung aultre tableau de une jeusne dame, accoustrée à la mode de Portugal, son habit rouge fouré de martre, tenant en sa main droite ung rolet avec un petit sainct Nicolas en hault, nommée La belle Portugaloise.* Perhaps this was one of the two portraits that Jan painted in 1429 of the Princess Isabella of Portugal (who became the third wife of Philip the Good).

48 Portrait
Sold on 13 March 1654 by the merchants Forchoudt of Antwerp as a work of Jan.

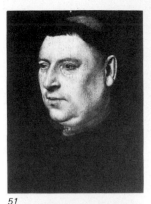

49 Portrait of a Woman
This was a small painting in which a woman was shown in a landscape. Van Mander (1617) considered it a work of Jan van Eyck and recorded it in the possession of Lucas de Heere. Some scholars have identified it as the painting listed here as 26.

50 Portrait of a Woman
Mentioned, together with 54 below, in the inventory (1640) of the collection of Rubens in Antwerp as a work by Jan van Eyck.

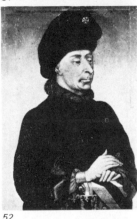

51

51 Portrait of an Ecclesiastic
Panel (26 × 19 cm) in the Musée Ingres, Montauban (attributed there to Ouwater). Formerly attributed to Memling (Bredius, OH, 1904), then to Hubert van Eyck (Durant-Greville, 1910), later considered a derivation of a work by Jan (Tolnay), which hypothesis was put in doubt by Beenken and rejected by Baldass.

52 Portrait of John the Fearless
Panel (21 × 14 cm); Antwerp, Musée Royal des Beaux-Arts
Formerly linked with Hubert van Eyck (Beenken, P, 1937), but it is probably a copy (ca. 1440) of an original by Rogier van der Weyden.

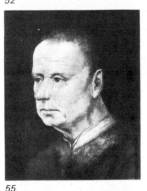

52

53 Portrait of Isabella of Portugal
See 47 above.

54 Portrait of a Man
This is presumably the companion piece to 50 above, and was included in the inventory of Rubens' possessions.

55 Portrait of a Man
Panel (18·4 × 14·3 cm) in the Pennsylvania Museum of Art, Philadelphia (J. G. Johnson Collection). Ascribed to Jan van Eyck by Conway (1921), while Tolnay thinks it is derived from a lost original, but this hypothesis is rightly rejected by Baldass.

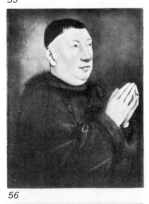

55

56 Portrait of Man with his Hands Joined (A Donor)
Panel (26·4 × 19·5 cm). In the Museum der Bildenden Künste, Leipzig, since 1878. Once considered a fragment of a larger work. It is possibly derived from Jan van Eyck, according to Weale and Brockwell (1912), though Beenken considers it an autograph work of Jan from about 1422–8. But this possibility is rejected by Denis (1954), Baldass and others.

57 Portrait of a Man with a Red Rose
Panel (18 × 12 cm); in the Berlin Museum since 1900 (gift of Beit). Attributed to Hubert van Eyck by Beenken (P, 1937). Baldass rightly rejects this attribution and ascribes the work to a Dutch artist of ca. 1430–40.

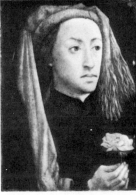

56

57

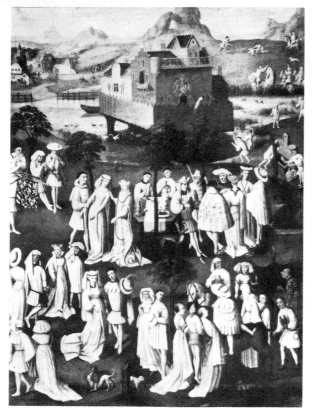

Hunt given by Philip the Good, a canvas in Versailles (Musée National): according to some scholars it is one of two known copies of painting 60.

Other Subjects

58 Women Bathing

Described by Facio (1454–5) as an original by Jan van Eyck in the possession of Cardinal Ottaviani (see *Critical Outline*). Ottafio Ottaviani, whose family was Florentine, was made a cardinal by Gregory XII in 1408. (See also 61 below).

59 The Otter Hunt

A small picture on canvas showing a hamlet with fishermen who have caught an otter, with two figures standing by, by the hand of 'Gaines da Brugia" (Jan of Bruges) is mentioned by M. A. Michiel (Anonimo Morelliano) as being in the house of the philosopher Leonico Tomeo in Padua. But there is no proof that this` attribution was correct (there is a similar scene depicted in a tapestry (ARQ, 1902).

60 A Hunt Given by Philip The Good

There is a painting (161 × 117 cm) of this subject that has been in the Musée National, Versailles, since 1898. (There is another canvas [219 × 118 cm] of the same subject in the Château of Azay-le-Rideau.) It is considered by some scholars (Post, JP, 1931; Tolnay and others) as a copy of a lost original by Jan van Eyck. Baldass rejects this hypothesis, attributing the prototype of this painting to a Franco-Flemish painter of about 1425.

61 Lady at Her Toilet

There is a painting (New York, Van Berg Collection) by Willem van Haecht, signed and dated 1628, of the picture gallery of the Antwerp collector Cornelis van der Geest on the day that Van der Geest was visited by the Archduke Albert and Archduchess Isabella, together with Rubens (15 August 1615). Among dozens of paintings and sculptures depicted in this painting, is a panel with a nude woman preparing to wash, together with a maid who is clothed. Weale, followed by all other scholars, considered this to be copied from a lost work by Jan van Eyck. J. S. Held has written an interesting article (GBA, 1957) about this lost painting, arguing that it was in all probability a companion picture to *The Arnolfini Marriage*. The room and its accessories are very similar, as is the composition, with the two standing figures enclosed by the small room. He considers that the subject was a ritual pre-nuptial bath, taken by Giovanna Cenami in the presence, probably, of Margaretha van Eyck, not a maid. Her presence was the counterpart of his own presence, recorded in *The Arnolfini Marriage*. Small and imperfect though our record of the lost painting is, it seems clear that the picture is in no way deliberately erotic, as has been suggested by some (e.g. Weale) on the analogy of the painting of naked women described by Fazio (58).

62 The Garden of Love

The subject of this picture is known from an engraving (21·8 × 28·1 cm) by the so-called "Master of the Gardens of Love," (an artist who was probably active in the Low Countries in the first half of the fifteenth century), that has apparently survived in only one copy (Berlin, Kupferstichkabinett). The hypothesis that this engraving is derived from wall paintings that Jan van Eyck did in the palace of the Count of Holland at The Hague has not been proved.

63 Pictorial Map of The World (*Mappemonde)*

Mentioned by Facio (1454–5) who said it was painted by Jan van Eyck for Duke Philip the Good (see *Critical Outline*).

64 A Woman on March (?) or A Merchant Woman (?)

A painting ascribed by Jan van Eyck and depicting a *marseringe* is mentioned (1660) as having been in the picture gallery of Dierick Ketgen in Antwerp. It is probably the same work that was recorded a few years later (1676) as being in the collection of Johannes van Hove in Antwerp. The second reference also speaks of a painting of a *marcheringe* (the

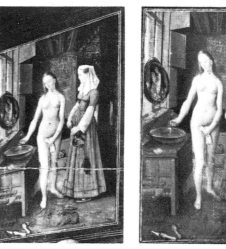

(Left) Detail (center right) of the painting (1628) by W. van Haecht, The Visit of Albert and Isabella of Austria to the Collection of C. van der Geest in Antwerp (New York, Van Berg Collection) showing 61. (Right) The same detail shown frontally, as the original of Jan van Eyck must have appeared.

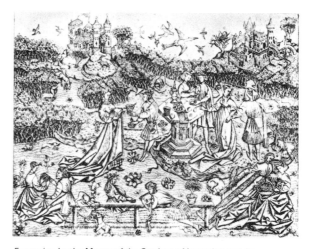

Engraving by the Master of the Gardens of Love that may be related to a wall painting of Jan van Eyck, see 62.

meaning of which is not clear) by Jan van Eyck.

65 A Landlord going Over Accounts with an Overseer

M. A. Michiel (Anonimo Moreliano) describes a small painting with half figures of a "patron" going over his accounts with his overseer, by the hand of "Juan Heio," whom he thought was Memling. Michiel said the painting was done in 1440. He saw it in the home of Niccolò Lampugnani in Milan in the first decades of the sixteenth century.

66 Vanity

There is a small painting of this subject in the Museum der Bildenden Künste (No. 509) in Leipzig. The feeling is decidedly archaic and may be related to a lost original by Jan van Eyck.

Appendix

Drawings by Jan van Eyck or related to his works

Except for the one drawing (see p. 86) that may possibly be directly connected with Hubert van Eyck, all the known drawings refer, albeit in varying degrees, to Jan alone.

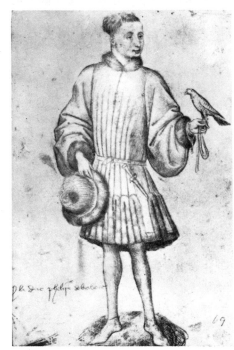

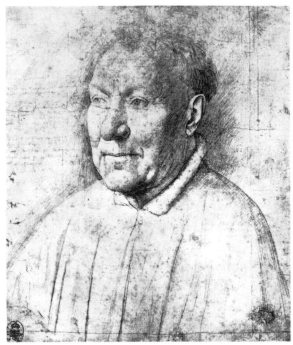

(Above) Portrait of Cardinal Albergati (Silverpoint, 21·2 × 18 cms; Dresden, Kupferstichkabinett). The writing on the drawing, although almost illegible, is considered autograph by most scholars. Examples of these color notes are: Die lippen zeer witachtich ("the lips very whitish"); und die nase sanguynachtich ("and the nose rather red"). It is unanimously agreed that this drawing was a preparatory work for Catalogue 11.

(Below) Four pen drawings, from a series of twelve, depicting the Apostles (20·4 × 13·7 cm each; Vienna, Albertina), six sitting and six standing, identified by name. Those of the drawings reproduced, are Sanctus andreae, S(anc)t(u)s IACOBVS MAIOR, S(an)c(tu)s Johan(n)es euangelista, and S(an)c(tu)s phippus. Generally considered copies from Jan.

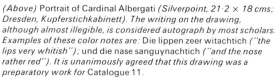

(Above) Drawings of Philip, Duke of Brabant, and Philip, Count of Nevers (above), and of Louis, Duke of Savoy, and John IV, Duke of Brabant; all silverpoint (20·4 × 12·8 cm each); the first two were formerly in the Mannheimer Collection, until they were burned; the others in the Museum Boymans-van Beuningen, Rotterdam. Most consider the drawings derived from Jan, but they were once considered autograph.
(Below, from left) Jael Slaying Sisara (pen and brush, 13·6 × 10 cm.; Brunswick, Herzog Anton Ulrich Museum), not unanimously considered a copy of an original by Jan; considered original by Baldass. Falconeer (silverpoint, 18·8 × 14·3 cm; Frankfurt, Städelsches Kunstinstitut), not unanimously considered a derivation from Jan. Man with a Hood (silverpoint, 12 × 9·5 cm; Paris, Louvre), generally considered a copy from Jan. Fishing-Party at the Court of William VI, colored drawing, 23 × 37·5 cm (Louvre), thought to be early Jan by O. Kurz (articles of same title, O H 1956).

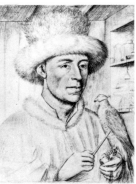

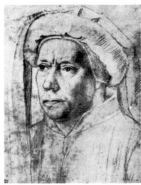

Indexes

Titles and Subjects

Adam 9 I²
Adoration of the Lamb 9 R
Albergati, Nicolas, Cardinal 11
Angels (singing) 9 J;
 (Musicians) 9 N
Angel of the Annunciation 9 A²,
 18, 24 A, 25 A, 35, 46
Annunciation 18, 35, 46;
 (Thyssen) 24 A-B, 46
Architectural Detail, 34
Arnolfini (husband and wife)
 15; (Giovanni) 20
Artois, Bonne of 39
Bathing Women 58
Barbara, St 26, 32
Belle Portugaloise, La 47
Bernard, St 43
Borluut, Isabelle 9 H
Catherine of Alexandria, St 25 F
Cenami Arnolfini, Giovanna 15
Christ 29, 30; (on the Cross with
 Mary and St John) 7
Christ Child, 14, 16, 21, 23,
 25 D, 31, 32, 42, 43, 44
Crucifixion 3 A, 8
Cumaean Sibyl 9 C¹
Donor 9 E, 25 C, 56
Donor's Wife 9 H
Donatian, St 21
Double-lighted window with
 View of Flemish City 9 B²
Ecclesiastic 51
Elizabeth of Hungary, St 32
Erythrean Sibyl 9 B¹
Eve 9 O²
Eyck, Margaretha van 27
Garden of Love 62
George, St 21; (and the
 Dragon) 45
Ghent Polyptych 9 A¹–T
God 9 L
Goldsmith 10
Gonnella, the clown 40
Head of Christ 29, 30
Holy Hermits 9 S
Holy Pilgrims 9 T
Hunt (Otter) 59, 60
Isabella of Portugal 53
Jerome, St, in his Cell 34, 46
John the Baptist, St 9 F, 9 M, 46
John the Evangelist, St 7, 9 G
John the Fearless 52
Just Judges 9 P
Lady at The Toilet 61
Lamb of God 9
Landlord going over accounts
 with his overseer 65
Lannoy, Baudouin de 19
Last Judgment 3 B
Leeuw, Jan de 22
Lomellino, Battista, and his
 wife 46
Madonna 7, 41, 44; (at the
 Fountain) 28; (and Child)
 42; (and child with
 Nicolaes van Maelbeke)
 31; (and Child in an
 Interior) 28; (and Child
 with Chancellor Rolin) 16;
 (and Child, Ince Hall) 14;
 (and Child with St

Elizabeth of Hungary, St
 Barbara and Jan Vos) 32;
 (and Child with an angel
 and St Bernard) 43; (and
 Canon van der Paele) 21;
 (Ypres) 31; (Ince Hall) 14;
 (Jan Vos) 32; (Lucca)
 23; (in her Chamber) 23;
 (and Child enthroned)
 25 D; (and Child
 enthroned, with St
 Donatian and the Donor
 presented by St George)
 (in a Church) 4. (See also
 Virgin.)
Maelbeke, Nicolaes van,
 Provost 31
Man 54, 55; (with joined
 hands) 56; (with red
 rose) 57; (with a pink) 17;
 (with a red turban) 13
Mappemonde (or)
 Pictorial Map of the
 World 63
Marys at the Sepulcher, Three 1
Merchant woman (?) 64
Micah, Prophet 9 D¹
Michael, St, and Donor 25 C
Nativity 44
New York Panels 3 A-B
Niche with a Tri-Lobed
 Window, wash basin, pot
 and towel 9 C²
Offering of Abel and Cain 9 I¹
Paele, van der, Canon 21
Person on march (?) 64
Portuguese Lady 47
Portraits 10–3, 15, 17, 19. 20,
 22, 28, 39, 40, 45–7
Prophets 9 R; (Micah) 9 D¹;
 (Zachariah) 9 A¹
Rolin, Nicolas, Chancellor 16
St Francis receiving the
 Stigmata 5, 6
Sibyl (Cumaean) 9 C¹;
 Erythrean 9 B¹
Slaying of Abel 9 O¹
Timotheos 12
Three Marys at the Sepulcher 1
Triptych (Dresden) 25 A–E;
 (Lomellino) 46
Vanity 66
Virgin 9 K; (of the
 Annunciation) 9 D², 18,
 24 B, 35, 46 (See also
 Madonna)
Vos, Jan, Carthusian 32
Vyd, Joos 9 E
Way to Calvary 2
Warriors of Christ 9 Q
Woman 49, 50
Zachariah, Prophet 9 A¹

Locations of Works

Antwerp
Musée Royal des Beaux-Arts
Portrait of John the Fearless 52
St Barbara 26
Madonna at the Fountain 28

Berlin
*Staatliche Museen
Gemäldegalerie-Dahlem*
Christ on the Cross with Mary
 and St John 7
Virgin in a Church 4
Portrait of Baudouin de
 Lannoy 19
Portrait of Bonne of Artois (?)
 39
Portrait of Giovanni Arnolfini 20
Portrait of a Man with a Red
 Rose 57
Head of Christ 29
Man with a Pink 17

Bruges
*Musée Communal des Beaux-
Arts*
Madonna with Canon van der
 Paele 21
Margaretha van Eyck 27

Bucharest
Muzeul de Artă
Portrait of a Goldsmith 10

Budapest
Szépmüvészeti Museum
Way to Calvary 2

Covarrubias (Burgos)
Collegiate Church
Madonna and Child in an
 Interior 38

Detroit
Institute of Art
St Jerome in his Cell 33

Dresden
Gemäldegalerie
Triptych 25 A-E

Frankfurt
Städelsches Kunstinstitut
Madonna in an Interior 23

Ghent
Cathedral of St Bavon
Polyptych 9 A¹-T

Leipzig
*Museum der Bildenden
Künste*
Portrait of a Man with Hands
 Joined 56
Vanity 66

London
National Gallery
The Arnolfini Wedding 15
Timotheos 12
Man with a Red Turban 13

Lugano
Thyssen Collection
Thyssen Annunciation 24 A-B

Madrid
Museo del Prado
The Fountain of Life 36

Melbourne
National Gallery of Victoria
Ince Hall Madonna 14

Montauban
Musée Ingres
Portrait of an Ecclesiastic

New York
Frick Collection
Jan Vos Madonna 32
Metropolitan Museum
Annunciation 35
Crucifixion 3 A
Last Judgment 3 B
Van Berg Collection
Lady at her Toilet 61

Newcastle-upon-Tyne
Miss J. Swinburne Collection
Head of Christ as King of
 Kings 30

Paris
Musée des Arts Décoratifs
Architectural detail 34
Musée National du Louvre
Madonna with Chancellor
 Rolin 16

Philadelphia
John G. Johnson Collection
Portrait of a Man 55
St Francis receiving the
 Stigmata 5

Rotterdam
*Museum Boymans-van
Beuningen*
Three Marys at the Sepulcher 1

Turin
Galleria Sabauda
St Francis receiving the
 Stigmata 6

Venice
*Galleria Franchetti alla Ca'
d'Oro*
Crucifixion 8

Versailles
*Musée National de Versailles et
des Trianons*
Hunt given by Philip the Good
60

Vienna
Kunsthistorisches Museum
Gonnella the Clown 40
Portrait of Cardinal Nicolas
 Albergati 11
Portrait of Jan de Leeuw 22

Warwick Castle
Private Collection
Madonna of Maelbeke 31

Washington
National Gallery of Art
Annunciation 18